The Esoteric Course of Alchemical Kabbalah

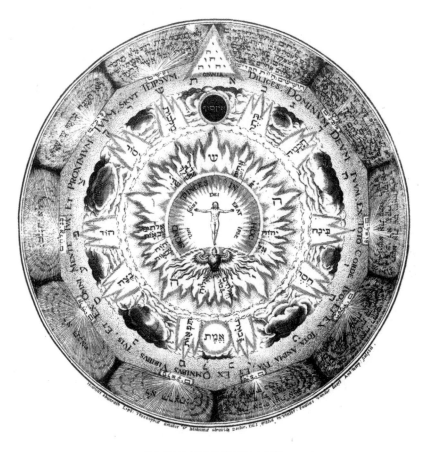

ENGRAVING BY HEINRICH KHUNRATH, 1602

The Four Worlds of Kabbalah. The outer circle of the Ten
Commandments is the World of Assiah. The Second circle of 22
Hebrew letters is Yetzirah. The third circle of Sephiroth is Briah.
The fourth circle of divine names is Atziluth. In the center is the
emanating source of creation, the Cosmic Christ, radiating fire.
Around Him is written "In Hoc Signo Vinces" ("In this sign shalt
thou conquer"). The sign referred to is the shape of the Christ
as a cross, the most holy symbol of Alchemy.

THE ESOTERIC COURSE
OF ALCHEMICAL
KABBALAH

Samael Aun Weor

THELEMA PRESS
2007

The Esoteric Course of Alchemical Kabbalah
A Thelema Press Book / 2007

Originally published as "Curso esoterico de kabala"

This Edition © 2007 Thelema Press

ISBN 978-1-934206-20-1

Thelema Press is a non-profit organization delivering to
humanity the teachings of Samael Aun Weor. All proceeds go to
further the distribution of these books. For more information,
visit our website.

www.gnosticteachings.org
www.gnosticradio.org
www.gnosticschool.org
www.gnosticstore.org
www.gnosticvideos.org

Contents

Preface .. 1

Introduction ... 3

Arcanum 1 .. 9

Arcanum 2 .. 13

Arcanum 3 .. 19

Arcanum 4 .. 25

Arcanum 5 .. 33

Arcanum 6 .. 37

Arcanum 7 .. 43

Arcanum 8 .. 51

 Disposition of the Two Witnesses 53

 Esoteric Ordeals .. 55

 The Flaming Fire .. 55

 The Equilibrium of the Scale .. 57

Arcanum 9 .. 59

 The Ninth Sphere ... 61

 Kabbalistic Traditions ... 63

 Sphere of Lilith ... 64

 Sphere of Nahemah ... 64

 The Forge of Vulcan ... 65

 Cosmic Rhythms .. 66

 Mantras for Sexual Magic ... 66

Arcanum 10 .. 67

 Lunar Conscience .. 67

 Solar Conscience ... 69

 Sexual Cycles ... 70

 Light and Consciousness ... 70

 The Ten Sephiroth ... 71

 Direct Clue for Direct Knowledge 72

 Initiation .. 73

Arcanum 11 .. 75

 Mithras .. 75

 The Number 11 ... 75

 The Pairs of Opposites of Holy Alchemy 76

 Chinese Alchemy .. 76

Schools of Regeneration ...77
Fire Projection..77
Imagination ..78
Practice...78

Arcanum 12 ...79

The Great Work ..81
White and Black Tantra ..81
Twelfth Key of Basil Valentine......................................82
Non-identification...83

Arcanum 13 ...85

The Embryo of a Soul..85
Immortality ..85
Mind...85
Astral-Christ...86
True Identity...86
Soul...86
Willpower ...86
The Laboratorium Oratorium..86
The Retort of Alchemy ..87
Serpents' Scales – Butterflies' Chrysalides89
Elixir of Long Life ..90
Resurrection ...90
The Great Service ...91
The Super-Human ..91

Arcanum 14 ...93

Transmutation..93
Work with the Prostatic/Uterine chakra........................95
Imagination and Willpower ..96
Heart...96
Transformation (shapeshifting).....................................96
Clue for Jinn State ..97
Genii of Jinn Science ..97
Transubstantiation..98

Arcanum 15 ...99

The Work with the Demon ..101
Techniques for the Dissolution of the Ego...................101
Mind and Sentiments ..101
Movement ...102
Instinct..102

Sex ... 103
Adultery ... 103
Death of Satan ... 104
We Need to Be Integral 104
The Mystery of Baphomet 105
The Door of Eden ... 105

Arcanum 16 ..107
Human Specter .. 107
Astral Christ and Mental Christ 107
Immortality .. 108
What is Fundamental ... 109
The Awakening of the Consciousness 109
Ordinary Sleep .. 110
Technique for the Awakening of the Consciousness 110
Memory .. 111

Arcanum 17 ..113
The Narrow Door ... 115
The Three Rays .. 116
Yoga .. 116
Astrology ... 117

Arcanum 18 ..119
Adam-Christ .. 122
Cosmic Christ .. 122
Solar Internal Bodies .. 122
Renowned Incarnations 123
The Embryo of the Soul 123

Arcanum 19 ..125
The Philosophical Stone 127
The Great Tempter ... 128
Love .. 128

Arcanum 20 ..129
Fatality .. 131
Three Types of Resurrection 132
Spiritual Resurrection 132
Resurrection with the Body of Liberation 132
Resurrection with the Physical Body 132
Elixir of Long Life .. 133

Arcanum 21 ..135
Coexistence .. 138

Intuition .. 139

Practice for the Development of Intuition 139

Arcanum 22 ...141

The Crown of Life ... 143

The Three Profundities .. 144

The Number 22 .. 144

Hieroglyph .. 145

The Ark of Alliance .. 145

The Internal Lodge .. 145

Index ...149

The Kabbalah is the science of numbers.

The author of the Tarot was the Angel Metatron. He is Lord of the serpent wisdom. The Bible refers to him as the Prophet Enoch.

The Angel Metatron, or Enoch, delivered the Tarot, in which the entirety of divine wisdom is enclosed. The Tarot remains written in stone.

He also left us the twenty-two letters of the Hebrew alphabet.

This great Master lives in the Superior Worlds, in the world of Atziluth, which is a world of indescribable happiness. According to the Kabbalah, this world is the region of Kether, a very high Sephirah. All Kabbalists base themselves on the Tarot and it is necessary for them to comprehend the Tarot and study it deeply. The Universe was made with the laws of numbers, measurements, and weight. Mathematics forms the Universe, and the numbers become living entities.

- The Initatic Path in the Arcana of Tarot and Kabbalah

Preface

Adorable and immortal Beings,

Greetings and adorations,

Beloved disciples,

There are two types of Kabbalists: intellectual Kabbalists and intuitive Kabbalists. The intellectual Kabbalists are Black Magicians, whilst the intuitive Kabbalists are White Magicians.

Many times the sidereal Gods answer our questions by showing us a tarot card; we must intuitively comprehend the answer that is given onto us. Intuitive Kabbalists comprehend what destiny held in reserve to them by just seeing any card of the tarot.

Gnostic Kabbalah is the doctrine of practical Christification. We do not theorize here. This is a one hundred percent practical work. Many students long for their Christification but they do not know where to start, because they do not know the clue, the secret.

Here we give away the clue, the secret, the key, to every student. Here is the clue, thirsty lovers of the truth: now practice.

You are not alone. We love you profoundly, thus when you tread on the path of the razor's edge, you will be internally assisted by the brethren of the temple.

In this course we deliver the clue of resurrection. We have torn the veil of the sanctuary. Here you have all the secrets; here are all the clues of Christification. Here is written the doctrine that the Adorable taught in secret to his humble disciples

The Adorable One will remain with us until the end of times. This is his doctrine. Here you have it: study it and practice it.

THE TREE OF LIFE: THE KABBALAH

Introduction

Children of man, do you want to enter into the ineffable joy of nirvana?

Do you want to become as Gods? Do you want to convert yourselves into Christs?

Do you want to liberate yourselves from the wheel of birth and death?

Here we will give you the clue of sexual magic! What else do you want?

Let us start seeing the existing relationship of the ten Sephiroth with the first ten cards of the Tarot.

The seven planets of the solar system are the seven Sephiroth, and the Thrice-spiritual Sun is the Sephirothic Crown.

These Sephiroth live and palpitate within our Consciousness and we must learn to manipulate and combine them in the marvelous laboratory of our interior universe.

The Ten Sephiroth are:

Kether – Crown; the equilibrated power; the magician, the First Arcanum of the Tarot whose primeval hieroglyph is represented by a man.

Chokmah – Wisdom; the Popess of the Tarot; occult wisdom, the Priestess. The second card of the Tarot; the moon; the primeval hieroglyph is represented by the mouth of man.

Binah – Intelligence; the planet Venus; third card of the Tarot, the Empress, primeval hieroglyph is represented by a hand in the attitude of grasping.

These three Sephiroth are the Sephirothic Crown.

The seven inferior Sephiroth come in the following order:

Chesed – Mercy; Jupiter, the Divine Being, Atman, whose primeval hieroglyph is represented by a breast. The fourth card of the Tarot, the Emperor.

Geburah – Severity; the Buddhic body of the Man, the Pope or the Hierophant of the Tarot, Mars, the warrior of Aries.

Tiphereth – Beauty, Venus of Taurus, love of the Holy Spirit, the Causal Body of the Man, the sixth card of the Tarot, the Lover.

Netzach – Victory, Justice of the Arcanum, the seventh card of the Tarot, the chariot, Saturn.

Hod – Glory, Mercury of Gemini, the eighth card of the Tarot, the Eternity of all.

Yesod – Foundation, the Sun of Leo, the ninth card of the Tarot. The Hermit, the Absolute.

Malkuth – Kingdom, the entire universe, Mary or Virgo, Nature.

These ten Sephiroth live within our Being and are our inner solar system. The Tarot is intimately related with Esoteric Astrology and with Initiation.

Arcanum X (10) First hour of Apollonius. Transcendental study of occultism.

Arcanum XI (11) Second hour of Apollonius. The strength; the abysses of fire; the astral virtues form a circle through the dragons and fire. Study of the occult forces.

Arcanum XII (12) Third hour of Apollonius. The serpents, the dogs and the fire; sexual Alchemy; Sexual Magic, work with the Kundalini.

Arcanum XIII (13) Fourth hour of Apollonius. The neophyte will wander at night among the sepulchers, will experience the horror of visions, and will be submitted to Magic and Goethia; this means that the disciple will be aware that he is being attacked by millions of black magicians within the astral plane; these tenebrous magicians attempt to drive the disciple away from the luminous Path.

Arcanum XIV (14) Fifth hour of Apollonius. The two amphorae: Divine and human magnetism; the superior waters of heaven. During this time the disciple learns to be pure and chaste because he comprehends the value of his seminal liquor)".

Arcanum XV (15) Sixth hour of Apollonius. The electric hurricane, Typhon Baphomet. Here it is necessary to

remain quiet, still, due to fear; this signifies the terrible ordeal of the Guardian of the Threshold, before whom a lot of courage is needed in order to overcome him.

Arcanum XVI (16) Seventh hour of Apollonius. The fire comforts inanimate beings, and if any priest, a sufficiently purified man, steals the fire and then projects it, if he mixes this fire with sacred oil and consecrates it, then he will achieve the healing of all sicknesses by simply applying it to the afflicted areas. Here the Initiate becomes aware that his material wealth is threatened and his business fails

Arcanum XVII (17) Eighth hour of Apollonius. The star of hope. The star of the Magi; the astral virtues of the elements, of the seeds of every genre.

Arcanum XVIII (18) Ninth hour of Apollonius. Study of the Minor Mysteries, the nine arcades on which the student must ascend

Arcanum XIX (19) Tenth hour of Apollonius. The resplendent light. The doors of heaven open and man comes out of his lethargy (this is the number 10 of the 2nd great Initiation of Major Mysteries that allows the Initiate to travel in the Ethereal Body. This is the wisdom of John the Baptist.

Arcanum XX (20) Eleventh hour of Apollonius. The awakening of the dead. The angels, the cherubim and seraphim fly with the sound of wings whirring; there is rejoicing in heaven; the earth and the sun which surge from Adam awaken. This process belongs to the great Initiations of Major Mysteries, where only the terror of the Law reigns

Arcanum XXI (21) Twelfth hour of Apollonius. The towers of fire are disturbed. This is the victorious entry into the limitless bliss of nirvana, where the Master eventually is clothed with the resplendent robe of Dharmakaya, or rather renounces the bliss of nirvana for the love of humanity, and becomes a Bodhisattva of Compassion, he becomes a savior of the wretched suffering humanity, he becomes one more wedge of the protective wall raised

with the blood of martyrs.. Samyak Sambuddha, Master of Perfection, renounced nirvana for the love of humanity.

The Pratyeka Buddhas when dressed with the glory of the Dharmakaya robe can no longer reincarnate to help man or humanity, because nirvana is the forgetting of the world and men forever.

The Bodhisattvas: Kuan-Chi-Yin, Tashisni, Buddha Gautama, and Christ always radiate their light over suffering humanity.

<div align="right">Samael Aun Weor</div>

Now we start the course of Kabbalah. Let us study the 22 Major Arcana of the Tarot. Therefore this course will have 22 lectures. We hope that you will study and practice with patience and tenacity so that you will attain great realizations.

We will start by studying the First Arcanum of the Tarot. We will enter into the Sanctum Regnum of High Magic.

Inverential peace,

Samael Aun Weor

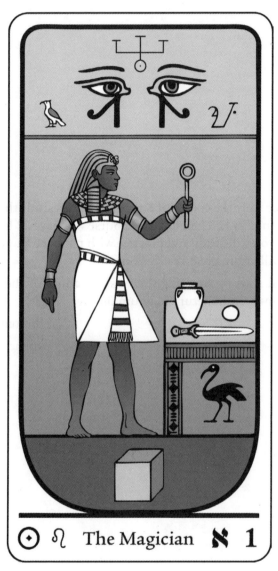

The Magicion · 1

Arcanum 1

This Arcanum is represented by the Magician. The Holy Eight, symbol of the infinite, appears above the head of the Magician; the Holy Eight encloses, defines, and joins the magnetic currents of the mind that deals with dream consciousness with the mind that deals with vigil consciousness. This sign joins or separates all of the elements which are controlled by the atomic energy, if it is traced with the middle finger, index finger and the thumb over the surface of the cardiac plexus.

PRACTICE: According with the former description the following exercise is suggested: Withdraw all type of thoughts from your mind, now imagine the Holy Eight as it is represented in the following graphic:

Allow the figure itself to submerge within your consciousness and thereafter, while falling asleep, empty your mind, without thinking in anything. Thus after a while, you will awaken your consciousness in the Astral Plane.

If we consider the formation of this symbol, we see that it illustrates the continuity of only one arm that encloses a double circuit in the beginning of the stroke, while enclosing only one circuit in the continuation of the stroke. Thereafter, the stroke divides the sign at the point where it centrally crosses it and it then continues into the other circuit in order to project itself towards the exterior. One circuit closes and the other opens.

This is the required key in order to open all the doors and to cut all the currents formed by the atomic energy, beginning with the one that we have imagined and placed within the depth of our consciousness and ending with the one that originated the rest, which circulates in the same manner in the center of the "Ninth Sphere."

Now then, to overcome by means of these requirements the risks per se of every astral experience and thus to obtain a fast and

also perfect astral projection is more than enough reason, among other things, in order for the Sacred Order of Tibet to affirm in its motto: "Nothing can resist our power."

Thus, moments before lying down in order to perform this practice, the disciple must invoke with all of his heart and with all of his soul, the great regent of the Sacred Order of Tibet. The name of this great Guruji is Bhagavan Aklaiva. This Order, that we have the honor of representing here in Mexico, is the most powerful Order of all the Oriental traditions. This Order is formed by 201 members. The major rank is formed by seventy-two Brahmans.

Papus in his *Treatise of Occult Science* stated that the true initiates from the east are the ones who belong to the secret sanctuaries of Brahmanism, since they are the only ones who can give us the royal clue of the Arcanum A.Z.F., thanks to their knowledge of the primeval Atlantean language "Watan," the fundamental roots of Sanskrit, Hebrew, and Chinese.

The Sacred Order of Tibet is the genuine owner of the real treasury of Aryavarta. This treasury is the Arcanum A.Z.F.

Bhagavan Aklaiva will help you to consciously travel in your Astral Body. Invoke him when you are meditating on the sacred sign of the infinite. On any given night, you will be invoked from the Temple of the Himalayas; there you will be submitted to "Seven Ordeals." There you will be taught the secret science.

Now then, after this digression, let us continue with our initial point. The Holy Eight symbolizes the Caduceus of Mercury and represents the two ganglionic chords that esoterically are entwined around the spinal medulla, these are: Ida and Pingala; the two witnesses, the olive branches, the two candlesticks standing before the God of the earth.

The solar atoms rise through the cord of the right and the lunar atoms rise through the cord of the left.

These solar and lunar atoms rise from our seminal system the fire of Phlegethon and the water of Acheron cross in the Ninth Sphere, sex, and form the sign of the Infinite.

F plus A equal C: fire plus water equal consciousness.

Whosoever meditates on the sign of the infinite, will utilize the Fire and the Water in order to awaken the consciousness. Now we

understand why the two witnesses of revelation have the power of prophecy.

> *And I will give power unto my two witnesses, and they*
> *shall prophesy a thousand two hundred and threescore*
> *days, clothed in sackcloth.*
>
> *As we said: These are the two olive trees, and the two*
> *candlesticks standing before the God of the earth.*
>
> - Revelation 11:3, 4

Now then, the quantity 1260 (a thousand two hundred and threescore days) is Kabbalistically added as follows:

1 plus 2 plus 6 plus 0 = 9; this is the symbol of the Ninth Sphere.

The Ninth Sphere is sex. The two witnesses have their root in the sex. These two witnesses Ida and Pingala are two fine ganglionic chords through which the solar and lunar atoms of our seminal system ascend to the "chalice." The chalice is the brain.

Fill your chalice, brethren of mine, with the sacred wine of light.

Now you comprehend why the sign of the infinite appears above the head of the magician, and why the sword, the cup and pantacles are before him, and why is he grasping the magic wand that symbolizes the spinal medulla.

When the solar and lunar atoms make contact in the coccygeal bone, the Kundalini, the igneous serpent of our magical powers awakens, then we are devoured by the serpent and we convert ourselves into excellent divine magicians.

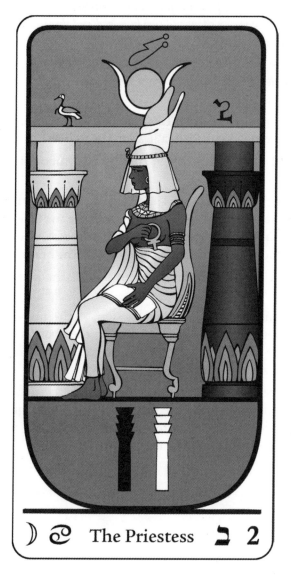

) ♋ The Priestess ב 2

ARCANUM 2

Arcanum 2

Now let us study the magical equilibrium of the Second Arcanum of the Tarot.

The physical body is organized by the elements. The Innermost emanated from the Inner Star that has always smiled upon us; He is positively polarized. The physical body is the negative shadow of the Innermost.

Spirit and matter live in eternal combat. When the Spirit defeats the matter, the Spirit then becomes a Master. Maya (illusion) could not exist without the duality. Force and matter are two modalities of the same thing: energy. Matter is determined energy and a determinator of new undulations. Evolution is a process of complication of the energy whose outcome is the Macrocosmos and the Microcosmos. The universe is Maya (illusion). The universe exists because of Karma and it is a mass of floating shadows.

When the Spirit (the Innermost) liberates himself from Maya, it returns to the Ain Soph of Kabbalah. In the last synthesis each Being is just a super divine atom from the Abstract Absolute Space. That atom is the Ain Soph.

The ineffable gods from the Ain Soph are beyond any comprehension for us. The human mind is for the gods of the Ain Soph what the activities of the mineral kingdom are for us. Within the Ain Soph only the unity of life reigns; that is supreme happiness. The universe is duality, Maya/Pain. We need to liberate ourselves from the Binary and to return into the unity of life. It is urgent to pass beyond the painful manifestations of Maya. A science exists; with it we can tear the veil of Maya and return into the Ain Soph; that science is Alchemy.

Dr. Arnold Krumm-Heller stated: "A chemist just happened to forget about an emerald ring that was close to a little test tube containing radium. After few weeks he saw that the emerald had absolutely changed into another stone, unknown to him. Thereafter he purposely left other stones like rubies, zephyrs, etc., in contact with the radium: his surprise was great when he discovered that after a little time such stones had absolutely changed their color; the blue ones had turned into red and the red ones into green."

Dr. Krumm-Heller continues saying, "Gentlemen, do you know what the former statement that I just mentioned means (since I do not consider that it is scientifically established)? It means that Shakespeare was right when he said that 'many things exist between heaven and earth that our scholastic consciousness does not even suspect,' and the science of alchemy is reborn when corroborating the transmutations of metals." Man and woman must equilibrate their forces; they must become alchemists, so that they can return to the Ain Soph. Circe offers the tempting cup and Ulysses rejects her with his sword. The sacred sign of the infinite represents the brain, heart, and sex of the planetary Genie. This struggle is terrible, brain against sex, and sex against brain, and what is even more terrible and more painful, heart against heart. You know this.

The Masters used to place three cups of glory, three cups of Alchemy upon the altars of the Temples of the White Lodge. Each one of these three sacred cups of the Temple contains a precious balm: the Red Balm is the Fire, the Blue Balm is the Water, and the White Balm is the Universal Spirit of Life.

Ida and Pingala are the canals through which the atoms of Fire and Water ascend; the Spirit grasps the cane with seven knots (that cane is the spinal medulla). When man and woman learn how to avoid the sexual spasm and the ejaculation of the "Ens Seminis," then the igneous lerpent of our magical powers awakens. If you want to return to the father who is in secret, you must first return to the bosom of your Divine Mother Kundalini. You need to raise the serpent of life through your medullar canal. This is Alchemy.

Alchemy: You have forgotten your Divine Mother Kundalini. You need to worship the divine and blessed Mother Goddess of the world. You have been ungrateful to your Cosmic Mother; She is the Virgin of all religious cults; She is Isis, Mary, Cibeles, Adonia, Insobertha, etc. The Stone of Grace is surrounded by nine delectable mountains; that Stone is sex. If you want to return to the bosom of your Divine Mother, you need to work with the Philosophical Stone: sex.

The Mayans stated that in the first heaven God, the Word, had held his stone, had held his serpent, and had held his substance. Only with the Arcanum A.Z.F. can the Word become flesh in order to grasp his stone, his serpent and his substance anew. Then we

will return into the Ain Soph; we will return into the Unity of Life. You are the children of the Widow, your Divine Mother is now a widow, but when She rises through the medullar canal, she is betrothed with the Eternal Beloved. Your Divine Mother is the Second Arcanum, the Popess of the Tarot. She is crowned with a Tiara. The head of the Divine Mother is surrounded by a veil. You must be courageous and lift the Veil of Isis. Our Gnostic motto is Thelema (willpower).

The Mother carries her son (the Word) within her arms; and she is seated between the two columns that symbolize man and woman. Worship the Virgin of the Sea, brethren of mine. The Divine Mother appears in the Second Arcanum making the priestly esoteric sign with her hand. Study within the sacred book of your Divine Mother. "Ask and it shall be given to you. Knock and it shall be opened unto you." (Matthew 7:7) Your Divine Mother can grant the longed for occult powers. Pray to your Divine Mother; practice your esoteric exercises; you can ask your adored Mother for clairvoyance, telepathy, clairaudience, the faculties for Astral projection, etc. You can be sure that your Divine Mother will listen to your beseeching. You must profoundly meditate everyday upon your Divine Mother, praying, pleading. "You need to be devoured by the serpent." One (1) is the man, two (2) is the woman; the man is one column the woman is the other column of the temple. The two columns must not be too close or too distant; there must be enough space so that the light can pass between them.

It is necessary to transmute the lead of the personality into the pure gold of the spirit: this is Alchemy. The moon must be transformed into the sun. The moon is the Soul; the sun is the inner Christ. We need to be Christified. No human being can return to the Father without having been devoured by the serpent. No one can be devoured by the serpent without having worked in the flaming forge of Vulcan (Sex). The key of Christification is the Arcanum A.Z.F. The mantra for the Arcanum A.Z.F. is I.A.O. – I (Ignis), Fire, A (Aqua), Water, O (Origo), Principle, Spirit.

Mars descends into the flaming forge of Vulcan in order to retemper his sword and to conquer the heart of Venus, Hercules descends in order to clean the stables of Augias with the sacred Fire and Perseus descends in order to cut off Medusa's head. Remember

beloved disciples that our Divine Mother is Nut and her word is (56) fifty-six. This number is Kabbalistically added as follows: 5 + 6 = 11, then 1 + 1 = 2. One is the Father; two is She, Nut, the Divine Mother Kundalini.

Practice

1. Lay down on your bed, facing up and with your relaxed body.

2. Achieve the state of slumber by meditating upon the sacred serpent that dwells in the coccygeal chakra.

3. Thereafter, pray with all of your heart, meditating on the following sacred, ritualistic prayer:

INVOCATION

Be thou, oh Hadit, my secret, the Gnostic mystery of my Being, the central point of my connection, my heart itself, and bloom on my fertile lips, made Word!

Up above, in the infinite Heavens, in the profound height of the unknowable, the incessant glow of light is the naked beauty of Nut. She reclines, she bends in delectable ecstasy, to receive the kiss of secret fervor of Hadit. The winged sphere and the blue of the sky are mine.

O.A.O. KAKOF NA. KHONSA

O.A.O. KAKOF NA. KHONSA

O.A.O. KAKOF NA. KHONSA

These mantras have the power of transmuting our sexual energy into light and fire within the alchemical laboratory of the human body. This prayer with its mantras can be utilized in Sexual Magic. This prayer with its mantras is an omnipotent clue in order to meditate upon our Divine Mother.

The Master Huiracocha (Dr. Krumm-Heller) stated the following in his *Rosicrucian Novel:* "When the man joins the woman in the secret act, he becomes a God since he converts himself into a Creator in this moment. Seers state that in those precise

moments of love, the two beings are seen enveloped by a brilliant burst of light; they are enveloped by the most subtle and potent forces that are in nature. If man and woman would know how to withdraw without the spasm and retain such a vibration, then they can operate with it as a magician in order to purify themselves and obtain everything. However if they do not know how to retain such light, it will withdraw from them in order to set out into the universal currents, yet leaving behind the open doors so that evil can introduce itself to them. Then love is converted into hatred, their illusion is followed by deception."

With the mantric prayer that we have taught in this lesson, we retain that brilliant cosmic light that envelops the human couple in that supreme moment of love with the condition of avoiding, by all means, the ejaculation of the Ens Seminis. The mantras of this invocation have the power of transmuting the creative energies into Light and Fire.

The bachelor and bachelorettes can also transmute and sublimate their sexual energies and carry them to the heart with this prayer and these mantras. You must know that in the Temple of the Heart, the creative energies are mixed with the forces of Christ and thereafter they elevate to the superior worlds. The inner Christ lives in the Heart Temple. The cross of initiation is received in the Heart Temple. This mantric prayer is also a formula of priestly power that the magician utilizes in his practices of internal meditation in order to arrive at the feet of his Divine Mother. If the meditation is perfect, your adorable Mother will hear your call and she will come to you; then you can converse with her about ineffable, paradisiacal things. She is Devi Kundalini; She is the Popess of the Tarot. The Divine Mother always listens to her devotees. In the sacred land of the Vedas, Ramakrishna was one of her greatest devotees.

Do you want to reach the heights of Nirvikalpa-Samadhi? Do you need to develop Anubhava (perception of your Inner God in meditation)? Do you want the Jinn Science? Remember that you have an adorable Mother.

> *Ask and it shall be given to you. Knock and it shall be opened unto you.* - Matthew 7: 7

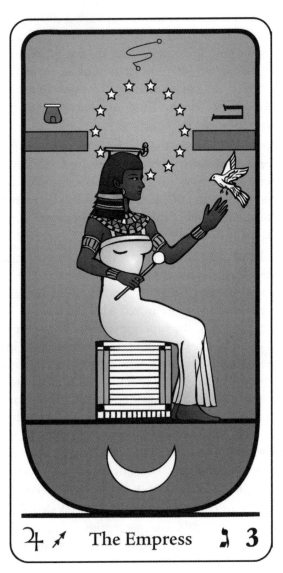

The Empress

ARCANUM 3

Arcanum 3

Remember that the *Sepher Yetzirah* marvelously describes all the splendors of the world and the extraordinary play of the Sephiroth within God and the human being through the thirty two paths of Wisdom. The entire science of the Sephiroth is hidden within the sexual mysteries.

The soul has three aspects:

1. Nephesh, the Animal Soul.
2. Ruach, the Thinking Soul.
3. Neshamah, the Spiritual Soul.

The Sephiroth are the substratum of these three aspects of the souls. The Sephiroth are atomic. *The Zohar* insists on these three "principle elements" which compose the world. These elements are: Fire (Shin), Water (Mem), Air (Aleph). These elements are the perfect synthesis of the four manifested elements.

SHIN MEM ALEPH

The powerful mantra I.A.O. encompasses the magical power of the triangle of these principle elements:

I – Ignis – Fire

A – Aqua – Water

O – Origo – Principle Spirit

I.... A... O... is the supreme mantra of the Arcanum A.Z.F.

Whosoever wants to raise the soul of the world through the medullar canal must work with the Sulfur (Fire), with the Mercury (Water), and with the Salt (Philosophical Earth). It is only in this way that one can be born in Spirit and Truth.

The Twelve Secret Keys of Basil Valentine (Basilius Valentinus), the Benedictine of Erfurt, are found within the Arcanum A.Z.F.

The entire secret of the Great Work is enclosed within the "Azoth" series of Basil Valentine. Azoth is the sexual creative

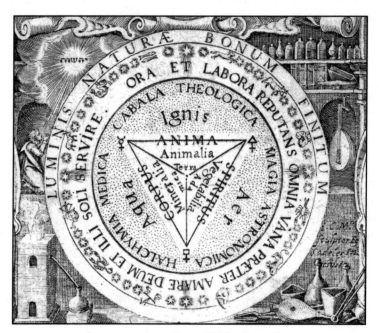

ENGRAVING FROM BASILICA CHYMICA (1622) BY OSWALD CROLL

principle of Nature. The Magnum Work has been performed when the rose of the spirit blooms upon the cross of our body.

The three Principle-Elements are the Three Mother Letters of the Hebraic alphabet. When one is practicing the Arcanum A.Z.F. one is working with these three principle-elements within the great laboratory of Nature. One works with Mercury, Sulfur and Salt when one practices the Arcanum A.Z.F.; this is how the lead of the personality is transmuted into the gold of the Spirit; this is how we create the Golden Child of Alchemy within us.

These three principle-elements become manifested within the four elements of Nature. There exists the heat of Fire and Air, the humidity of Air and Water, and the dryness of Fire and Earth.

These are the three principle-elements, the I.A.O., the Sulfur, Mercury, and Salt contained within the four elements of Nature. The Elemental Paradises of Nature are found within these principle-elements. The Kabbalist-Alchemist must learn how to use Sulfur, Mercury, and Salt.

The larvae of the Astral Body (incubi, succubi, basilisks, dragons, phantoms, etc.) are destroyed by putting sulfur powder inside of our shoes. Sulfur originates invisible vapors that rise in order to disintegrate these types of larvae. Malignant forms of thoughts and larvae enclosed within any room are disintegrated when one burns sulfur upon a flaming piece of charcoal. Mercury serves in order to prepare Lustral Water; the great astrologer Nostradamus spent many nights before a copper container filled with water. This is how, by looking within these waters, this great seer saw the future events that he left written in his famous prophesies.

If we add mercury to water and place a mirror at the bottom of the copper container, a marvelous "clairteleidoscope" is formed. We advise the use of any copper container with the exception of the so-called cauldron (a symbol of Black Magic).

Copper is intimately related with the pituitary gland and has the power of awakening clairvoyance.

Salt is also used often in White Magic. Salt must be combined with alcohol. If alcohol and salt are placed within a container and if this mixture is then ignited, a marvelous smoke offering is obtained. This type of smoke offering is only done when invoking

the Gods of Medicine, when a sick person needs to be healed. Thus, they will attend to your call.

The sulfur (fire) totally burns without leaving any residue. Sulfur is the Shin of the *Zohar*. The water (the Ens Seminis) is the Mem of the *Zohar*. By means of successive transmutations, Fire and Water are reduced to the Kabbalistic Aleph (which the alchemist calls Alkaest). This is how the I.A.O. is performed, and this is how the twelve faculties of the soul are opened. The Soul is Christified, "the Kundalini blooms upon our fertile lips made Word." The ternary is the Word, plenitude, fecundity, nature, the generation of the Three Worlds.

The Third Arcanum of Kabbalah is that woman dressed with the sun, with the moon under her feet, and crowned with twelve stars. The symbol of the Queen of Heaven is the Empress of the Tarot. She is a mysterious, crowned woman, seated with the Scepter of Command in her hand. The globe of the world is on top of the Scepter. She is Urania-Venus of the Greeks, the Christified Soul.

The man is Arcanum number one and the woman is Arcanum number two of the Tarot. The Christified soul is the outcome of the sexual union of both (the secret is the Arcanum A.Z.F.). The woman is the Mother of the Word. Christ is always the child of Immaculate Conceptions. It is impossible to be born without a mother.

When the initiate is ready to incarnate the Word, a woman appears in the superior worlds as if with child, having labor pains in delivery.

> *When Jesus therefore (on the cross) saw his mother and*
> *the disciple standing by, whom he loved, he said unto his*
> *mother: Woman, behold thy son! Then he said to (John)*
> *the disciple, Behold thy mother! And from that hour that*
> *disciple took her unto his own home.* - John 19:26, 27

The word John can be rearranged as follows: I.E.O.U.A.N., the Word (the Dragon of Wisdom). Indeed, the woman is the Mother of the Word and the woman officiates upon the altar of the blessed Goddess Mother of the world. Now brethren, know that the venerable priestess of your Divine Mother Kundalini is your spouse.

Brothers and sisters, pray and meditate a great deal to your Divine Mother Kundalini as follows:

INVOCATION

Oh Isis! Mother of the Cosmos, root of Love, trunk, bud, leaf, flower and seed of all that exists; we conjure Thee, naturalizing force. We call upon the Queen of Space and of the Night, and kissing her loving eyes, drinking the dew from her lips, breathing the sweet aroma of her body, we exclaim: Oh Thou, Nut! Eternal Seity of heaven, who art the primordial Soul, who art what was and what shall be, whose veil no mortal has lifted, when Thou art beneath the irradiating stars of the nocturnal and profound sky of the desert, with purity of heart and in the flame of the serpent, we call upon Thee!

Pray and meditate intensely. The Divine Mother teaches her children. This prayer must be performed while combining meditation with the state of slumber. Then as in visions of dreams, illumination emerges; thus the Divine Mother approaches the devotee in order to instruct him in the great mysteries.

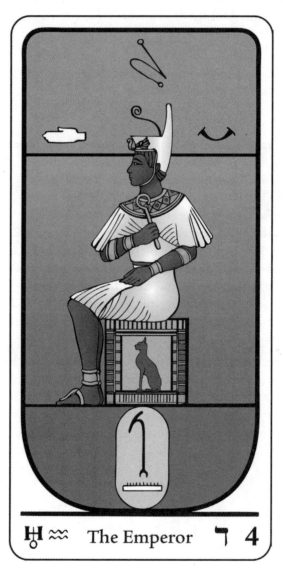

The Emperor

Arcanum 4

Arcanum 4

AUM. The Arcanum Four of the Tarot is the Holy and Mysterious Tetragrammaton, the sacred name of the Eternal One that has four letters: Iod, Hei, Vau, Hei.

TETRAGRAMMATON

"Iod" is the Man, "Hei" is the woman, "Vau" is the phallus, "Hei" is the uterus. Yet, we can also state: "Iod" is the man, "Hei" is the woman, "Vau" is the fire, "Hei" is the water. The profound study of the four letters of the Eternal One takes us inevitably to the Ninth Sphere (sex). We must lift our serpent through the medullar canal and carry it up to her heart's sanctuary.

The cross of the initiation is received in the Heart Temple. The magnetic center of the Father is found between the eyebrows. The sanctuary of the Mother is found within the Heart Temple. The four points of the cross symbolize the Fire, the Air, the Water, and the Earth (also Spirit, Matter, Movement, and Repose).

Remember, beloved disciple, that the four elements of Alchemy are: Salt, Mercury, Sulfur, and Azoth: the Salt is the matter; the Mercury is the Ens Seminis, the Azoth is the mysterious ray of Kundalini.

The Mercury of Secret Philosophy must be fecundated by Sulfur (Fire) so that the Salt can become regenerated. Only like this can we write the book of Azoth, write it upon a reed if what you want is initiation. The clue of our liberation is found in the lingam-yoni.

The cross has four points. The cross of initiation is phallic. The insertion of the vertical phallus into the formal cteis forms a cross. This is the cross of initiation that we must place upon our shoulders.

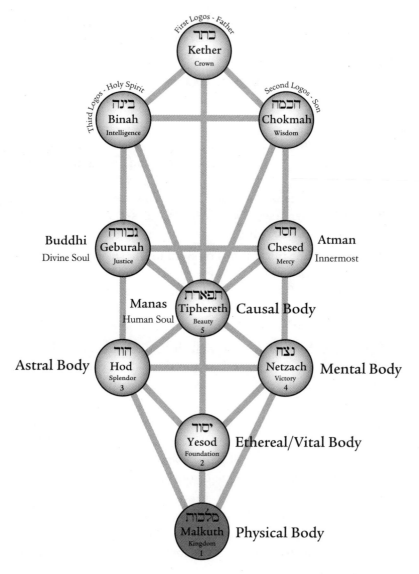

THE TREE OF LIFE AND THE BODIES OF THE SOUL

The four sacred animals of Alchemy are: the Lion that hides the enigma of Fire; the Man the represent the Mercury of Secret Philosophy; the Eagle that corresponds to the Air; the Bull that symbolizes the Earth. Egypt's sphinx (as well as Ezekiel's sphinx) has the sacred symbolism of the four creatures of alchemy.

The water contained in the lakes, rivers and oceans when heated by the fire of the sun are transformed into clouds that ascend up to the sky, and after a period of digestion are converted into lightning and thunder. This same process is repeated in the sexual laboratory of the alchemist. Our motto is Thelema (Willpower).

The entrance into the old, archaic temples was commonly a hidden hole in some mysterious spot in the dense jungle. We departed from Eden through the door of sex, and only through that door can we return to Eden. Eden is sex. It is the narrow, straight, and difficult door that leads us into the light.

In the solitude of these mysterious sanctuaries, the neophytes were submitted to the four initiatic ordeals. The ordeals of fire, air, water and earth always defined the diverse purifications of the neophytes.

Commonly, these sanctuaries of mysteries were found located at the foot of some volcano. There the disciples would fall to the ground and lose consciousness; in those moments the hierophant would take the students out of their physical bodies (thus, they would already be in the Astral Plane) and into the profundities of the sanctuary. Then he would teach them the grandiose mysteries of life and death. The volcanic emanations of the earth produced that apparent state of death. Some disciples fall in that apparent state of death within the Gnostic Lumisials. The ceremony of carrying the cross (as was practiced in the Gnostic Lumisials), serves in order to humbly confirm some internal, esoteric initiation.

Each one of the seven bodies of the human being must be crucified and stigmatized. All students of Kabbalah must be familiar with all of the elementals of Fire, Air, Water, and Earth. The present "human being" is still not a king or queen of Nature, but all are called to be kings or queens and priests and priestesses according to the Order of Melchizedeck.

It is necessary for the student to become familiar with all the elemental creatures of the four elements. Salamanders live in

Fire; Undines and Nereids live in Water; Sylphs live in the Air and Gnomes live in the Earth.

The gospel of Mark is symbolized by a Lion (fire); the gospel of Matthew is represented by a Youth (water); the gospel of John is represented by the Eagle (air) and the gospel of Luke is represented by the Bull (earth). The four gospels symbolize the four elements of nature and the realization of the Great Work (the Magnus Opus).

Every Hierophant of Nature is converted into a King of the Elementals. If you want to be admitted into the Elemental Paradises of Nature, then respect all life, do not kill any animal species, do not drink wine that contains alcohol; love vegetables, do not ever destroy a plant or a flower. You only need two things in life: Wisdom and Love. This is how you will attain happiness, peace and abundance.

Be ye therefore perfect, even as your Father which is in heaven is perfect. - Matthew 5:48

Every initiate must work with the elementals in the central mountain range. That mountain range is the spinal medulla. The Prima Matter of the Great Work of the Father is the Ens Seminis. You know this.

The sacred receptacle is in your creative organs, the furnace is the Muladhara chakra, the Chimney is the medullar canal, and the distiller is the brain. When we work in the laboratory of the Third Logos we must transmute the lead of our personality into the gold of the Spirit. The Magnus Work cannot be performed without the cooperation of the elementals.

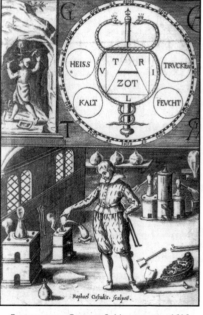

ENGRAVING FROM CABALA BY S. MICHELSPACHER, 1616

Note that the Alchemist is indicating the Wet Path: the union of the two vessels, a clear symbol of the sexual union.

The Gnomes and Pygmies are the great alchemists that transmute the lead into gold; they reduce the metals to its semen (seed) in order to transmute them into the pure gold of the spirit; their labor would be impossible if the Undines did not obey or if the Salamanders of fire would not make the voluptuous Undines fertile, because without the fire, the tempting Undines can only take us to a shipwreck. Ulysses (the cunning warrior destroyer of citadels) was himself bound to the mast of the ship so that he would not fall seduced by the sexual beauty of the Undines. Ancient Gnostics stated: "All of you will become Gods if you leave Egypt and pass through the Red Sea (the ocean of temptations)."

The vapors of the prima matter of the Great Work would not ascend through the chimney without the help of the disquieting Sylphs. The Gnomes need to distil the gold in the brain and this is only possible with the help of the aerial Sylphs. The Gnomes transmute the lead into gold. The Magnus Opus would be impossible without the elementals. We need to become familiar with the elementals of Nature.

Practice

Fire: Light a fire then vocalize the mantra **INRI**. This mantra is vocalized in two separate syllables: IN – RI:

Prolong the sound of each letter.

IiiiiiiiiiiiiiNnnnnnnnn RrrrrrrrrrrrIiiiiiiiiiiiiii

Thereafter, concentrate on the fire that you have lit (on the candle, on the oil lamp or on the charcoal) and profoundly meditate on the fire. Invoke me, Samael, your friend, who wrote this lecture, I will assist you in this practice. Then vocalize the "S" as an affable and fine whistle, like the buzzing of a rattlesnake.

Practice with the Sylphs

Air: Seated on a comfortable chair or laying down (face up) with the body relaxed, you will profoundly meditate on the following plagiary:

Spiritus Dei Ferebatur super aquas, et inspiravit in faciem hominis spiraculum vitae. Sit Michael Dux

Meus, et Sabtabiel servus meus, in luce et per lucem.
Fiat verbum halitus meus, et imperabo Spiritibus
aeris hujus, et refrenabo equos solis voluntate
cordis mei, et cogitatione mentis mei et nutu oculi
dextri. Exorciso igitur te, creatura aeris, per
Pentagrammaton et in nomine Tetragrammaton, in
quibus sunt voluntas firma et fides recta. Amen. Sela
Fiat.

Blow towards the four cardinal points of the Earth. Pronounce the letter H many times as if imitating a very deep sigh. Then slumber while meditating on the Genii Michael and Sabtabiel. This way you will become in contact with the Sylphs.

Practice with the Undines

Water: Before a cup of water, get into the state of slumber while meditating on the following exorcism:

EXORCISM

Fiat firmamentum in medio aquarum et separet
aquas ab aquis, quae superius sicut quae inferius,
et quae inferius sicut quae superius ad perpetranda
miracula rei unius. Sol ejus pater est, luna mater et
ventus hanc gestavit in utero suo, ascendit a terra ad
coelum et rursus a chelo in terram descendit exorciso
te creatura aquae, ut sis mihi peculum die vivi in
operibus ejus, et fons vitae, et abllutio pecatorum.
Amen.

Thereafter, while still in a state of slumber, vocalize the letter **M** as follows: *Mmmmmmmm*, with your lips hermetically sealed. This sound is like the bellow of the bull, yet it is a prolonged sustained sound that does not decrease like the bull does. The letter "M" is the mantra of the waters. This is how you will be in contact with the creatures of the waters. Thereafter, invoke the genie of the waters; the genie's name is Nicksa.

Practice with the Gnomes

Profoundly meditate on the Heart Temple of the center of the Earth. Meditate on the Genie of the Earth whose name is Cham-Gam. Beseech him to place you in contact with the Gnomes that inhabit the entrails of the Earth; call the Genie of the Gnomes, the Genie's name is GOB. Get into a state of slumber while concentrating on that Genie; then vocalize the mantra **I.A.O.**

Iiiiiiiiiiiiiiiiiiiiiiiiiiiiiiiiii Aaaaaaaaaaaaaaaaaaaaaaaa aaaaaOoooooooooooooooooooo

When profound meditation is intelligently combined with the state of slumber, it allows you to enter into the elemental paradises of Nature.

Every alchemist needs to work with the Elementals of Nature.

The hieroglyphic of the Fourth Arcanum of the Tarot is the Emperor; the sovereign appears forming a marvelous triangle with his body. When the legs of the Emperor are crossed, they form a cross; this is the image of the athanor of alchemists; the joint of the cross with a triangle is only possible by means of the potable gold (sacred fire) of alchemy.

The Innermost puts the cross of initiation with the Arcanum Four of the Tarot over his shoulder.

We will end this lecture by stating that the elementals of fire are commanded with the trident of iron or with the wand of iron; the elemental of the Air are commanded with an eagle feather or any other bird; the elementals of Water are commanded with a cup filled with water and the elementals of the Earth with a sword or with a new knife.

The main kingdom of the Gnomes resides in the North; the one of the Salamanders in the South, the one of the Sylphs in the East and the one of the Undines in the West. These four elemental hierarchies form a cross. Behold here, the holy and mysterious Tetragrammaton.

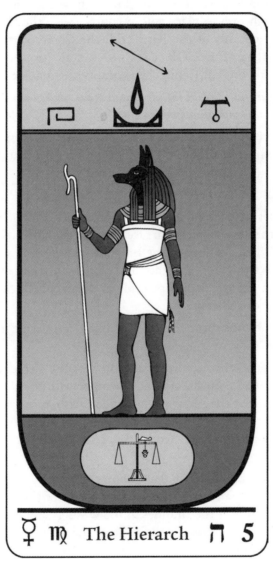

ARCANUM 5

Arcanum 5

Beloved brethren of my soul, today we are going to study the Fifth Arcanum of the Tarot. This Arcanum is the flaming pentagram, the blazing Star, the sign of divine Omnipotence. This is the ineffable symbol of the Word made flesh, the terrifying star of the Magi.

When the pentagram elevates its two inferior rays towards the sky it represents Satan.

When the pentagram becomes light, it elevates only one of its rays towards the sky; this represents the internal Christ of every human being who comes into this world.

The human being with his legs and arms spread out to the right and left is the star of five points. Brain and sex live in an eternal struggle. Brain must control sex. When sex overcomes the brain, then the star of five points (the human being) falls into the abyss with the feet pointing upwards and the head pointing downwards; this is the inverted star, the male goat of Mendes. A human figure with the head aiming downwards and the feet aiming upwards naturally represents a demon.

The entire science of Gnosis is found summarized within the flaming star. Many Bodhisattvas (human souls of Masters) have fallen inverted, like the five pointed star, with the superior ray aiming downwards and the two inferior rays aiming upwards.

When any of these Bodhisattvas rise again, when this soul returns to the Path, when this soul recapitulates initiations, then the brethren become astonished and say, "This fellow is only a

beginner in these studies and now he boasts of being an initiate."
Truly, many times students judge *a priori* because they ignore the
great mysteries. Therefore, we must know how to differentiate
between a soul that is just starting these studies and a fallen
bodhisattva. In Saint John's Revelation 8:10, the pentagram (the
five pointed star) falls from heaven (burning as if it were a lamp)
and the human waters became bitter, they became wormwood. In
Isaiah 14:12, the prophet said:

> *How art thou fallen from heaven, O shiny star (Lucifer),*
> *son of the morning? How art thou cut down to the*
> *ground?*

Nevertheless, the luciferic star (the fallen soul) will shine one
day as the morning star in the right hand of the Word.

Many times a man or a woman in search of the divine torch of
truth arrives at any Gnostic Lumisial; apparently the newly arrived
is now a beginner, however, the brethren ignore what the soul of
that person is; he or she can be a bodhisattva (the human soul of
a Master) that wants to return to his own Father who is in Secret.
Thus, the brethren become overwhelmed when something superior
occurs to the apparent beginner, then they say: "We, who are older
in these studies, are not passing through what this beginner is now
passing through," thus, they ask themselves: "How is it possible
that this person who has only just begun is boasting about being
an initiate?"

> *Judge not, that ye be not judged. For with what judgment*
> *ye judge, ye shall be judged: and with what measure ye*
> *mete, it shall be measured to you again.* - Matthew 7:1-2

We need to be humble in order to acquire wisdom, and after
acquiring it we need to be even more humble. The Bodhisattvas
fall because of sex, and they also rise up because of sex. Sex is the
Philosophical Stone. The decapitation of Medusa (the Satan that
we carry within) would be impossible without the precious treasury
of the Philosophical Stone. Remember that Medusa is the maiden
of evil (the psychological "I"), whose head is covered with hissing
vipers. In occult science, it is stated that the union of the Sophic
mercury with the Sophic Sulfur results in the holy Philosophical
Stone. The Ens Seminis is the Mercury; Sulfur is the sacred Fire of
love.

We live now in the specific age of Samael; we live in the Fifth Era. Life has initiated its return towards the Great Light and in these moments we have to define ourselves by becoming eagles or reptiles, Angels or demons.

We are before the philosophical dilemma of "to be or not to be." The Arcanum Five of the Tarot is represented by the Hierophant. The fifth sphere is definitive because here the human being holds in his hands the reins of his own destiny and becomes an Angel or a demon.

The great hierophant of the Tarot also appears seated between the two columns of the temple making the sign (the pentagram) of esotericism.

The number five is grandiose, sublime. Remember that the human being is also a star of five points; this human star must cleanse itself constantly with the five perfumes. If we can make a metallic pentagram and consecrate it, we can also consecrate ourselves with the same rites and perfumes that we use to consecrate our metallic pentagram. This is because the human being is a Star of Five Points.

Those who feel that they are polluted with larvae, or in misery, must smudge themselves with the five perfumes in order to become clean. This must be performed in conjunction with treading on the path of perfect chastity. In the Lumisials, this custom of cleansing the brothers and sisters that are full of larvae should be established. Thus, they will receive the benefit in their Souls and in their bodies.

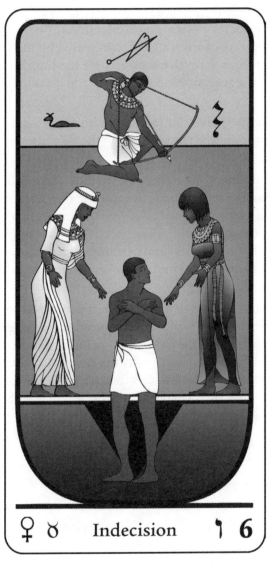

♀ ♉ Indecision ʮ 6

Arcanum 6

Beloved brethren of my soul: we are now going to study the Sixth Arcanum of the Tarot.

Beloved, remember that indeed without any doubt, the two interlaced triangles of the Seal of Solomon, which join or separate love, are the two shuttles with which the ineffable mystery of eternal life in the loom of God is woven or unwoven. The upper triangle symbolizes Kether (the Father who is in secret), Chokmah (the Son), and Binah (the Holy Spirit of each human being). The lower triangle represents the three traitors of Hiram Abiff; those three traitors are inside of us. The first traitor is the Demon of Desire; that traitor lives within the Astral Body. The second traitor is the Demon of the Mind; that traitor lives within the Mental Body. The third traitor is the Demon of Evil Will; that traitor lives within the Body of Willpower (Causal Body). The Bible cites these three traitors in the Apocalypse of Saint John in Revelation 16:13, 14:

> And I saw three unclean spirits like frogs come out of the mouth of the dragon, and out of the mouth of the beast, and out of the mouth of the false prophet; for they are the spirits of devils, working miracles, which go forth unto the kings of the earth and of the whole world, to gather them to the battle of that great day of God Almighty (El-Shaddai).

The three traitors constitute the reincarnating ego, the psychological "I," the Satan that must be dissolved in order to incarnate the Inner Christ, which is constituted by Kether, Chokmah, and Binah. The superior triangle is the resplendent Dragon of Wisdom, whereas the inferior triangle is the Black Dragon.

The sign of the infinite or the tau cross are found in the center of the two triangles; both are phallic (sexual) signs. The soul is found between the two triangles and has to decide between the White Dragon and the Black Dragon. Such a dilemma is absolutely sexual.

The clue is found in the serpent. In the Abraxas, the rooster's legs are made by the double tail of a serpent. The tempting serpent of Eden exists as well as Moses' serpent of brass (nachash) interlaced around the tau, in other words, entwined around the sexual lingam (the phallus); the yoni is the uterus. Normally, the serpent is enclosed within the chakra Muladhara (Church of Ephesus). The serpent slumbers in that coccygeal center entwined three and a half times. The serpent must inevitably leave from its church. If the serpent rises through the medullar canal we convert ourselves into angels and if the serpent descends we convert ourselves into demons. Now you can comprehend why there are always two serpents around the Caduceus of Mercury. The sexual force is the Hyle of the Gnostics.

When the students spill the Cup of Hermes during their practices with the Arcanum A.Z.F. they commit the crime of the Nicholaitans, which used a system in order to make the serpent descend. This is how the human being is converted into a demon.

The complete and positive development of the serpent is only achieved by working with the Philosophical Stone within the sexual laboratory of the practical alchemist.

The superior triangle is the center of the alchemist's Microcosmos and the alchemist's Macrocosmos. The sign of the Mercury of the Secret Philosophy (the Ens Seminis) cannot be missed in the center of the triangle. Man and woman must work with the Sun and with the Moon, with the Gold and with the Silver (sexual symbols) in order to perform the Great Work. Nevertheless, this work is very difficult because the male goat of Mendez (the Black Dragon) always tries to make the alchemist sexually fall. It is urgent to work with the four elements of alchemy in order to perform the Great Work.

The alchemical Macrocosmos is illuminated by the Light; this is the superior triangle of the Seal of Solomon. The alchemical Microcosmos is in the shadows, in the region where the souls fight against the Black Dragon.

It is precisely in the Microcosmos, represented by the inferior triangle, where the entire work of alchemical laboratory must be performed by us.

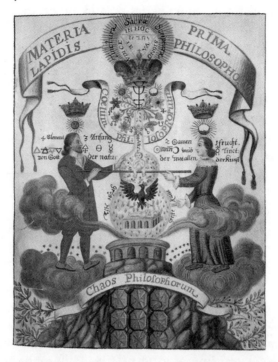

The marvelous microcosmic and macrocosmic alchemical illustration above (from *Chimica Basilica Philosophica*) represents the man and the woman working with the Sun (the symbol of the phallus) and with the Moon (the symbol of the uterus). In this medieval painting, two men together or two women together do not appear because such a crime against Natura only creates a filthy vampire. The tenebrous ones justify their crimes against Nature, thus, the Law punishes them by separating them from their superior triangle forever. This is how they roll into the abyss.

The mysteries of lingam-yoni are terribly divine and cannot be altered. The lingam can only be united with the yoni; this is the law of Holy Alchemy. The Alchemical Weddings signify, as a fact, a Perfect Matrimony. The alchemist must not only kill desire, but moreover, he has to kill the very shadow of the horrible tree of desire.

Sacred dances between men and women were performed in the mysteries of Eleusis along with love and the music of the centers in order to enchant the Serpent. Then, the dancers of the temple were clean from the filthy venom of desire. All kind of sins are forgiven, except the sins against the Holy Spirit. *"Flee fornication. Every sin that a man does is without the body; but he that commits fornication sin against his own body."* - 1 Corinthians 6:18 However, fornication does not pertain only to the physical body; it is also related to thoughts, emotions, words and animal sensations.

In the mysteries of Eleusis, the couples danced in order to mutually magnetize themselves; then while dancing, the couple (man and woman) together attained ecstasy. The bio-electromagnetic interchange between man and woman cannot be replaced by anything; this is a gigantic, grandiose and terribly divine power. God shines upon the perfect couple.

If you want in-depth realization of your Self, remember this alchemical aphorism: "Nature must be imitated in everything. Nature enjoys Nature; Nature dominates Nature."

The task of the alchemist is to search for the occult and ancient knowledge and to perform the Great Work in his sexual laboratory. The Great Work is difficult, it signifies many years of experiments, terrible sacrifices and tremendous difficulties. There exists a transmutator agent (the Philosophical Stone), a heavenly influence (cosmic religiosity), diverse astral influences (esoteric astrology), influence of letters, numbers, correspondences, sympathies (Kabbalah).

The sacred principles of Alchemy are:

* Unity

* A Pair of Opposites (Man/Woman; Active/Passive)

* Trinity (Active, Passive, Neutral)

* The Elements (Fire, Air, Water, and Earth)

The entire work of the Great Work (the Magnus Opus) is reunited in the Seal of Solomon. The six points of the star are masculine; the six outer obtuse angles that exist between point and point are feminine. In synthesis, this star has twelve rays: six masculine and six feminine. The Star of Solomon is the perfect symbol of the central Sun, all of the zodiacal measurements are

found summarized within the Seal of Solomon. The entire sexual Genesis of the zodiac is hidden in the Seal of Solomon. The inner relation that exists between the zodiac and the invincible central Sun is found in the Seal of Solomon. The twelve rays of the brilliant star crystallize by means of Alchemy in the twelve zodiacal constellations.

When the student enters into the Temple of the Sphinx he studies the great book of Nature, where all of the Cosmic Laws are written.

Indeed, very few are the ones who can open the book and study it. The "ordeal of the sanctuary" is very terrible. Very few are the human beings who have succeeded in passing such an ordeal. A precious jewel (with the Seal of Solomon), a ring filled with ineffable light is granted to the one who victoriously passes the ordeal of the sanctuary. The neophyte who touches the ring with the left hand loses it inevitably.

Another explanation of the Seal of Solomon is the following: above: the Father, the Son and the Holy Spirit; below: the power that governs (the Innermost), the power that deliberates (the mind), and the power that executes (the personality).

When the power that deliberates and the power that executes rebel or are subordinate against the governor (the Innermost) then the outcome is failure.

The three traitors use to take possession of the powers that deliberate and the powers that execute. The Bodhisattvas sometimes used to receive (kabbel) messages from the superior worlds; nevertheless, ignoramuses mistake the Bodhisattvas with the mediums of Spiritism ("chanellers").

The medium and the mediator (Bodhisattva) exist. The medium is negative whereas the mediator is positive. The medium is a vehicle of the tempting serpent of Eden. The Bodhisattva, the mediator, is a vehicle of the serpent of brass (nachash) that healed the Israelites in the wilderness.

Great Masters used to dictate messages through the lips of their Bodhisattvas. People do not understand this and mistake the mediators with the detrimental mediums of Spiritism because people allow themselves to be carried away by false appearances.

The entire positive and negative forces of the universal magnetism are found represented in the Seal of Solomon.

In the works of high magic, it is necessary to trace a circle around us. Such a circle must be totally closed, interrupted by the Seal of Solomon.

With the seven metals, Gnostic brothers and sisters can manufacture medallions and rings with the Seal of Solomon. The Seal of Solomon must be utilized in all of the works of invocations, and in the practices with elementals (as we have already taught in Arcanum Four of this series of lectures on Kabbalah).

The elementals of nature tremble before the Seal of the Living God. The Angel of the Sixth Seal of the Apocalypse has reincarnated at this time within a feminine body (this angel is a specialist in the sacred Jinn science).

Arcanum 6 is the Lover of the Tarot. It is the soul between vice and virtue. The Arcanum Six is enchainment, equilibrium, amorous union between man and woman, terrible struggles between love and desire, the mysteries of lingam-yoni, connection. The struggle between the two ternaries is found in the Sixth Arcanum of the Tarot. The Sixth Arcanum is the supreme affirmation of the internal Christ, and the supreme negation of Satan.

Watch and pray.

Arcanum 7

Remember that the number seven represents magical power in all of its strength.

The Holy Seven is the Sanctum Regnum of Sexual Magic; the number seven is the Innermost served by all of the elemental forces of Nature.

Every one who works with the Arcanum A.Z.F. receives the flaming sword of the Seventh Arcanum. In the name of truth, we affirm that the flaming sword of the great hierophants is absolutely transmuted semen, it is the outcome of Sexual Magic. This is how we transform ourselves into terribly divine Gods.

The sexual organs are the legitimate Laboratorium Oratorium of the Amphitheatrum Sapientiae Aeternae. These are the Sanctum Regnum where the hierophant receives the sword of justice.

In the alchemical garden of pleasures, we find the word "Vitriol." This word is an acrostic, derived from the phrase "Visitam interiore terras rectificatur invenias ocultum lapidum," (Visit the interior of our earth, that by rectifying, you will find the occult stone).

We must search within the interior of our philosophical earth (the human organism); then by rectifying and working with the Arcanum A.Z.F., the Maithuna, we will find the Philosophical Stone.

The sun (phallus), masculine principle, is the father of the Stone. The moon (uterus) is the feminine principle, the mother of the Philosophical Stone. The wind bears the son in its womb and the earth nourishes it. The Sun and the Moon, masculine and feminine principles are combined inside of the Chalice (symbol of the mind). The Sun (fire) is the Father of the Stone, the Moon (water) is the Mother, and the Wind (seminal steam) bear the son in its Alchemical Womb and the Philosophical Earth nourishes it.

The chalice is resting on the Caduceus of Mercury (the central system, spinal column) with the two sympathetic cords known in the east as Ida and Pingala.

The Chariot

ARCANUM 7

Two influences interact in the generation of the Philosophical Stone: one of a masculine character and the other of a feminine character.

The entire work is performed with the Great Arcanum. The Star of Seven Points is an inseparable part of the acrostic VITRIOL. The Seven Serpents of Alchemy are related with the seven planets and the seven great cosmic realizations.

The acrostic VITRIOL with its seven letters and its seven words symbolizes the entire septenary Great Work that shines like the Sun in the temple of science.

The Sun and the Moon, the Fire and the Water, the King and the Queen form an integral part of any alchemist fledgling.

The fledgling has to perform seven great works that culminate with the crowing of the Great Work.

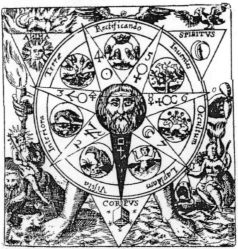

VITRIOL, VIRDARIUM CHYMICUM

The face of a venerable elder appears in the center of the septenary star of Alchemy according to the illustration of *Viridarium Chymicum*.

Such a venerable face in the septenary star of Alchemy symbolizes the Sophic Mercury (the Ens Seminis). Listen fledglings of Alchemy, listen to how Estolsio explains this emblem:

That which was enclosed within many forms, now you see it included in one thing; the beginning is our Elder and he has the

key; sulfur with salt and mercury give wealth. If you do not see anything here, there is no reason for you to keep searching, for you will be blind even in the midst of the light.

Those students of occultism who think that they can acquire in depth realization of the Self without the Arcanum A.Z.F. are absolutely mistaken. The Secret Sister Master stated that those who want to know the mysteries of Chiram (the Fire) must search among the Medieval Alchemists. This Great Master was a true yogini disciple of Kout Humi, nevertheless, after she had been widowed (by the Count Blavatsky) she married the Colonel Olcott, in order to work with the Arcanum of Sexual Magic. Only thus, could she achieve in depth realization of the Self.

The great Yogi-Avatar Sri Lahiri Mahasaya was called to the Initiation by the immortal Babaji when he already had a spouse. Thus, this is how the Yogi-Avatar was Self-realized. In Hindustan, Sexual Magic is known by the Sanskrit term *Urdhvareta* and the yogis who practice it are named Urdhavareta Yogis.

Authentic yogis practice Sexual Magic with their spouse. There are two types of brahmacharya (sexual abstinence), solar and lunar. The solar type is for those that have performed the Second Birth. The lunar type of brahmacharya is that absurd sexual abstinence that serves only to produce filthy, nocturnal sexual pollutions with all of its fatal consequences.

Hatha Yoga is just a matter of acrobatics that have the power of taking the student out of the superior worlds in order to enslave him to the physical world. We have never known of an acrobatic Hatha yogi with internal illuminated powers.

Three rays of inner illumination of the realization of the Inner Self exist: the Yogic, the Mystic, and the Perfect Matrimony; however the three rays inevitably have the need for Sexual Magic. Anything that is not directed through Sexual Magic is a useless waste of time. We departed from Eden through the doors of sex and only through those doors can we return to Eden. Eden is sex itself.

The Seventh Arcanum is represented by a crowned warrior that carries a triangle above his crown and he is standing upon the cubic stone of Yesod (sex). The two sphinxes, a white one and a black one are pulling his chariot; this symbolizes the masculine and feminine

forces. His armor is the divine science that makes us powerful. The warrior must learn how to use the staff and the sword, thus he will attain the great victory (Netzach). Our motto is Thelema (willpower).

Let us remember that there are seven vices that we must transmute into wisdom and love:

Lunar Avarice is transformed into Hope and Altruism.

Laziness is transmuted into prudent Mercurian Diligence.

The fatal Venusian Lust is transmuted into the Chastity of Venus and Charity of the Spirit.

Pride must be transmuted into Solar Faith and into the humility of Christ.

Martian Anger is transmuted into the marvelous force of Love.

Envy is transmuted into Jupiterian Philanthropy and Happiness for Others.

Gluttony is transmuted into Saturnian Temperance.

We can disintegrate our defects and dissolve the psychological "I," only by means of the science of transmutations. Work with the Arcanum A.Z.F. so that you can receive the sword.

The Governors of the seven planets are:

1. Gabriel: Moon
2. Raphael: Mercury
3. Uriel: Venus
4. Michael: Sun
5. Samael: Mars
6. Zachariel: Jupiter
7. Orifiel: Saturn

The seven notes of the lyre of Orpheus correspond to the seven planets. A planetary note corresponds to each one of the seven colors of the solar prism. Alchemy is intimately related to music.

Atalanta is the voice that flees; Hippomenes is the voice that pursues and the apple is the voice that delays.

IAO

I.A.O. is the supreme mantra of Sexual Magic. I.A.O. is the name of the serpent. Blessed be the I.A.O.

I.A.O. must be chanted during the practices of the laboratory (Sexual Alchemy); thus, this is how the Serpent moves about and is joyful. Chant I.A.O. seven times while in the Laboratorium Oratorium.

The mantra I.N.R.I. has an absolute power over the fire; chant this mantra also in the Laboratorium Oratorium in order to carry the fire to each one of your seven chakras. Chant I.N.R.I as follows:

INRI ENRE ONRO UNRU ANRA; these mantras must be chanted by syllabifying them as follows:

Iiinnn Rrriii (Clairvoyance)

Eeennn Rrreee (Clairaudience)

Ooonnn Rrrooo (Heart – Intuition)

Uuunnn Rrruuu (Telepathy –solar plexus)

Aaannn Rrraaa (Pulmonary chakras – memory of past lives)

The great Hierophant Jesus-Christ chanted these mantras in the Laboratorium Oratorium of the Pyramid of Kephren.

The seven Kabbalistic signs of the planets are:

Moon: A globe divided by two middle moons.

Mercury: A caduceus and the cynocephalus.

Venus: A sexual lingam.

Sun: A serpent with the head of a lion.

Mars: A dragon biting a sword's guard.

Jupiter: A pentagram, or an eagle's beak.

Saturn: A limping elder, or a rock entwined by a serpent.

The seven talismans have the power of attracting the seven planetary forces. Gold is the metal of the Sun; silver is the metal of the Moon; iron is the metal of Mars; copper is the metal of Venus; quicksilver is the metal of Mercury, tin is the metal of Jupiter and lead is the metal of Saturn. Perfect talismans can be prepared with the proper stones and metals.

The Pater Noster (Lord's Prayer) is the most perfect prayer because it has seven magical petitions.

Practice

Asana: student, you must lie down on the floor so that you can spread out your arms and legs to each side until you form the five pointed star. Relax all of your body, do not think about anything, place your mind in blank, concentrate your mind on your Inner God and start praying the Pater Noster extremely slowly, and think about the sense of each petition. Become sleepy, fall profoundly asleep while meditating upon each word, upon each phrase, worshiping...worshiping...worshiping...

Student, you must not move when you wake up... be motionless and practice a retrospective exercise in order to remember your internal experiences: remember where you were, what places you visited while in the Astral Body, what you did, what you saw, etc. This practice must be performed daily without ever becoming weary. Seeing and hearing the great internal realities must be your goal.

Our Father, Who art in heaven,
Hallowed be Thy Name.
Thy Kingdom come.
Thy Will be done, on earth as it is in Heaven.
Give us this day our daily bread.
And forgive us our trespasses, as we forgive those
who trespass against us.
And lead us not into temptation, but deliver us from
evil. Amen.

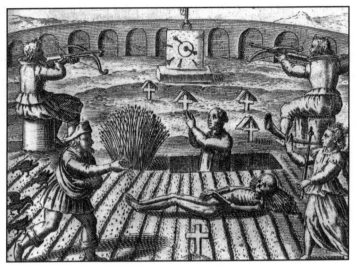

THE EIGHTH KEY OF BASIL VALENTINE, FROM VIRIDARIUM CHYMICUM, 1624

Arcanum 8

Let us study in this lecture the Eighth Key of Basil Valentine, an illustration of the *Viridarium Chymicum*.

The Eighth Key is a clear and perfect alchemical allegory of the processes of death and resurrection that inevitably occur in the esoteric preparation of the Philosophical Stone.

The entire inner preparation of the stone and the metallic transmutation are represented in this allegory. The entire human material employed in this work dies, it becomes rotten, corrupted and becomes blackened within the Philosophical Egg, then it becomes marvelously white.

The entire work of the Great Work is found within the Philosophical Egg. The masculine and feminine sexual principles are contained within the egg. Thus, like the fledgling that emerges from the Egg, or like the Universe of Brahma that emerges from the Golden Egg, so too does the Master emerge from the Philosophical Egg.

In the Eighth Key, an illustration of the *Viridarium Chymicum* shows death represented as a corpse, putrefaction represented as crows, the sowing as a humble agriculturalist, the growth as a wheat stalk, and the resurrection by a deceased person who rises from the grave and by an angel that plays the trumpet of the Final Judgment.

We, the Gnostics, know that the corpse, death, in the Eighth Key represents the two witnesses of the Apocalypse (Revelation 11: 3-6) that are now dead. By means of alchemical putrefaction, by means of the works of alchemy (represented by the crows) the two witnesses resurrect.

Our motto is Thelema. The entire power is found enclosed within the seed that is symbolized in the wheat stalk. The sacred angel that we carry within plays his trumpet, and the two witnesses rise from the grave.

Two archers, one who hit the bull's eye and the other who misses, symbolize the two alchemical interpretations that can

occur, the right and the wrong: White Sexual Magic and Black Sexual Magic, Golden Alchemy and Satanic Eroticism.

The ejaculation of the Ens Seminis does not exist in Golden Alchemy, whereas in Satanic eroticism the ejaculation of the Ens Seminis exists. In India, the black yogis (Asura Samphata) ejaculate the Ens Seminis (Shuhsra) in order to criminally mix it with the feminine "Raja" within the vagina, thereafter; by handling the "Vajroli" in a negative way, they reabsorb this fluid already mixed with feminine Raja. The black yogis (Drukpas) believe that through this way they are wisely achieving the union of the solar and lunar atoms in order to awaken the Kundalini, but the outcome of such Black Tantrism is the negative awakening of the serpent (Kundabuffer). Therefore instead of ascending, the serpent descends downwards into the atomic infernos of the human being and becomes the Tail of Satan.

This is how these black yogis end up separating themselves from their inner God forever; they become demons. So, that is Black Magic. Through this way the two witnesses of the Apocalypse do not ever resurrect because this way leads into the abyss and the second death. Therefore, whosoever ejaculates his seminal liquor withdraws himself from his inner God.

The yogis who practice Urdhavareta Yoga (positive Sexual Magic) do not ejaculate their Ens Seminis. Through this way, the combination of Shuhsa (solar atoms) and Raja (lunar atoms) is performed within the Philosophical Egg, in other words, within the very sexual laboratory of the alchemist.

Thus, this is how the two witnesses resurrect.

> These are the two olive trees, and the two candlesticks standing before the God of the earth. And if any man will hurt them, fire proceed out of their mouth, and devour their enemies: and if any man will hurt them, he must in this manner be killed. These have power to shut heaven (to those who practice Sexual Magic with seminal ejaculation), that it rain not in the days of their prophecy: and have power over (the human) waters to turn them to blood, and to smite the (philosophical) earth (the human organism of fornicators) with all plagues, as often as they will (according with the Law). - Revelation 11:4-6

Disposition of the Two Witnesses

The two witnesses are a semi-ethereal, semi-physical pair of sympathetic cords that are entwined along the spinal medulla, forming the Caduceus of Mercury, the sacred eight, the sign of the infinite. In the male, the two witnesses part from the right and left testicles and in the female they part from the ovaries. These two witnesses are situated to the right and left sides of the dorsal spine. The two witnesses alternatively ascend from left to right until forming a marvelous knot in that space situated between the two eyebrows, thereafter they continue through the nasal cavities. The two witnesses connect the sexual organs with the nasal cavities. The ganglionic cord that proceeds from the left side is cold, lunar and the ganglionic cord that proceeds from the right side is hot, solar. These two nervous cords are graciously knotted in the coccyx. The Kundalini (serpent of brass, nachash) awakens when the solar and lunar atoms of the seminal system make contact in the Triveni, close to the coccyx.

The sexual act between the male and female initiates has only one objective, that of establishing a contact of opposite poles in order to awaken their Kundalini; because the mercury of secret philosophy is multiplied (the seminal fluid increases) with the sexual contact and when the Ens Seminis is not ejaculated it is transmuted into seminal vapors. These vapors, in its turn, are converted, are bipolarized into positive and negative energies. The positive are solar forces, the negative are lunar forces; these solar and lunar energies rise through the pair of sympathetic cords that are known as the two witnesses: Ida and Pingala.

The medullar canal has an inner orifice that is normally found blocked in ordinary people; however the seminal vapors open up this orifice so that the sacred serpent (of brass, nachash) can enter there within that medullar canal.

It is necessary to warn the Gnostic-Rosicrucian Brethren that they must learn how to polarize the sacred fire of the Kundalini. Some devotees eat meat everyday and drink alcohol; with the pretext of working in the Great Work they pleasurably enjoy lust,

ち ♑ Justice ח 8

ARCANUM 8

they bestially enjoy carnal passion even when they do not waste their Ens Seminis. Therefore, the outcome of this is that these devotees totally polarize the fire within the chakras of their lower abdomen and lose the happiness of enjoying the ecstasy of the lotus of one thousand petals. Such a lotus flower is found situated in the pineal gland, which is the crown of saints that shines over the head of the great initiates. The lotus of one thousand petals converts us into Masters of Samadhi (ecstasy).

The work in the Laboratorium–Oratorium is a true mystical ceremony that must not be profaned by animal desire or by sinful thoughts. Sex is the Sanctum Regnum of the temple, therefore, purify your mind from any type of impure thoughts when entering in the Sanctum of Sanctums.

Esoteric Ordeals

The Eighth Arcanum encloses the Initiatic ordeals. Each initiation, each degree, has its ordeals. These initiatic ordeals get stricter each time, in accordance with the initiatic degree. The number 8 is the degree of Job. This sign, this number, signifies ordeals and sufferings. These initiatic ordeals are performed in the superior worlds and in the physical world.

A woman with a sword in her hand, facing the scale of Cosmic Justice appears in the Eighth Arcanum of the Tarot. Indeed, only she (the priestess) can deliver the sword to the magician, thus, an initiate (the priest) without a woman cannot receive the sword.

There exists the Eve-Venus, the instinctual woman; the Venus-Eve, the noble woman of the home. There also exist Venus-Urania, the woman initiated into the great Mysteries and finally, we confirm the existence of the Urania-Venus, the female adept, the woman who is Self-realized in depth.

The Flaming Fire

The flaming fire opens the Seven Churches of the Apocalypse (seven magnetic centers of the spinal medulla).

Chakra Sahasrara	Church of Laodicea
Chakra Ajna	Church of Philadelphia
Chakra Vishuddha	Church of Sardis
Chakra Anahata	Church of Thyatira
Chakra Manipura	Church of Pergamos
Chakra Swadhisthana	Church of Smyrna
Chakra Muladhara	Church of Ephesus

THE CHAKRAS AND CHURCHES

We conquer the powers of the earth with the first center (situated at the height of the sexual organs).

We conquer the water with the second center (situated at the height of the prostate/uterus).

We conquer the universal fire with the third center (situated at the height of the navel).

We conquer the air with the fourth center (situated at the height of the heart); the heart is the sanctuary of Sephirah, the Mother of the Sephiroth, the Divine Cosmic Mother.

With the fifth center (situated at the height of the larynx) we receive the sacred ear and dominate the Akasha with which we can preserve the physical body alive (even during the great cosmic nights).

We conquer the magnetic center of the Father with the sixth center (situated between the two eyebrows), thus we become clairvoyant.

We receive the polyvoyance, the intuitive sight, the ecstasy, with the seventh center (situated in the pineal gland).

The Equilibrium of the Scale

The woman of the Eighth Arcanum of the Tarot has in one hand the scale, and in the other, the sword. It is necessary to equilibrate the forces; it is necessary and urgent to completely sanctify ourselves and to practice the Arcanum A.Z.F. The forces of man and woman are equilibrated with love and with wisdom.

Venus equilibrates the works of Mars.

Mercury equilibrates and performs the works of the Sun and of the Moon, above in the Macrocosmos and below in the Microcosmic human being.

The works of the Sun and of the Moon, the man and the woman are equilibrated by the Mercury of the Secret Philosophy (the Ens Seminis).

Old Saturn balances thundering Jupiter, the Father of all Gods. This is the law of equilibrium.

A yogi (or a yogini) cannot Self-realize himself without the Arcanum A.Z.F., therefore those who want to exclude the Arcanum A.Z.F. from their whole Yoga are violating the law of the Eighth Arcanum. They are the failures.

The double cross on the wheel of Pythagoras and on the wheel of Ezekiel, are pantacles that represent the Eighth Arcanum.

THE NINTH KEY OF BASIL VALENTINE, FROM VIRIDARIUM CHYMICUM, 1624

Arcanum 9

The Ninth Key represents old Saturn falling and the Goddess Moon victoriously rising. Saturn is the lead and the Moon is the silver. The terrestrial Adam, the psychological "I" must fall and die so that the Adam-Christ can be born within us. We need to transmute the lead into gold. The lead of our personality must be transmuted into the gold of the Spirit.

The Moon-Mercury-Sophic (the Ens Seminis) must rise and return inwardly and upwardly.

To disincarnate signifies to perpetuate error. The psychological "I," the terrestrial Adam is born millions of times; it incarnates in order to satisfy desires. Terrestrial births are the perpetuation of ignorance. To be born in spirit and in truth signifies death for the terrestrial Adam.

The Adam-Christ is born from the seed. The grain, the seed, needs Thelema (willpower) in order for the Superman to heroically germinate; the birth of the Superman is not the outcome of evolution. The Superman does not need to evolve to attain perfection as is assumed by many students of occultism. Evolution is simply the movement of the universal life according to the concepts of time, space, and movement. All possibilities are contained within the evolving nature; thus, many become very good and others very bad. Nonetheless, the Superman is not the result of any sort of evolution but the outcome of a tremendous revolution of the consciousness.

Adam-Christ is as different from the terrestrial Adam as lightning is from a black cloud. Lightning is born from a cloud, yet it is not a cloud. Lightning is like the Superman while the cloud is like the man. To be born is a sexual problem, the path is sexual transmutation.

A rectangle appears in the Ninth Key, this represents the four elements of Alchemy. By carefully studying this rectangle, we discover a double circle that wisely symbolizes the mercurial matter with its two properties (generation and regeneration). The double circle contains three serpents that emerge from three hearts. Indeed, we need to work with Mercury, Sulfur, and Salt in order to

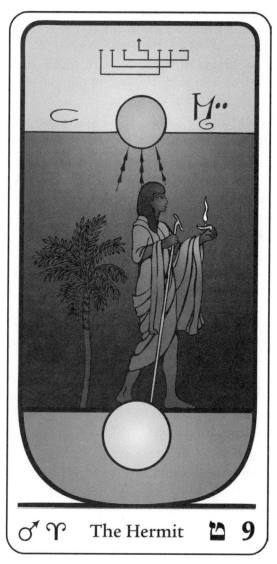

♂ ♈ The Hermit ט 9

ARCANUM 9

lift the metallic serpent upon the pole. The Adam-Christ is born in us only by working with the Prima Matter: Mercury, Sulfur, and Salt; the Phoenix Bird that is born from its own ashes stands upon the double circle of Mercurial Matter. We need to become imitators of this mythological bird; however, this is only possible when we work with the seed.

The eagle of volatility is the terrestrial Adam that is dominated by the crow of putrefaction. The Goddess Moon carries upon her head a white swan. We must whiten the crow with sexual transmutation until transforming it into the immaculate swan of Ascension. The entire symbolism of the Great Work is enclosed within the Ninth Key. No one can work with the Sephirothic Tree without being an Alchemist and a Kabbalist. The wise man of the Ninth Arcanum must search for the treasury within the Ninth Sphere. It is necessary to study the explanatory statements, the principles and methods of the science of Kabbalah and to work with the seed. "Practice without theory cannot exist."

The Ninth Sphere

An occultist sentence affirms that "One can only depart through the same door that one has entered." We departed from Eden. Eden is sex itself. Therefore, only through the doors of sex can we enter into Eden. The fetus (after having accomplished its entire process of gestation) arrives at the moment when it must depart through the same door that its seed-germ entered. This is the Law.

The physical body of the human being is the outcome of nine months of gestation within the maternal womb. By means of philosophical analogies we also deduce that the human species remained within the maternal womb of the Divine Cosmic Mother Isis (Rea, Cibeles, Mary, Adonia, Insobertha, Kali, etc.) gestating for nine ages.

In the "authentic initiation," this return to the point of departure is nothing more than the descent into the Ninth Sphere, which is a test of action for the supreme dignity of the great hierophant of mysteries.

"Abandon hope, all you who enter here..."

The flaming forge of Vulcan is found in the Ninth Sphere (sex). There, Mars descends in order to retemper his flaming sword and conquer the heart of Venus (the Venustic Initiation). Hercules descends in order to clean the stables of Augias (our animal depths). Perseus descends in order to cut off the head of Medusa (the psychological "I," or the terrestrial Adam) with his flaming sword.

All of the great Masters of humanity such as Hermes, Buddha, Jesus, Dante, Zoroaster, etc., had to pass through this utmost test. The following phrase is written upon the frightful threshold of the Ninth Sphere (which does not grant access to profaners): "Lasciate Ogni Speranza Voi Ch'entrate" (Abandon hope, all you who enter here).

The Zohar emphatically warns us that within the depths of the abyss lives the Adam protoplastus, the differentiating principle of the Souls. With this principle we have to dispute victory to the death. This fight is terrible, brain against sex, and sex against brain, and what is even more terrible and more painful is heart against heart, you know this.

Resplendently, the sign of the Infinite is within the heart of the Earth. The sign of the infinite is the Holy Eight.

In this sign the heart, brain and sex of the Genie of the earth are represented. The secret name of this Genie is Cham-Gam.

The sign of the Infinite is in the center of the Ninth Sphere. The earth has nine atomic stratums and the sign of the Infinite is found within the Ninth Stratum. The Nine Initiations of Minor Mysteries gradually corresponds with each one of these nine stratums. Each Initiation of Minor Mysteries gives access to each one of these terrestrial stratums. Therefore, only the ones who have attained the Nine Initiations of Minor Mysteries can reach the heart of the earth.

Each terrestrial stratum is guarded by terrifying guardians. Secret paths lead the disciple towards the heart of the earth. The double vital current of the Genie of the Earth is represented in the sign of the infinite.

The double vital current sustains and nourishes the entire planet Earth, thus, we (all the living beings) are organized upon this divine archetype. A Divine Atom exists in the center of the sign of the Infinite. The nine spheres of atomic vibration are concentrically focused within this atom of the Genie of the Earth. The Holy Eight is resplendent with glory within the center of the Earth.

In the center of this Holy Eight the central atom is found, which is where the Nine Spheres of Universal Vibration are focused; this is the Law.

Kabbalistic Traditions

Kabbalistic traditions tell us that Adam had two wives, Lilith and Nahemah. It is stated that Lilith is the mother of abortion, homosexuality and all crimes against nature in general. Nahemah is the malignant and fatal beauty; Nahemah is the mother of adultery and passionate fornication.

Any marriage that is a violation of the law is easy to recognize because on the day of the wedding, the bride appears bald. Since hair is the symbol of chastity for the woman, on wedding days of Nahemah it is prohibited to display hair, thus, she instinctively covers her hair with the veil (as if she is trying to conceal it).

Thus, the abyss is divided into two large infrasexual spheres. These are the spheres of Lilith and Nahemah. The inhabitants of the sphere of Lilith do not have any hope for salvation, whereas the inhabitants of the sphere of Nahemah still have hope for redemption.

Sphere of Lilith

Here we find those who abhor sex, for example, monks, anchorites, mystics, spiritualists, people from different pseudo-esoteric organizations, etc. All types of infrasexual people hate sex and consider themselves to be highly superior to those of normal sexuality. All of the taboos, restrictions, and prejudices that currently condition the lives of people of normal sexuality were firmly established by infrasexual people. Infrasexual people mortally hate the Arcanum A.Z.F. nevertheless, they give to themselves special credentials, and therefore, it is not difficult to find homosexuality within many convents and schools that are dedicated to spiritualistic or pseudo-esoteric studies. All of the crimes against nature are found in the infrasexual sphere of Lilith.

Sphere of Nahemah

Nahemah seduces with the enchantment of her malignant beauty. Adultery is the outcome of this fatal enchantment. In the sphere of Nahemah we find the delectable cruelties from the kingdom of infrasexuality. In the atomic regions of the infrasexual sphere of Nahemah live the Don Giovanni types of men and Dona Ines or rather the beautiful Hetaeras, sometimes sweet and sometimes cruel in others. If people of normal sexuality do not live alert and vigilant, they can convert themselves into fatal proselytes of these infrasexual people, since they garnish themselves as Saints, Apostles, Anchorites, etc. and believe themselves to be superior; they go and cheat the people of normal sexuality, converting them into their henchmen. Understand that people of normal sexuality are those who have no sexual conflicts of any kind.

The sexual force of the people of normal sexuality is in perfect equilibrium with the spheres of thought, feeling, and will. These

types of people do not abuse sex nor do they have any type of sexual aberrations.

The sphere of Suprasexuality is the sphere of internal illumination. Sexual enjoyment precedes the mystic ecstasy. Sexual sensations are transmuted into sensations of ineffable ecstasy. The human life span of Mystical Ecstasy is always preceded by the human life span of Sexual Enjoyment.

Thus, the human life span of Mystical Ecstasy begins where the human life span of sexual enjoyment ends. After having attained the Venustic Initiation, in other words, after the Adam-Christ has been born within us, we must then extract the philosophical egg from the rottenness of the matter and deliver it to the Son of Man, meaning to transplant the totality of the sexual energies to Adam-Christ; this is how he becomes absolutely strong. The path is named Transmutation and Sexual Sublimation. Whosoever reaches these heights becomes a Master of Samadhi.

The same energy that produces sexual sensations (when it is transmuted) then produces mystical ecstasy. Christ, Buddha, Hermes, Quetzalcoatl, and many other Avatars were Suprasexual.

The Forge of Vulcan

Sexual energy is divided into three distinct types. First: the energy having to do with the reproduction of the species. Second: the energy having to do with the spheres of thought, feeling and will. Third: the energy that is found related with the world of pure Spirit.

All of the processes related with sexual transmutation are possible because of the intervention of the Vital Body. This is the Archaeous that elaborates the blood and the semen in the human organism. This is Vulcan that transmutes the seminal liquor into Christic Energy. The Vital Body is the vehicle of the Soul-Consciousness in the human being. The consciousness is the flame and the vital body is the wick. Vulcan exists within the Microcosmos and within the Macrocosmos, in the human being and in Nature. The Great Vulcan of Nature is Eden, the Ethereal Plane.

Cosmic Rhythms

Any alchemist fledgling (after having been crowned) is leaving the sexual act little by little; the secret connubial is more distant each time according to certain cosmic rhythms marked by the oriental gong. This is how the sexual energies are sublimated and transmuted in a continuous ecstasy.

The alchemist fledgling that worked in the magisterium of fire in former reincarnations performs this laboratory work in a relatively short time. However, those who for the first time work in the Great Work need at least (20) twenty years of intense work in order to enter into the second part, for another (20) twenty years in order to slowly withdraw from the work of the laboratory; a total of (40) years in order to perform the entire work. However, when the alchemist spills the Cup of Hermes, the fire of the furnace of his laboratory is extinguished and the entire work is lost.

Mantras for Sexual Magic

I.A.O. OU AOAI OUO OUOAE KORE

Now continue with the powerful mantras:

Kawlakaw, Sawlasaw, Zeesar

Kawlakaw is the Inner God. **Sawlasaw** is the terrestrial man and **Zeesar** is the Astral Body. These powerful mantras develop all of the internal powers. We have already mentioned the mantra INRI and its modifications. The alchemist must not forget any of these mantras.

The Ninth Arcanum of the Tarot is the prudent and wise hermit who is covered with the protective robe of Apollonius which symbolizes prudence; he holds onto the staff of the Patriarchs and illuminates himself with the lamp of Hermes (wisdom). The alchemist must always perform the will of the Father; he must be humble in order to attain wisdom and after having attained it he must be even more humble, more than anyone else. It is better to be silent and die. While the sinning Adam is dying, the Adam-Christ is sequentially being born.

Arcanum 10

In this lecture we are going to study the Arcanum 10 of the Tarot. It is necessary to analyze the cosmogonic wheel of Ezekiel. In this wheel, we find the battle of antitheses. Hermanubis rises on the right and Typhon descends through the left of the fatal wheel. This is the wheel of the centuries, the wheel of reincarnations and of karma. Upon the wheel appears the mystery of the sphinx grasps the flaming sword between its lion's paws. This is the wheel of antithesis. The serpent of brass that healed the Israelites in the wilderness and the terrible, tempting serpent of Eden are mutually combating each other.

The entire secret of the Tree of Knowledge is enclosed within this wheel; the four rivers of paradise flow from this unique fountain, one of them runs through the thick jungle of the sun watering the philosophical earth of gold and light and the other tenebrously and turbulently runs into the Kingdom of the Abyss. Light and darkness, White Magic and Black Magic, are mutually combating each other. Eros and Anteros, Cain and Abel, live within us in an intense battle, until by discovering the mystery of the sphinx, we grasp the flaming sword, and thus, this is how we become liberated from the wheel of the centuries.

Lunar Conscience

The lunar conscience is the outcome of our unfaithful memory; this type of consciousness sleeps profoundly. The humanoid has conscience of that which he remembers; no humanoid has conscience of that which he does not remember. The sinning Adam is memory, he is the same reincarnating ego, he is the lunar conscience. Clairvoyants affirm that the atoms of the secret enemy constitute this conscience and that it is a tenebrous remnant of our lunar past (a threshold's larva).

Our Gnostic disciples must comprehend the significance of this type of conscience: The lunar conscience is something that must be conscious; and it needs someone who is conscious of it. The lunar conscience is submitted to every type of limitation,

♂ ♏ Retribution ' 10

ARCANUM 10

qualification, restriction, reaction; it is the outcome of matter, the outcome of our race's inheritance, family, habits, customs, prejudices, desires, fears, appetencies, etc. The sinning Adam with his lunar conscience reincarnates with the goal of gaining more experiences within the school of life. However, life's experiences complicate and strengthen the sinning Adam. The once innocent humanity from Eden is now this terrible and perverse humanity of the atomic and hydrogen bomb.

The innocent child (with the experiences of life) is converted into a sly, distrustful, malicious, avaricious, fearful elder; such is the lunar conscience. The devil is a devil and can never acquire perfection. The great Master H.P. Blavatsky stated: "Strengthen your soul against the stalking of your 'I;' make her worthy to bear the name of 'Diamond Soul.'"

Solar Conscience

There exist changes in the lunar conscience and there exist changes of consciousness. Every improvement in the lunar conscience originates changes within it. These types of changes in the lunar conscience are superficial and useless. What we need is a change of consciousness. When we dissolve the lunar consciousness then the solar consciousness is born within us.

It is necessary for the sinning Adam to die within us so that Adam-Christ can be born within us. We grasp the flaming sword when we liberate the solar electronic energy that is enclosed within the seminal atoms.

Perseus descends into the flaming forge of Vulcan in order to decapitate the sinning Adam (Medusa) with his flaming sword. John the Baptist is decapitated and Christ is crucified in order to save the world. The slaughter of the innocent children (the initiates) is a repetitive action throughout the initiation. This is how the solar consciousness is born within us; this type of consciousness contains in itself the knower, the knowledge and the known thing, three in one and one in three. The solar consciousness is omnipresent and omni-penetrating. The solar consciousness liberates the human being from the fatal wheel of the centuries.

Sexual Cycles

Uranus is the octave of Venus. It governs the masculine and feminine facets of sex. It has a sexual cycle of eighty-four years. Uranus's cycle is divided into two periods of 42 years, positive-masculine and negative-feminine. Uranus' two poles are always facing toward the sun. For 42 years the positive pole is directed towards the sun and another 42 years the negative pole. Now we can understand where that alternated stimuli for both sexes comes from; the marvelous biorhythm of 84 years. The wheel of the centuries rotates in periods of forty-two years each. The masculine sex predominates for one half and the feminine sex for the other half. The sexual cycle of Uranus corresponds with the average length of a human life; this signifies that the antithesis of the sexual cycle in which we were born, vibrates within us during our adulthood. Then we feel sexually stimulated. We comprehend why mature men and women are indeed mature enough to work in the Great Work, because sexual sentiments are more vigorous at forty years of age.

Light and Consciousness

Light and consciousness are two phenomena of the same thing. The more levels of Christic Consciousness we develop the more levels of light we attain. The planets are gradually absorbing the Christic consciousness of the Sun. Thus when the planets of our solar system have integrally absorbed the divine Solar Consciousness, then life, light, and heat will no longer occupy only the astronomical place of the sun, but the entire solar system will then shine like the sun. This is the case of the gigantic sun Antares, which is a million times more rarified than our sun. The light of the solar system of Antares is not only localized in its sun, because each one of its planets has become a sun. The planetary humanities enjoy the solar consciousness; the outcome of this joy is the splendors of the solar system of Antares.

The Ten Sephiroth

Ten Sephiroth are spoken of, but in reality, there are twelve. The Ain Soph is the eleventh, and the twelfth Sephirah is its tenebrous antithesis within the Abyss.

These are twelve spheres, or universal regions, which mutually penetrate and co-penetrate without confusion. These twelve spheres gravitate within the central atom of the sign of the Infinite. A solar humanity unfolds within these twelve spheres. We have said that the sign of the Infinite is in the center of the earth, in the heart of the earth. The Ten Sephiroth of universal vibration emanate from the Ain Soph (the Microcosmic star) that guides our interior. The Ain Soph is the Being of our Being.

The Ten Sephiroth emanate from the Ain Soph as follows:

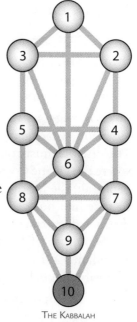

THE KABBALAH

First, Kether, the Ancient of Days

Second, Chokmah, the region of wisdom

Third, Binah, intelligence

Fourth, Chesed, the world of the Innermost

Fifth, Geburah, the world of soul-consciousness, the region of rigor and justice

Sixth, Tiphereth, the causal world, the region of willpower, equilibrium and beauty

Seventh, Netzach, the region of victory, the world of the mental man (anyone who liberates himself from the four bodies of sin is a Buddha).

Eighth, Hod, the splendor, the region of the Astral Body

Ninth, Yesod, foundation, sex, the ethereal plane

Tenth, Malkuth, the kingdom in general, the physical world; Malkuth is a supreme filter; from this region we depart to the Ain Soph or to the abyss, such is the law.

The Sephiroth are atomic; these ten Sephiroth can be reduced to three tables:

First: The Quantum Table of the radiant energy that comes from the Sun

Second: The Atomic Weight Table of the Elements of Nature

Third: The Molecular Weight Table of the Compounds

This is Jacob's ladder, which goes from earth to heaven. All of the worlds of cosmic consciousness are reduced to these three tables.

All of the ten known Sephiroth come from Sephirah, the Divine Mother; She dwells in the Heart Temple.

Direct Clue for Direct Knowledge

It is necessary that our Gnostic disciples learn how to leave their physical body in order to travel with their internal vehicles with complete cognizance in order to penetrate within the distinct Sephirothic regions.

It is necessary to directly know the twelve spheres of universal vibration, where all of the being of the universe develops and lives. The disciple must concentrate on the chakra of the heart, which is where the Divine Cosmic Mother abides. The disciple must beseech Sephirah, the Mother of the Sephiroth; the disciple muse beg her to take him out of his physical body in order to take him to the distinct departments of the kingdom in order to directly study the Sephiroth of Kabbalah. The disciple must pray and meditate abundantly on the Divine Mother while mentally vocalizing the following Kabbalistic mantras:

Lifaros – Lifaros – Licanto – Ligoria

Vocalize these mantras by syllabifying them. If you carefully observe the intelligent phonetic structure of these mantras, you will see the three vowels I.A.O. of the great Mysteries.

I.A.O. is hidden and combined in these sacred mantras of Kabbalah. The disciple must become sleepy while mentally vocalizing these four Kabbalistic mantras. It is necessary to practice

a retrospective exercise when awakening from our normal sleep; this in order to remember what we have seen and heard during the dream.

Initiation

Flee from those who sell initiations. Remember that the initiation is your own life. If you want initiation, write it upon a reed (whosoever understands this let him understand it, for there is wisdom within). The path of liberation is represented by the life, passion, death, resurrection, and ascension of our adorable Savior. Remember that your ego does not receive initiations. Thus, you must not boast of being an initiate; do not say, "I have these initiations" or "I have these powers" because this is arrogance and vanity. Only the Innermost receives initiations. You, wretched creature are nothing but the sinning shadow of the one who has never sinned. Exert yourself so that you can die more each time within yourself so that the "Son of Man" can be born within you.

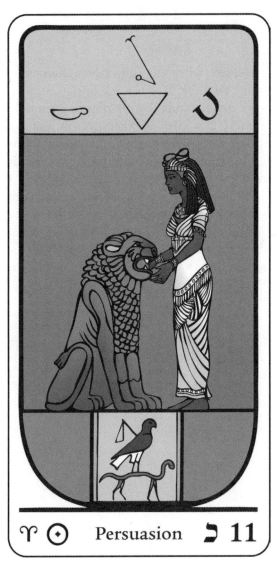

Persuasion 11

ARCANUM 11

Arcanum 11

The study of the Eleventh Arcanum of the Tarot corresponds to this lecture. The hieroglyphic of this Arcanum is a beautiful woman crowned with the sacred sign of infinity and who very gently (with Olympic serenity) shuts the jaw of a furious lion with her own hands.

Divine kings' thrones were adorned with lions made out of massive amounts of gold. The gold signifies the sacred fire of Kundalini; this reminds us of Horus, oro (Spanish for gold). We need to transmute the lead of the personality into the gold of the Spirit and only in the alchemist's laboratorium is it possible to perform this work.

Mithras

When the alchemist fledgling is crowned, he is transformed into a God of fire; it is then that he opens the terrible jaw of the furious lion with his own hands. The potable gold of alchemy is the sacred fire of the Holy Spirit. To bind the Cross-Man within the Triangle-Spirit would be impossible without the potable gold.

The Number 11

The number 11 is formed by two unities that Heinrich Kunrath translated in these two words, "Coagula Solve." We need to accumulate the sacred fire, and then learn to project it. The clue to this is in the connection of the Membrum Virile with the Genitalia Murielis, quietude of the Membrum Virile and the Genitalia Murielis, and the use of a very gentle movement occasionally. Thus, we transmute the animal instincts into willpower, the sexual passion into love, lustful thoughts into comprehension, and vocalize the secret mantras.

The number eleven is Kabbalistically disarranged as follows: 1 plus 1 equals 2. Number 1 is masculine and number 2 is feminine.

The Pairs of Opposites of Holy Alchemy

> Positive = Negative
>
> Active = Passive
>
> Osiris = Isis
>
> Baal – Bel = Astarte – Ishtar
>
> Shiva = Parvati
>
> Husband = Wife
>
> Father = Mother
>
> Sun = Moon
>
> Fire = Water
>
> Heat = Cold
>
> Volatile = Fixed
>
> Sulfur = Mercury

Chinese Alchemy

Heaven is masculine, Yang, and its element is fire. The earth is feminine, Ying, and its element is water. In the Taoist doctrine, we find White Tantrism. The Ying-Yang, the Dragon, and the Tiger are the axis of Taoism. According to Taoist interpretation, the Ying-Yang is the outcome of T'ai Chi, the Prima Matter of the universe and creation emerges from the sexual union of this pair of opposites. Maithuna (Sexual Magic) exists within the White Tantrism of India and Tibet.

Buddhist White Tantrism, Chinese Taoism, and the legitimate Tibetan Yogas practice the Arcanum A.Z.F. Only the infrasexual pseudo-yogis and yoginis (that are so abundant in America and Asia) hate the Arcanum A.Z.F. Chinese Alchemy is the foundation of the authentic schools of Yoga. The Yellow Lodges are schools of regeneration. Infrasexual people mortally hate the schools of regeneration.

Schools of Regeneration

To regenerate oneself means to generate oneself anew, in other words, to recreate oneself, to recreate oneself anew. This matter about being born anew is an absolutely sexual problem. Neptune governs schools of regeneration; this planet has a cycle of 165 years. Such a cycle controls the periods of public and secret activities of these schools. The esotericism of the schools of regeneration is the Arcanum A.Z.F. The masters of these schools teach their disciples the science that allows them to dissolve their ego. It is necessary that the Being (which is not the ego) be born within us. Something old must die within the human being and something new must be born within. Regeneration signifies the creation of a new cosmos within us. This type of creation is possible only by working with the Lion of Fire. Uranus controls the chakras of the sexual glands, yet the schools of regeneration are Neptunian.

Eminent astrologers affirm that Neptune influences the pineal gland; the potency of the pineal gland depends on the sexual potency. Great schools of regeneration have existed through the course of history (it is enough for us to remember the Rosicrucian Alchemical school that became secret in the year 1620). Likewise, it comes into our memory the schools of Aryavarta Ashrama of Tibet, as well as the sect of the Manicheans of Persian origin, and the famous Sufis with their sacred dances, the Templars, etc. All of these were schools of regeneration; the "coitus reservatus" is practiced in all of them. The schools of regeneration constitute the Golden Chain of the White Lodge.

Fire Projection

The Kundalini can be aimed or projected to any chakra or to any distant place. Within the cervical vertebrae, the Kundalini use to take the shape of a Quetzal (the bird of Minerva). In the supreme moment of the sacred copulation, we can send this fiery bird to each one of the seven chakras in order to awake them totally. The two Quetzals (one from the man and one from the woman) are nourished with water (the Ens Seminis) of the well (sex). Man and woman can command the Quetzal and the fiery bird will obey. The

powerful mantra **Jao Ri** is the secret clue that grants us the power of commanding the Quetzal. This miraculous bird can transform our face or make us invisible if we are in very grave danger, it can also awaken within us any chakra of the Astral Body or heal any distant ill person, etc.

Imagination

There exist two types of imagination: mechanical imagination (fantasies) and cognizant imagination (clairvoyance).

Gnostic students must learn how to use their cognizant imagination.

PRACTICE

1. The disciple must quiet his mind and emotions while seated in a comfortable chair or while lying down (face up, in a reclining position).

2. Now, imagine the marvelous Quetzal floating above your head.

3. Mentally vocalize the mantra of power **Proweoa**. The Quetzal's divine image (splendid bird of beautifully intense emerald feathers, golden green plume with a red belly and long green feathers yet with a white undertail) will come to your imagination with this mantra. The disciple must become familiar with this bird and learn how to handle it. You can awaken your internal powers with this fiery bird.

QUETZAL

4. The mantra **Proweoa** (utilized often by the schools of the Great Chain) allow us to bring into our cognizant imagination any image from the Superior Worlds; this is how we can clairvoyantly see. The alchemist must utilize this mantra during the trance-state of Sexual Magic in order to see the Quetzal.

Arcanum 12

We must now study the Twelfth Arcanum of the Tarot. Chinese tradition mentions the ten trunks (Shikan) and the twelve branches. It is necessary to know that the seven chakras and the five senses are the twelve faculties. The universe emerged from the Chinese Hoel-Tun; this is the primordial chaos. The ten trunks and the twelve branches emerged from the chaos, which in Alchemy is the Ens Seminis, the Lapis Philosophorum or the Philosophical Stone.

The entire Misterium Magnum is found enclosed within this Sum Matter.

The alchemist must extract the potable gold from within this Menstrum Universale in order to achieve the blending of the cross with the triangle. Before achieving this amalgamation, we do not have a true existence. The four bodies of sin (Physical, Vital, Astral and Mental) are controlled by the Ego.

The ego, the "I," is not the Divine Being of the human being. Indeed, the "I" is the total sum of successive "I"s, for instance: John the drunkard, John the tenor, John the intellectual, John the religious one, John the merchant, John the youth, John the mature one, John the elder, etc... all are a succession of "I"s, a succession of phantoms that inevitably are condemned to death. The "I" does not constitute the whole of what the human being is. John fought in the tavern, John is now a religious one, John is now a bandit; to that end, every person is a dance of Johns, so who is the true John? Therefore, if we do not escape from the fallacy of all of these multiple "I"s, we cannot asseverate that we have a true existence.

Present humans have not incarnated their immortal Soul (their Divine Being) yet. Thus, from this point of view we can asseverate that present humans have no true existence yet. The annihilation of all of those false and mistakenly called centers of consciousness is only possible by denying oneself.

We are astonished when seeing how so many students of occultism (as if they were great Masters) attire themselves with tunics and disclose beautiful and sounding names upon themselves, when indeed they do not even have true existence.

The Apostolate 12

It is necessary to annihilate the "I" in order to attain true existence. Do you want to drink? Then do not drink; do you what to smoke? Then do not smoke. Did they strike your right cheek? Then present your left cheek to them. The supreme negation of oneself is found in the coitus. Not to ejaculate the Ens Seminis in the supreme moment is an absolute sacrifice of the "I"; the outcome of such a negation of oneself is the awakening of the Kundalini. The fire burns the evil scoria and in the end it absolutely dissolves the "I." The fire is the Potable Gold.

The Great Work

The Twelfth Arcanum of the Tarot represents the Great Work. On this card, we see a man that hangs from one foot. The hands of this man are tied in such a way that they form an apex of an inverted triangle; with his legs, he forms a cross that is over the triangle (over the rest of his body). The objective of the entire work is to acquire the soul, in other words, to attain the amalgamation of the cross with the triangle. This is the Great Work. The Twelfth Card of the Tarot is Sexual Alchemy. The Cross-Man must join the Triangle-Spirit by means of the sexual fire.

According to the Chinese, the God Fu Ji (the Adam-Christ) was born at midnight, on the fourth day of the tenth moon. Precisely at twelve years old, the virgin Hoa Se, while walking along the shore of the river (the seminal liquid), conceived the Christ in her womb while placing her foot on the print of the Great Man.

You must study these dates 4, 10, 12 under the light of the lectures 4, 10, and 12 of this present course.

White and Black Tantra

Two types of Tantra exist in the east. The ejaculation of the Ens Seminis is not taught in positive Tantra, whereas the ejaculation of the Ens Seminis is practiced in Black Tantra. Grey Tantra also exists, however this type of Tantra is not concerned with whether or not seminal ejaculation occurs; this Tantra is very dangerous because it can easily mislead the students towards negative Tantra (Black Tantrism).

The sexual positive yoga is practiced without the ejaculation of the seminal liquor. A Tantric sadhana exists for the connection of the Membrum Virille and the Genitalia Murielis; the sexual connection is performed after an interchange of caresses between man and woman. The couple remains quiet, with their mind in blank so that their "I" does not interfere, thus, this is how they reach ecstasy during the Tantric sadhana. The entire work is performed by the Tantric yogis under the guidance of a Guru. The only significant thing (in Tantra) that comes from India is White Tantra because it forbids the ejaculation of the Ens Seminis.

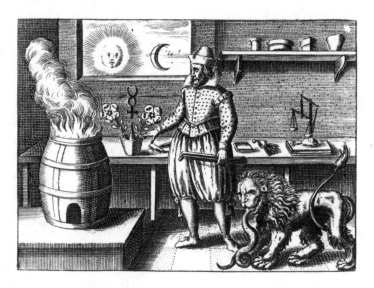

Twelfth Key of Basil Valentine

In the twelfth key of Basil Valentine, the Twelfth Arcanum is profoundly studied, thus, it is important to comprehend it.

As the lion transforms the serpent into its own flesh when he devours it, likewise the philosophical stone or powder of projection (red lion and living fire) has the power to transmute or transform all imperfect metals into his own igneous substance. The vile metals are the false values that constitute the "I." The fire transmutes them, and then the "I" is dissolved. Thus, this is how we acquire Soul, Being; this is to be Different. Without the fermentation of the Gold (fire) no one can arrange the philosophical stone or develop

the tincturing virtue. The tincture of the fire has the power to penetrate all of the internal bodies in order to radically transform them. Similar is united to its similar in order to transform it. The fire transforms the lead of the personality into the gold of the spirit. Three serpents that symbolize Mercury, Sulfur, and Salt represent the synthesis of the Great Work. The Phoenix Bird rises from within its own ashes. The alchemists must work for twelve hours in order to attain the fermentation of the gold. Behold here the Twelfth Arcanum of Kabbalah. Whosoever possesses the fermented gold can have the joy of truly being.

Non-identification

The present human is a dormant machine. If you want to awake from the profound dream in which you live, then do not identify with pleasures, desires, emotions, dramas, scenes of your life, etc... Call yourself to vigilance in each step; remember good disciple, that people are dreaming. Observe people and their dreams, analyze all of those dreams in which humanity lives, but do not identify with those dreams so that you can awaken. People believe they are awakened because they are not sleeping in their beds; regardless, they have their consciousness profoundly asleep, thus they dream. Everything that you see amongst the people is simply dreams. Nevertheless, remember that not to identify with one's dreams, does not mean to abandon your duties as a father, a mother or a son/daughter, etc. However, do not identify; thus this is how you will awaken from the profound dream in which you live.

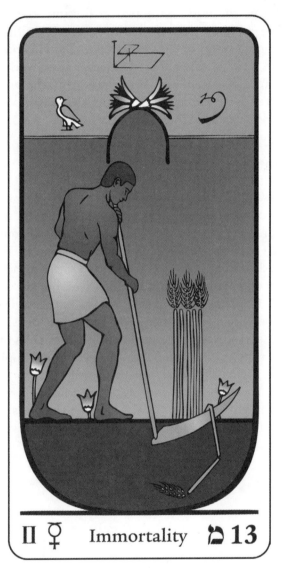

Ⅱ ☿ Immortality �121 13

ARCANUM 13

Arcanum 13

Let us now study the Thirteenth Arcanum of the Tarot. This is the Arcanum of Death.

Indeed, death is the return into the womb. Life and death are two phenomena of the same thing. Death is the difference of whole numbers; only the values of the consciousness are what remain after this mathematical operation is completed. These values (when seeing them clairvoyantly) look like a legion of phantoms that continue. The return of these values occurs in the mechanism of Nature. Indeed, the soul does not reincarnate, because the human being does not have his soul incarnated yet. Only the values are what return and incarnate.

The Embryo of a Soul

Present humans only have an embryo of a soul; this embryo can be developed and strengthened by means of Sexual Magic. Often this embryo believes that it is whole and forgets its origin; when this occurs, we totally fail.

Immortality

Humans must attain immortality, because they do not have it. Only those who have incarnated their soul are immortal.

Mind

It is stated that humans have one mind, yet we state that each human has many minds. Each phantom from the pluralized "I" has its own mind and even self-independence. Present humans are dormant machines driven by the legion of "I's." We need to engender the Christ-Mind.

Astral-Christ

Whosoever engenders the Astral-Christ can become immortal within that body. The Astral-Christ is born only by Sexual Magic. People who engendered the Astral-Christ in past reincarnations retain the memory of their past lives, and with their Astral-Christ they know how to depart and return into their physical body at will. These people are immortal.

True Identity

Common and ordinary people do not have a true identity, because only those phantoms of the pluralized "I" are expressed through them. Thus, after death each human is a legion.

Soul

Whosoever incarnates their Soul acquires true identity and thus already IS. Present humans are not Self-realized beings.

Willpower

Present humans confuse the force of desire with willpower. We need to engender Christ-Will.

The Laboratorium Oratorium

The Adept and his/her spouse must work together in the Laboratorium Oratorium. The king and the queen perform their alchemical combinations in the nuptial chamber [SEE FIGURE A]. Outside of this royal chamber, the ravens of putrefaction devour the Sun and the Moon (blackening and putrefaction of the internal chrysalides or bodies of sin); within a tomb of glass [FIGURE B] the bodies of sin become putrid; this tomb of glass is the glass of alchemist. The souls rise up to fly [FIGURE C](symbol of the butterfly that comes out from within the chrysalis, a symbol of the Christified vehicles that come out from within their chrysalides). A hermaphrodite

ENGRAVINGS FROM PHILOSOPHIA REFORMATA, BY J. D. MYLIUS, 1622

body (Sun and Moon) comes to life with the heavenly influence of the dew (the Ens Seminis). The hermaphrodite body [FIGURE D] encompasses the internal Christic vehicles that were engendered by means of Sexual Magic. All of these Christic vehicles penetrate and co-penetrate without confusion. When a person has these vehicles, he/she can incarnate his/her soul. Without having these Christic bodies, no human being is a true human being.

The Retort of Alchemy

The Prima Matter of the Great Work is within the Alchemical retort. This venerable matter is very volatile and it is not still; its special characteristic is its instability and variability. This venerable matter boils and dissolves by lighting the sexual fire under the retort of Alchemy.

S. Trismosin, Splendor solis, 16th century

Those who have succeeded in creating all of these
Christic Vehicles within the Alchemical Retort can
incarnate their soul totally and integrally.

When arriving at this step of the work, the venerable matter has converted itself into a very gorgeous child glowing with beauty. This is the Soma Psuchikon, the Body of Gold; we can consciously visit all the departments of the Kingdom with this precious vehicle. Then, by giving new properties to this Alchemical alloy, the Astral-Christ appears within the astral phantom; this is a very precious child who grants us immortality. After this second body has been created, the problem of integrally comprehending all of the acquired powers and knowledge arises. This problem is only resolved when the Christic intelligence is given to this Alchemical alloy. Thus, the precious vehicle of the Christ-Mind happily rises from within the Retort of the Laboratory; this vehicle emerges from within the mental phantom.

After this work has been completed, something is still missing. Christ-Will is what is missing. Thus by intensely reheating the Retort of the Laboratory, a Divine Child comes to life; this is the Christ-Will, the Divine Body of the Soul. Those who have succeeded in creating all of these Christic Vehicles within the Alchemical Retort can incarnate their soul totally and integrally. Only those who achieve the incarnation of their soul deserve the precious title of Human. Only these true humans can elevate themselves up to the kingdom of the Human-Being, the Superhuman, the Super-Man. Only these true Human Beings can receive the Elixir of Long Life.

No human-sketch-creature can incarnate the soul; not a single soulless creature can receive the Elixir of Long Life. It is necessary to create the Christic Vehicles in order to incarnate the Soul. Only those who incarnate their Soul have the right to receive the marvelous Elixir that elevates us to the kingdom of the Super-Human-Being.

Serpents' Scales – Butterflies' Chrysalides

After each one of the great Initiations of Major Mysteries, the Ethereal, Astral, Mental, and Causal phantoms are similar to scales that have been discarded by serpents, or as chrysalides that have been discarded by butterflies (after they have flown away). Precisely after the Great Initiations is a work for Humans, Angels,

and Gods: to disintegrate the shells and to dissolve the pluralized "I." Ahamsara, the karmic remnants of the Gods, are precisely those phantom-like "I's."

Elixir of Long Life

Every true human being that incarnates the Soul can ask for the Elixir of Long Life; this is a gas of immaculate whiteness; such a gas is deposited in the vital depths of the human organism.

Resurrection

On the third day after the death of his physical body, the initiate (in his Astral Body, accompanied by the Divine Hierarchies) goes to his holy sepulcher. The initiate then invokes his physical body (with the help of the divine hierarchies); thus his physical body gets up and penetrates hyperspace. This is how the initiate achieves the escape from the grave.

BABAJI

In the supersensible worlds of hyperspace, holy women treat the body of the initiate with perfumes and aromatic ointments. Then, by obeying superior orders, the physical body penetrates within the Astral Body (through the top of his sidereal head). This is how the Master once again possesses his physical body. This is the Gift of Cupid. After the Resurrection, the Master does not die again; He is eternal. The Yogi-Christ from India, the immortal Babaji, and his immortal sister Mataji, live with the same physical bodies they had more than a million years ago. These immortal Beings are the watchers of the Guardian Wall that protects humanity.

The Great Service

Immortal Beings can appear and disappear instantaneously. They can make themselves visible in the physical world. Cagliostro, St. Germain, Quetzalcoatl, and many other immortal Masters have performed great works in the world.

The Super-Human

First, we must become complete Humans; thereafter (after resurrection) we elevate ourselves into the Kingdom of the Super-Human. Present humans are nothing more than human phantoms.

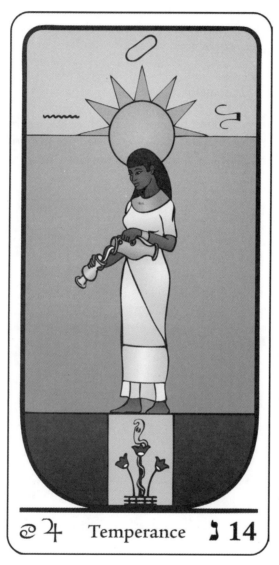

ARCANUM 14





Seven bodies appear within the hearth; this represents that the bodies
are within both alchemists (man and woman, the sun and the moon)
because these are engendered when we combine the red elixir (the
Sun) and the white elixir (the Moon) in the Ninth Sphere (represented
by the well of Jacob, the sexual center). In the center of the Garden
of Eden we find a Cherub (an Androgynous Being) located between
the man and the woman. He holds the Star of David in his right
hand, indicating to us that he is the outcome of the union of the two
triangles, the two elixirs (Sun and Moon, Man and Woman). They
combine the substances of their seven bodies (Above and Below) by
sexual crossing the four elements (fire, air, water and earth), which
are represented in each corner of the square.

the musical scale are the foundation of all creation. If we transmute the creative energy, we initiate a new octave in the Ethereal World, whose outcome is the birth of To-Soma-Psuchikon (the wedding garment of the soul). We can consciously penetrate all of the departments of the Kingdom with this vehicle.

A third octave will permit us to engender the true Astral Body, the Astral Christ (the Christic Astral Body). When reaching these heights, the old astral, the phantom, is left reduced to an empty shell, which, little by little, will be disintegrated.

A fourth octave permits us to engender the Christ Mind. This vehicle gives us true wisdom and unity of thought. Only the one who engenders the Christ Mind has the right to say, "I have a Mental Body." The present Mental Body is only a phantom-like-shaped body. This phantom-like-shaped mind really converts itself into an empty shell when the true Mind is born. Then, the old mental carcass is disintegrated and reduced to cosmic dust.

In the fifth musical octave, the true Causal Body is engendered. When reaching this height, we incarnate the Soul, then we have a real existence. Before this moment, we do not have a real existence.

WORK WITH THE PROSTATIC/UTERINE CHAKRA

Immediately after finishing the daily work with the Arcanum A.Z.F., the Alchemist should lie down in the dorsal decubitus position (facing up); he/she must work with his/her prostatic/uterine chakra. This is a very important chakra in high magic.

The Alchemist must inhale the vital air, then retain the breath and in those moments direct the nervous currents towards the prostate/uterus with the intension of closing the sphincters that exits between the seminal vessels and the urethra.

The effort of sending the electro-magnetic currents must be similar to the supreme effort that a woman does when giving birth. The woman moans in those moments, in other words, her larynx emits the moaning sound of the letter "M." Krumm-Heller stated that initiation must start with the letter "M" and "S." If we want to be born in the internal worlds, then we must also utter the sound

of the letter "M" (as when one moans). It is about being born and we must be born.

Thereafter we slowly exhale, we wait for the breath to naturally return to us and we inhale, we mentally pump the creative energy and make it rise through the two canals Ida and Pingala to the chalice (the brain). We continue repeating the exercise.

IMAGINATION AND WILLPOWER

Imagination is feminine and willpower is masculine. When we work with the Prostatic/Uterine chakra we must unite these two powers in an Alchemical Wedding in order to promote the ascension of the creative energy. We do this first through the sympathetic chords of the physical body; second through the sympathetic chords of the ethereal body; third through the sympathetic chords of the body of desires; fourth through the sympathetic chords of the mental body; fifth through the sympathetic chords of the causal body. Advanced students must carry the creative energy even to the Ain Soph.

HEART

After a certain time of practice, students must learn how to direct their creative energy from their brain to their heart; the Fourteenth Arcanum is the Arcanum of Temperance.

Transformation (shapeshifting)
(Second aspect of the Fourteenth Arcanum)

In the Jinn State, a body can shapeshift easily. Circe shapeshifted men into pigs; legend states that Apuleyus shapeshifted himself into an Ass. To manage shapeshifting the following Latin mantras are used: "EST SIT, ESTO, FIAT." Only while in a Jinn State can we adopt any type of shapeshifting.

CLUE FOR JINN STATE

The devotee must sit at a table and cross his arms, placing them on the table; while resting his head on his arms, he must willingly fall asleep. The student must relax his mind by emptying it from any type of thoughts until it is blank. Thereafter, imagine the slumber state (that precedes the dreaming state); identify with it and fall asleep. When the student feels that he is slumbering, he should get up from his chair (but keep the slumber state as if he was a somnambulist) and attempt a long jump, as far as possible, with the intention of submerging himself within hyperspace (with his physical body). Thereafter with a pencil, he must mark the exact spot on the floor where his foot landed.

As the student practices this exercise, he will notice that each time the length of the jump is longer and longer. Finally, the day will arrive in which he will perform a jump that is beyond average. This will give the student joy because it will indicate that his physical body is now penetrating into hyperspace. Finally, constancy, patience, willpower and tenacity will grant triumph to the student; thus, on any given day the student will definitely sustain himself with his physical body in hyperspace. With his physical body he will penetrate into the internal worlds; he will be in "Jinn State." Then within a few moments, he will be able to transport himself to any place on earth. He will become an investigator of the superior worlds.

GENII OF JINN SCIENCE

Before initiating the former Jinn practice, the student must invoke the Genii of Jinn Science. The devotee will invoke the Master Oguara many times, as follows:

> *I believe in God, I believe in Oguara and in all the*
> *Genii of the Jinn Science, take me with my physical*
> *body to all the Temples of Jinn Science. Oguara!*
> *Oguara! Oguara! Carry me.*

This invocation must be repeated thousands of times before falling asleep.

Transubstantiation
(Third part of the Fourteenth Arcanum)

The Last Supper of the adorable Savior of the world comes from archaic epochs. The great Lord of Atlantis also practiced this ceremony, as Jesus Christ did.

This is a blood ceremony, a blood pact. Each one of the Apostles put their blood into a cup and then they mixed their blood with the royal blood of the Adorable One within the chalice of the Last Supper (the Holy Grail). Thus, this is how the astral bodies of the Apostles joined the Astral Body of Christ, by means of this blood pact. The Apostles drank the blood contained within the Chalice and Jesus likewise drank from it.

The Holy Gnostic Unction is united to the Last Supper through this blood pact. When the Christic atoms (Solar Astral Atoms) descend into the bread and the wine, they are in fact converted into the flesh and blood of (the Cosmic) Christ. This is the mystery of the transubstantiation.

Arcanum 15

Let us now study the Fifteenth Arcanum of the Tarot. We are going to study the male goat of Mendez, Typhon Baphomet, the devil. The alchemist must steal the fire from the devil. When we work with the Arcanum A.Z.F. we steal the fire from the devil; this is how we transform ourselves into Gods.

The esoteric pentagram shines upon the forehead of the male goat. The Caduceus of Mercury replaces the sexual organs. In synthesis, we can state that the Caduceus of Mercury represents the sexual organs. Any alchemist needs to work with the Caduceus of Mercury. This work is performed by means of transmutation. The star of five points shines when we steal the fire from the devil.

We need to develop the Kundalini and to dissolve the "I," only in this way can we attain liberation.

The Alchemist must steal the fire from the Devil.

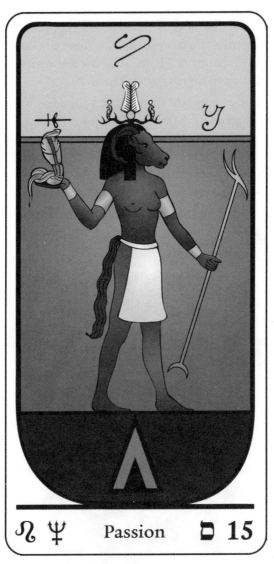

Passion

Arcanum 15

The Work with the Demon

The Initiates of the fourth path, which is "The Path of the Astute Man," choose "to work with the devil" on the process of the dissolution of their "I." The tenebrous ones violently attack anyone who works in the dissolution of their "I"; this is why even though they are not demons they are, nonetheless used to being surrounded by demons. When non-initiated seers, clairvoyantly see a human being like this, they mistakenly misjudge him and end up calumniating him when qualifying him as a demon. The initiates of "The Path of the Astute Man" become enigmatic. Disciples from the path become confused when they contemplate black candles upon the altars of these initiates; then, as usual, they mistakenly misjudge them.

Techniques for the Dissolution of the Ego

The "I" exerts control upon the five inferior centers of the human machine; these five centers are the: intellectual, emotional, motor (movement), instinctual, and sexual.

The "I" cannot control the two superior centers of the human being, which are the Superior Mind and Superior Emotion. If we want to dissolve the "I," we must study it through the inferior centers; we need comprehension. It is urgent to comprehend the actions and reactions of each one of the five inferior centers of the human machine. The "I" exerts control over these inferior centers; therefore, we walk on the path of the dissolution of the "I" by in depth comprehension of the activity of each one of these five inferior centers.

Mind and Sentiments

Two people react differently before any given representation; what is pleasant for one person could be unpleasant for the other. The difference lies in the fact that one person judges and perceives the representation through his mind while the other does it through his feelings (the representation touches his feelings). Therefore, we must learn how to differentiate the mind from the

sentiment. One thing is the mind and another is the sentiment. Within the mind there exists an entire play of actions and reactions that must be carefully comprehended; within our sentiments exist affections that must be crucified, emotions that must be studied and in general an entire mechanism of actions and reactions that can easily be misplaced and confounded with the activities of the mind.

Movement

We need to self-discover ourselves and to comprehend our habits in depth. We must not allow our life to continue to develop mechanically. It seems incredible that we live within the molds of habits and that we do not know those molds that condition our life; we need to study our habits; we need to comprehend our habits. We need to self-observe the way we speak, the way we dress, the way we walk, etc...

Habits belong to the center of movement. Football, tennis and all sports in general belong to this center. When the intellect interferes in the center of movement, it destroys it and damages it because the intellect is too slow and the center of movement is very fast. When a typist works, he works with the center of movement; he can commit a mistake in his typing if his intellect interferes with his movements; a man driving a car could suffer an accident if his intellect interferes with his movements.

Instinct

There exist various types of instincts: the instinct of preservation, the sexual instinct, etc. Many perversions of instinct also exist.

Deep within every human being there exist sub-human, instinctual forces that paralyze the true spirit of love and charity. These demonic forces must first be comprehended, then brought under control and eliminated. These bestial forces are: criminal instincts, lust, cowardliness, fear, etc. We must comprehend and subdue these bestial forces before we can dissolve them.

Sex

Sex is the fifth power of the human being. Sex can liberate or enslave the human being. No one can attain integrity, no one can be deeply Self-realized, without sexual energy. Sex is the power of the Soul. The integral human being is achieved with the absolute fusion of the masculine and feminine poles of the Soul. Sexual force develops, evolves and progresses on seven levels (the seven levels of the Soul). In the physical world, sex is a blind force of mutual attraction. In the astral, sexual attraction is based on the affinity of types according to their polarities and essences. In the mental plane, sexual attraction occurs according to the laws of mental polarity and affinity. In the causal plane, sexual attraction takes place on the basis of conscious will. It is precisely on this plane of natural causes where the complete union of the soul is consciously performed. Indeed, no one can attain the complete glory of the Perfect Matrimony without having attained this fourth state of human integration.

We need to comprehend in depth the entire sexual problem. We must transcend the mechanicity of sex. We need to know how to procreate children of wisdom.

In the supreme moment of conception, human essences are completely open to all types of influences. Thus, the state of purity of the parents and their willpower used in order not to spill the Cup of Hermes, is all that can protect us against the terrible danger that the spermatozoon and the ovum face regarding the infiltration of subhuman substances of the bestial egos which want to reincorporate.

Adultery

Since a woman's body is a passive and receptive element, it is clear that her body collects and stores more of the results of the sexual acts than all of those men who commit adultery with her; those results are atomic substances from the men with whom she has had sexual intercourse. Therefore, when someone has sexual intercourse with a person who has been with another partner or other partners, both then absorb the atomic essences of the other

partners and poison themselves with them. This is a very grave problem for those brothers and sisters who are dissolving the "I" because then, not only do they have to fight against their own errors and defects, but more over, they have to fight against the errors and defects of those other partners with whom they had sexual intercourse.

Death of Satan

We discover the entire process of the "I" by comprehending the inner activities of each one of the five inferior centers. The outcome of this self-discovery is the absolute death of Baphomet or Satan (the tenebrous lunar "I" or sinning Adam).

We Need to Be Integral

Integration has seven perfectly defined steps:

First: Mineral state, dominion of the physical body and its five centers.

Second: Vegetal state, absolute control over the Astral Body and of its chakras, discs or magnetic wheels. This vehicle represents the vegetal state.

Third: Humanization of the Mental Body, ordinarily, the phantasmal mental body of every human being has an animal face and an animal figure; it is animalized.

When the mental matter is transformed into the Christ Mind, we achieve the mental humanization. The mind represents the intellectual animal; presently we are human only in our physical appearance because in our depths we are still animals. In the mental plane each one has the animal figure that corresponds to his individual character.

Fourth: The sexual function is the basic foundation of the Human Soul; those who transmute their sexual energies have the right to incarnate their soul.

Fifth: The fifth degree of integration is represented in any perfect human being.

Sixth: Universal, infinite compassion.

Seventh: This seventh definitive step is only possible within Human-Gods. These are Super-Humans.

The Mystery of Baphomet

It is indeed true and certain that the mystery of Baphomet is Sexual Alchemy. We transform the lead of our personality into the gold of the spirit based on rigorous comprehension and sexual transmutation. This is how the "I" is annihilated. The rose elaborates its perfume with the mud of the earth; the perfume of the rose is transmuted mud.

The Door of Eden

Sex is the door of Eden. The guardian of this door is the Assyrian sphinx, the Egyptian sphinx, the bull (golden calf) of Moses with the sword between its paws. This is the psychological "I" reflected in the Baphomet that with his sword drives out from the threshold all of those who are not prepared. The enemy is within us; we need to work with the demon in order to dissolve it. We need to steal the fire from the devil.

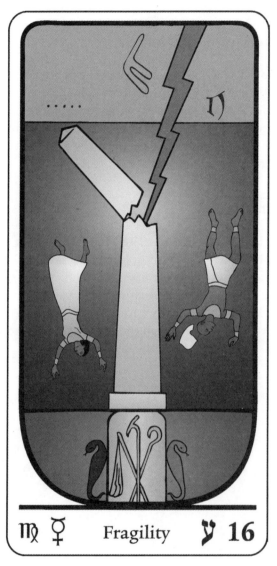

mg. ☿ Fragility ט 16

Arcanum 16

Arcanum 16

Let us study now the Sixteenth Arcanum of the Tarot. This is the Arcanum of the Fulminated Tower. This is the Tower of Babel. Two personages are precipitated to the bottom of the Abyss. One of these personages when falling with his head downwards and his legs and arms outstretched represent the inverted pentagram. Many are the initiates that allow themselves to fall; many are the fulminated towers. Any initiate that spills the Cup of Hermes falls inevitably. The legend of the fallen Angels has been repeated and will be repeated eternally.

Presently many fallen Gods live in the world; they are now camouflaged with the body of human beings.

Human Specter

Present humans are soulless creatures; when death arrives for them, only the human specter continues!

The embryo of the Soul escapes from within this specter.

The post-mortem states mentioned by occultists correspond to the embryo of the Soul; this embryo returns to its true Being who normally lives in the Causal World.

An in-depth analysis takes us to the conclusion that the human specter is a den of filthy demons; the conclusion is that after death, the present humans are transformed into a legion of demons that continue on. Indeed, the physical human person dies, because present humans are not immortal; nonetheless, present humans believe themselves to be immortal and powerful, but their breaking point of arrogance is fulminated by the Ray of Death, and from their Tower of Babel they roll into the abyss. This is the Fatality.

Astral Christ and Mental Christ

Present humans have two centers that they do not use: the Superior Mind and the Superior Emotion. These are two divine centers, the true instruments of the eternal and imperishable

Humans with Soul. We can profoundly study the great mysteries of life and death with these two superior centers. It has been said to us that we can even penetrate into the Great Reality that is far beyond time and eternity with these two superior centers.

Those who believe that they already use these two centers without having engendered the vehicle of the Mind-Christ and the vehicle of the Astral-Christ are completely mistaken, because is necessary to engender these two vehicles in order to clothe the superior mind and the superior emotion (only by means of the Arcanum A.Z.F. is it possible to engender these two superior vehicles). The Astral-Christ is born in the Third Initiation of Major Mysteries and the Mind-Christ is born in the Fourth Initiation of Major Mysteries. Therefore, the Astral and Mental bodies studied by occultists and often referred to by Theosophy are just miserable specters of death that eventually will be fulminated by the terrible ray of Cosmic Justice. Thus, this is how the Tower of Babel along with Satan will roll into the abyss.

Immortality

Whosoever possesses the Astral and Mental bodies becomes absolutely immortal. When we study these Christic vehicles and compare them with the astral and mental vehicles that are used by the defunct, then we find the following differences:

The Astral-Christ shines marvelously, whereas the astral of death does not shine because it is just a fatal shadow.

The Mind-Christ shines gloriously, whereas the mind of death does not shine.

The Astral-Christ is clean from passions, whereas the astral of death is a vehicle for animal passions.

The Mind-Christ has an angelical, divine figure, whereas the mind of death has an animal figure.

The Astral-Christ has the Kundalini and the chakras awakened, whereas the astral of death does not have the Kundalini awakened and if by chance it has the chakras awakened (by means of any genre of esoteric discipline) they shine like fatuous fires within the darkness of the abyss.

Conclusion: The Human-Christ is immortal, whereas the terrestrial human is not. The Human-Christ shines like the Sun, whereas the terrestrial human is just a shadow. The Human-Christ is a Self-realized Being!

What is Fundamental

Those students of occultism that practice esoteric exercises without working with the Arcanum A.Z.F. are similar to the man that builds his house upon the sands, his building will roll into the abyss; we must build upon the living rock: this rock is sex. Whosoever develops his chakras within the specter of death will roll into the abyss; his temple will be a fulminated tower.

Whosoever engenders their Christic bodies with the Arcanum A.Z.F. and works with the development of their chakras become Living Christs.

The Awakening of the Consciousness

It is necessary to awaken the consciousness in order not to fall into the abyss of perdition. Presently, many leaders of esoteric groups who have their consciousness profoundly asleep exist; blind leaders guiding the blind, all of them will roll into the abyss; this is the law.

Present human beings live absolutely asleep; for example, if suddenly during a football game a group of football players were to awaken their consciousness, you can be absolutely sure that the game would unexpectedly end because all the players, ashamed of themselves, would immediately flee from the football field.

The fundamental cause of the profound dream in which the consciousness of humanity lives in is that which is called F-A-S-C-I-N-A-T-I-O-N. Football players' consciousnesses are profoundly fascinated by the game, thus they play sleepily, apparently they are playing while awake, but nonetheless the reality is that they are playing while asleep.

Ordinary Sleep

During the hours of rest (while the body ordinarily sleeps in bed), the ego travels out of the physical body many times to very remote places. However, out of the physical body, the ego lives asleep; indeed, the ego takes its dreams into the supersensible worlds. In the internal worlds, carpenters are in their carpentry shops dreaming about all of the things they do in the physical world; likewise, the blacksmiths are in their forges, the policemen are patrolling the streets, the tailors are in their tailor shops, the drunkards are in the bars, etc., all of them dream, all of them carry their dreams into their supersensible worlds. And after death they continue repeating the same thing; their ego continues with the same dreams. Indeed, as in ordinary sleep the ego carries out their dreams; it is likewise after the physical death.

Technique for the Awakening of the Consciousness

The technique for the awakening of the consciousness is based on the Self-remembering of oneself. Every humanoid is found fascinated by many things as we have already stated in the former paragraph. We forget ourselves when fascinated before a certain representation; we then dream.

During a public assembly people have launched themselves into violence. Gentlemen (when in their sane judgment) who are not capable of uttering a bad word, suddenly, while confounded by the multitudes, end up insulting and stoning their neighbor; behold here the power of fascination. One forgets oneself, then dreams and while dreaming one performs many completely absurd things. Shame and problems come after the dream has passed. Thus, it is necessary that the Gnostic student does not become fascinated with anything.

Gnostic students must remember themselves while in the presence of any interesting representation; they need to ask themselves the following questions: "Where am I? What am I doing here? Am I out of my physical body?"

Then, carefully observe everything that surrounds you; with inquisitive eyes look very carefully at the sky and all of the details

of the internal worlds, at the strange colors, at the rare animal, at the beloved shadow of a deceased relative, etc., these will confirm that you are out of your physical body; thus, this is how you will awaken your consciousness. In those moments of reflection and self-remembrance, it becomes very useful to perform a small jump with the intention of floating in the surrounding environment. Thus, logically, if we float it is because we are out of our physical body.

If all those who dream would ask such reflective questions during their dream, then logically, they would awaken their consciousness. If after the death of the physical body, the ego would ask itself such reflective questions while in the presence of any representation, then it would instantaneously awaken. Unfortunately, such reflective questions are never uttered by the ego because during life it does not have the habit of doing so. Therefore, it is necessary to develop this habit and to intensely live it. Thus, only in this way is it possible to have the idea of asking ourselves such reflective questions during ordinary sleep and after death.

Therefore the outcome of this practice is the awakening of our consciousness. Whosoever awakens their consciousness becomes clairvoyant. Whosoever awakens their consciousness lives completely awakened in the superior worlds during the sleep of the physical body.

The great Masters do not dream; they are cognizant citizens of the supersensible worlds. The great Masters work consciously and positively within the superior worlds during the sleep of their physical bodies. Therefore, it is necessary to awaken the consciousness in order not to go there blind. The blind can fall into the abyss. The Arcanum Sixteen is very dangerous.

Memory

The entire memory is found deposited within the subconsciousness. Many initiates work in the internal worlds during ordinary sleep with cognizance; unfortunately, in the physical world they ignore this because they do not have good memory; thus we must learn how to handle the subconsciousness.

In the moments of physically awakening from ordinary sleep, we must command the subconsciousness as follows: "Subconsciousness, inform me of everything that I saw and heard while out of my physical body." Thereafter, practice a retrospective exercise in order to remember everything that you did while out of your physical body. Force your subconsciousness to work, give imperative orders to it in order to oblige it to inform you. Practice this exercise during the slumber state in those moments when you are awakening from your ordinary sleep.

Arcanum 17

Seventeenth Arcanum of the Tarot: the hieroglyphic of this Arcanum is the Radiant Star and the Eternal Youth. A naked woman appears in this Arcanum; over the earth she is pouring the sap of universal life from two jars, one made of gold and the other made of silver. If we carefully study the esoteric context of this Arcanum, we then discover perfect Alchemy. We need to work with the gold and with the silver, with the sun and with the moon so that we can incarnate the Star; this Star has eight points.

Indeed, the star of eight points is Venus. Whosoever attains the Venustic Initiation has the joy of incarnating the Dragon of Wisdom (the Inner Christ), the seventeenth Arcanum is Hope.

The Gnostic student must be very careful with the work of the Laboratorium Oratorium. Since the betrayal of the Sanctuary of Vulcan, the doctrine of Ahriman was spread to many places; this is the doctrine of the Nicholaitans that transform human beings into disgusting sub-lunar demons.

The left-hand adepts paint their doctrine a very beautiful hue filled with ineffable and sublime mysticism. Many are the brethren of the path that have entered this tenebrous path. The basic foundation of the doctrine of the Nicholaitans consists of spilling the Cup of Hermes. These offspring of darkness ejaculate the Ens Seminis during their practices of Sexual Magic. Billions of solar atoms are lost with the ejaculation of the Ens Seminis, which are replaced by billions of atoms from the occult enemy.

After the ejaculation, the creative organs collect these satanic atoms from the atomic infernos of the human being. When such satanic atoms intend to rise through the sympathetic canals to the brain, they are downwardly precipitated by the Three Rays: Father, Son, and Holy Spirit. When these types of tenebrous atoms descend, they violently crash against a master atom of the black lodge that resides in the fundamental chakra of the coccygeal bone. This atomic evil entity then receives a formidable impulse which gives him power to negatively awaken the fiery serpent of our magical powers (the Kundabuffer). In such a case, the fiery serpent descends downward to the atomic infernos of the human being

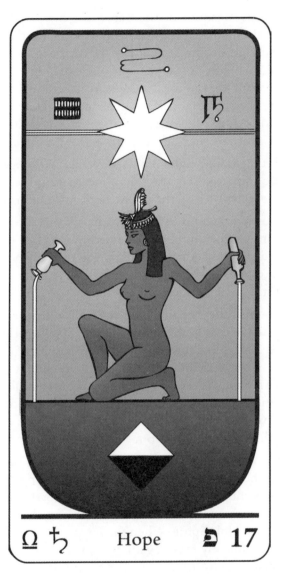

ARCANUM 17

and becomes the Kundabuffer (the tail of Satan). This is how the human being is definitively born in the abyss as a submerged sub-lunar type of demon. Many are the students of the luminous path that have gone astray by this dark path. It is good to remember that the great Masters of the Sanctuary of Vulcan fell under this subtle temptation and were converted into terrible, perverse demons.

The Narrow Door

There are many students of occultism who are convinced that many paths exist in order to reach God. There are some who affirm that three paths exist; there are others who state that seven paths exist, and some others who believe that twelve paths exist. We state that the three, the seven and the twelve are reduced to One, which is sex. We have carefully studied the four Gospels and have not found within any of the four Gospels such an affirmation, which states that there are many ways in order to reach God.

Conclusion, such an affirmation is absolutely false; indeed such an affirmation is a sophism in order to cheat those who are naïve.

Jesus, the chief of the souls, only spoke about one gate and about one strait and difficult narrow path. He never stated that there were many ways to reach God. The great Master Jesus textually stated the following:

> *Strive to enter in at the strait gate: for many, I say unto you, will seek to enter in, and shall not be able. When once the master of the house is risen up, and hath shut to the door, and ye begin to stand without, and to knock at the door, saying, Lord, Lord, open unto us; and he shall answer and say unto you, I know you not whence ye are: Then shall ye begin to say, We have eaten and drunk in thy presence, and thou hast taught in our streets. But he shall say, I tell you, I know you not whence ye are; depart from me, all ye workers of iniquity. There shall be weeping and gnashing of teeth, when ye shall see Abraham, and Isaac, and Jacob, and all the prophets, in the kingdom of God, and you yourselves thrust out.*
> - Luke 13:24-28

Therefore, anyone who states the contrary is a flat-out liar.

Indeed, those who are saved are very few, because few are those who enter through that strait, narrow and difficult door of sex. Another door does not exist; it has never existed and will never exist!

The mechanical evolution of Nature does not save anybody; time does not save anybody. It is necessary to be born again, and this subject matter about birth has been, is, and will always be an absolutely sexual matter. Thus, anyone who wants to be born again has to work with the sap of life that is contained within the two sacred cups that the naked woman of the Seventeenth Arcanum has in her two hands.

The Three Rays

It has been stated unto us that there exist three rays of the realization of the Inner Self. These three rays illuminate only one door and only one path, this is sex. The three rays are: the Mystic, the Yogic, and the Perfect Matrimony. Nevertheless, one does not advance a single step on the Path of the Razor's Edge (Spinal Medulla) without the Arcanum A.Z.F.

Yoga

Yoga has been taught very badly in the Western World. Multitudes of pseudo-sapient yogis have spread the false belief that the true yogi must be an infrasexual (an enemy of sex). Some of these false yogis have never even visited India; they are infrasexual pseudo-yogis.

These ignoramuses believe that they are going to achieve in-depth realization only with the yogic exercises, such as asanas, pranayamas, etc.

Not only do they have such false beliefs, but what is worse is that they propagate them; thus, they misguide many people away from the difficult, straight, and narrow door that leads unto the light.

No authentically initiated yogi from India would ever think that he could achieve the realization of his Inner Self with pranayamas or asanas, etc. Any legitimate yogi from India knows very well that such yogic exercises are only co-assistants that are very useful for their health and for the development of their powers, etc. Only the Westerners and pseudo-yogis have within their minds the belief that they can achieve realization of the Self with such exercises.

Sexual Magic is practiced very secretly within the ashrams of India. Any true yogi initiate from India works with the Arcanum A.Z.F. This is taught by the great yogis from India that have visited the Western world, and if it has not been taught by these great, initiated Hindustani yogis, if it has not been published in their books of yoga, it was in order to avoid scandals. You can be absolutely sure that the yogis who do not practice Sexual Magic will never achieve birth in the Superior Worlds. Thus, whosoever affirms the contrary is a liar, an impostor.

Astrology

In each reincarnation the human being is born under a different star. A wise man stated: "I raise my eyes towards the stars that will come to my rescue; nevertheless, I always guide myself with my Star, which I carry within my Inner Self." Indeed, such a star is always the same; it never changes in any of our reincarnations; this is the Father Star. Thus, what is important for us is to incarnate the Father Star. Behold here the mystery of the Seventeenth Arcanum. When the sap that is contained within the cups of gold and silver is wisely combined and transmuted, it allows us to attain the incarnation of the Star. Christ is the Star, crucified on the cross.

Twilight

ARCANUM 18

Arcanum 18

Now, let us study the Eighteenth Arcanum of Kabbalah. This is the Arcanum of the Twilight. It is necessary for our Gnostic disciples to profoundly reflect on the esoteric context of this Arcanum. We have been strongly criticized for not continuing with the already known Hebraic monotony. Indeed, we do not want to follow the same Hebraic monotony. We, Gnostics, are only interested in that which is called C-O-M-P-R-E-H-E-N-S-I-O-N.

We want our students to comprehend each Arcanum and thereafter develop it within themselves.

First, we want our disciples to discover each Arcanum within themselves, then subsequently within all of Nature. The Eighteenth Arcanum is Light and Darkness, White Magic and Black Magic. On the eighteenth card a dog and a wolf appear, howling at the moon. Two pyramids are found, one black and the other white, as well as the symbol of the scorpion at the bottom.

The number nine is found twice in the Eighteenth Arcanum, 9 plus 9 equals 18. Thus, the Ninth Sphere is repeated twice in this Arcanum. We already know that the number one is positive and that the number two is negative. Therefore, if we repeat the ninth sphere twice, we then have Sex in its two aspects: the first being the positive aspect and the second the negative aspect.

Now our disciples will comprehend why the Eighteenth Arcanum is Light and Darkness, White Magic and Black Magic. The secret enemies of Initiation are found in the Eighteenth Arcanum. Beloved disciples, you must know that the Kundalini rises very slowly through the medullar canal. The ascension of the Kundalini, vertebra by vertebra, is performed very slowly according to the merits of the heart. Each vertebra represents certain virtues. The ascension to a certain vertebra is never acquired without having achieved the conditions of sanctity that are required for such a vertebra, which we long for. Therefore, those who believe that once the Kundalini is awakened, it instantaneously rises to the head in order to leave us totally illuminated, are indeed learned ignoramuses.

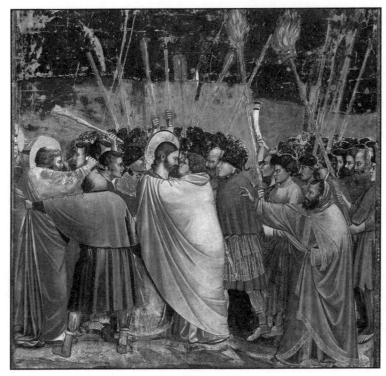

JUDAS BETRAYS HIS MASTER

In the Eighteenth Arcanum, we have to endure bloody battles against the tenebrous ones.

> *Now the kingdom of heaven suffers violence and the*
> *violent take it by force.* - Matthew 11:12

Within the internal worlds, the tenebrous ones of the Eighteenth Arcanum violently assault the student. The devotee must endure terrible battles against these tenebrous ones.

The conquest of each vertebra in the dorsal spine signifies fights to the death against the shadow's adepts. Fortunately, those who work with the Kundalini receive the flaming sword and they defend themselves with it. Sometimes the student, too weary, yet still holding the sword in his hands, achieves the entrance into the temple. Terrible are the efforts that the tenebrous ones exert in order to withdraw the student from the Path of the Razor's Edge. This Path is full of dangers from within and from without.

Many are those who begin, yet few are those who finish. The great majority deviate towards the Black Path; very subtle dangers that the student ignores exist within the Eighteenth Arcanum. The tenebrous gather in their temples in order to count the number of vertebrae conquered by the student. They represent each vertebra with a cup; thus upon the altar they place the same number of cups as the number of vertebrae conquered by the student. Thus, it is on this basis that they judge the neophyte and consider him a thief. The tenebrous ones' thoughts could be formulated as follows: "You have stolen from us these cups. You are stealing powers from us. You are a thief."

The tenebrous never believe themselves to be evil, on the contrary they believe themselves to be wells of sanctity. Therefore, when they attack the student they do it with good intentions because they believe the student to be a thief of powers and that is all.

Indeed, the abyss is filled with sincere but mistaken people; these are people with very good intentions. The number nine is positive and negative at the same time. Now we will explain the mystery of the Eighteenth Arcanum. In this disturbing Arcanum we find all the potions and witchcraft of Thessaly. Here is the cuisine of Conidia; we can read (in the times of Horaccio) how this horrible witch of Rome made all of her potions. The books of the Grimoires are full of tenebrous recipes which are obviously related to the Eighteenth Arcanum, such as erotic magical ceremonies, rites in order to be loved, dangerous potions, etc... All of this is the Eighteenth Arcanum. We must warn the Gnostic students that the most dangerous potion that the tenebrous ones use in order to take the student off of the path of the razor's edge is the intellect.

Bluntly we warn our disciples that out of the billions of people who live in the world, only a small handful of souls (which we could count on our fingers) will be worth the angelic state!

The rest, the great majority, is a lost harvest that will sink into the abyss forever. To become an Angel is very difficult, neither time nor the mechanical evolution of Nature can ever convert the present human being into an Angel, because this is a sexual subject-matter.

Adam-Christ

In order for the Christ to be born within us, it is first necessary for the Buddha to be born in us. When a person has engendered all of his internal vehicles, he then incarnates his Buddha and becomes a Buddha. We warn our students that the Soul is not Christ.

Many Buddhas exist in Asia that still do not have the Christ incarnated. Remember beloved disciples that the resplendent Dragon of Wisdom is beyond any Buddha. The resplendent Dragon of Wisdom is the Inner Christ of every human being that comes into the world. When the resplendent Dragon of Wisdom enters into the Soul, then he is transformed into the soul and the Soul is transformed into him. That which is called the Adam-Christ, the Son of Man is the outcome of this Divine and Human mixture.

Cosmic Christ

It is necessary for our Gnostic disciples to comprehend that the resplendent Dragon of Wisdom (the Inner Christ) of every human being that comes into the world, has no individuality. The latter is the outcome of the "I," and the Christ is not any type of "I." Thus, it is absurd to talk about the "I" Christ, when indeed the Internal Christ does not have any type of "I."

The resplendent Dragon of Wisdom transcends beyond any type of "I" and beyond any individuality. The adorable one is absolutely infinite and impersonal.

Solar Internal Bodies

Indeed, present humans still do not possess their internal vehicles. Present astral, mental and causal vehicles that are used by humans are nothing more than mental formations that we need to disintegrate. Those mental formations constitute the human specter within which the "I" lives.

We need to engender the Solar Internal Vehicles in order to incarnate the Buddha and thereafter, the Christ. This is an absolutely sexual subject-matter.

Renowned Incarnations

Living Buddhas are renowned incarnations. These are the unique cases in which the universal Spirit of Life incarnates and reincarnates; within the rest of the ordinary people, only their values reincorporate, in other words, their "I", their ego, Satan. Indeed, Satan (the ego) only reincorporates in order to satisfy its desires, and that is all. The only reincarnations worthy of admiration are the Living Reincarnations. The Ninth Sphere in its positive aspect brings Living Buddhas into the world; yet, in its negative aspect it only brings memories (egos), specters of personalities that were physically alive and died; this is the fatal wheel. Now, you will comprehend the whole drama of the Eighteenth Arcanum. Positive nine plus negative nine is equal to eighteen.

The Embryo of the Soul

The embryo of soul lives within the specter and reincorporates together with the specter and with the "I." It is necessary to comprehend that the "I" and the embryo of the soul exist within any specter.

We have spoken about this in former lectures, yet it seems that many students have not yet understood this. Thus we clarify that the Embryo of the Soul, which every human has within, is not the Christ, because the Christ is not incarnated within present human beings yet. Only those who reach the Venustic Initiation incarnate the Christ and no one can reach said Initiation without previously having incarnated his Buddha of Perfections.

↗ ♂ Inspiration ק **19**

Arcanum 19

Let us now study the Hieroglyphic of the Nineteenth Arcanum of the Tarot: a radiant sun and two children holding hands.

In the Egyptian Tarot, the hieroglyphic is of a man and a woman, holding with their hands the symbolic Egyptian tau cross. This type of cross is phallic. The Nineteenth Arcanum is the Arcanum of the Alliance.

In the third lecture of our course, we broadly spoke about the Salt, the Sulfur, and the Mercury. Indeed, these are the passive instruments of the Great Work. The Positive Principle is the Interior Magnes of Paracelsus. We need to transmute and thereafter sublimate the sexual energy to the heart. It is impossible to advance in the Great Work without the force of love. The psychological "I" does not know how to love; because the psychological "I" is desire.

It is easy to mistake desire with that which is called love. Desire is a substance that decomposes into thoughts, volitions, sentiments, romances, poetries, tenderness, sweetness, anger, hatred, violence, etc. The poison of desire always cheats people. Those who are in love always swear that they are loving, when in reality they are desiring. Present humans do not know that which is called love; nevertheless, we have within the most recondite parts of our Being a principle that loves. Unfortunately, we do not have this principle incarnated. This principle is the Soul (the Inner Magnes of Paracelsus).

If people would have that soul-principle incarnated, then they could love; only from heart to heart, from Soul to Soul is it possible to love. Unfortunately, people only have Satan incarnated and the latter does not know what love is; Satan only knows about desire, that is all.

Daily we see multitudes of lovers that swear eternal love to each other; yet, after they satisfy their desire (that desire that they believed to be love) disillusionment, along with disenchantment and total disappointment arrives. Desire is a great swindler.

Whosoever wants to work in the Great Work has to annihilate desire. It is necessary to know how to love. Love has its peculiar

happiness and its infinite beauty. People do not know that which is called love. Love is similar to the sentiments shown by a new born baby. Love forgives everything, gives everything, it does not demand anything, it does not ask for anything, it only wants the best for the one that loves and that is all. The true sentiment of love is perfect and Satan knows nothing of perfection, because Satan is desire.

If you want to love, be prudent; do not confuse love with desire. Do not allow yourself to be cheated by desire, the great swindler.

You have an embryo of a soul within and this can love. Indeed, this is an embryonic love because it is an embryo of Soul; yet if you annihilate desire you will feel that spark of love. When you learn how to feel that spark, then that spark will become a flame and you will experience that which is called love. Therefore, strengthen your embryo of soul with the blessed flame of love, and then you will achieve the miracle of your incarnation. It is necessary for you to be integral and that is only possible by loving.

In the Nineteenth Arcanum, a great Alliance is established between two souls. Man and woman must kill desire in order to achieve the great Alliance. If you want to incarnate your soul, you must then celebrate the great Alliance of the Nineteenth Arcanum.

Reflect a little; until now you are just a living specter, a sleeping specter. You wretched specter sleep during the slumber of your physical body and after your death, asleep you escape from the graveyard or cemetery... Miserable specter! Wretched soulless creature! Reflect and meditate. You must celebrate the great Alliance of the Nineteenth Arcanum so that you can incarnate your soul and thus truly BE, because you, wretched creature, are not being yet. You are dreams; you die without knowing why and are born without knowing why. Only the blessed flame of love can make you truly exist because you do not have a true existence yet.

Only with the Arcanum A.Z.F. can you engender your Christic Vehicles. Your Inner Buddha will be dressed with those vehicles first, thereafter your Inner Christ. This is how you will become integral; you need to become integral. Remember, good disciple, that now you are nothing but a sleeping specter and that your present internal vehicles are only mental formations that you must

FROM *ATALANTA FUGIENS* BY M. MAIER, 1618

disintegrate, reduce to cosmic dust. Be patient in the Great Work. If you want to incarnate your Inner Christ, then you must be sour like the lemon: be displeased, kill not only desire, but even the very shadow of desire. Be perfect in thought, word and deed; be pure... pure... pure..!

The Philosophical Stone

Sex is represented by the Philosophical Stone; this is the Heliogabalus Stone. The Elixir of Long Life cannot be acquired without this stone. The two columns of the temple, Jachin and Boaz, are the man and the woman who are in alliance in order to work with the Philosophical Stone. Whosoever finds the Philosophical Stone is transformed into a God.

The Great Tempter

The psychological "I" is the great tempter. The "I" hates Sexual Magic because the "I" wants the complete satisfaction of desire. The "I" is the one who thinks and searches whereas the Being does not need to think or search. When we are working in the Great Work, the "I" does not feel secure; thus, it searches for that which is called security. The students of the luminous path always fall into the abyss of perdition when searching for security. Therefore, do not allow yourself to be seduced by the great tempter. When the mind goes around searching for something, when the mind is searching for security, when the mind is looking for end results, it is because we are not prepared for the Great Work. Satan always goes around hunting for something; thus do not allow your mind to be poisoned by Satan. Do not waste your mental energy torpidly.

You waste your mental energy with the battle of reasoning; remember that your "I" is the one who reasons, whereas your soul does not need to reason. It is painful to see the specters of death reasoning about problems that do not exist. Sleeping specters are worthy of pity. Indeed, the "I" is the one who reasons.

Love

When the mind does not search anymore, when the mind does not search for refuge, when the mind does not go around coveting more books or knowledge, when the mind ignores the memories of desire, then only that which is called love will remain within us. How great it is to love! Only the great souls can and know how to love.



Arcanum 20

Let us now profoundly concentrate on the study of the Twentieth Arcanum of the Tarot. The Hieroglyphics of this Arcanum are related to Judgment. As the Angel is playing the trumpet the dead are escaping from the graveyard. In this Arcanum a man, a woman and a child are resuscitating. This is a marvelous ternary.

When studying this Arcanum, we must not continue with the old Hebraic monotony; it is necessary for us to judiciously concentrate on the problem of resurrection if what we truly want is to be Resurrected Masters.

Questions: How do we reach resurrection? How do we do not reach Resurrection? How do we triumph? How do we fail?

Answers: We reach resurrection by working with the Arcanum A.Z.F., without spilling the Cup of Hermes. We do not reach resurrection by spilling the Cup of Hermes. When covetousness does not exist within us, we triumph; however, when covetousness exists within us, we fail.

Concrete explanation: there exist two types of covetousness-the first type of covetousness is for money. The second type of covetousness is for psychic powers. Covetousness for money exists when we long for it for psychological purposes and not in order to acceptably take care of our physical necessities. Many people want money in order to gain social prestige, fame, high positions, etc. Covetousness for money does not exist when we get it with the sole purpose of taking care of our physical necessities. Thus, it is necessary to discover where necessity ends and where covetousness begins.

Covetousness for psychic powers exists when we want end results. Those who only want end results are covetous. Those who go around here and there accumulating theories, searching for powers, which today are in this school and tomorrow are in another, are in fact, bottled up within covetousness.

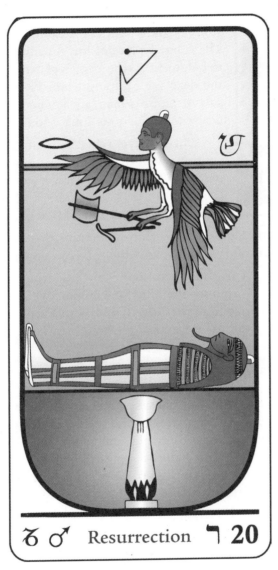

ARCANUM 20

The mind that is bottled up within covetousness is unstable. It goes from lodge to lodge, from school to school, from sect to sect, always suffering, always longing for powers, light, wisdom, illumination, etc., without ever achieving anything since what is unstable can never comprehend that which is stable, permanent and divine. Only God comprehends himself, thus the mind bottled up within the bottle of covetousness is incapable of comprehending the things that are not within the bottle.

Covetous people want to bottle up God. This is why they go around from school to school, always searching, always uselessly longing, because God cannot be bottled up by anybody.

Therefore, whosoever wants to work in the Great Work must first abandon covetousness. The stonemason, who is covetous, abandons the Great Work when he finds other work (even when the latter is indeed of darkness). Covetous people withdraw themselves from the Great Work. Many are they who start the work, yet few are those who finish it. The Resurrected Masters can be counted on the fingers of the hands.

Fatality

We knew the case of Geronimo (who was a disciple of Cagliostro) who worked in the Great Work. This man acquired degrees, powers, initiations, tunics, capes, shrouds of distinction, a sword, etc.; thus, the progress of Geronimo was worthy of admiration.

Everything went very well until the day he had the weak misfortune of revealing his intimate secret matters to an occultist friend. This friend was horrified by the fact of not ejaculating the Ens Seminis and considered Geronimo a barbarian. Thus, he advised Geronimo to ejaculate the Cup of Hermes; he instructed Geronimo, telling him that in the supreme moment of orgasm, he must mentally assume an edifying and essentially dignified manner and thereafter, he said, "very saintly spill the Cup of Hermes, and this is how one must work in the Great Work" (this is truly absurd logic).

Thus, the disciple of Count Cagliostro, Geronimo (who indeed was not a strong man as was Cagliostro, the great Coptic) allowed

himself to be convinced by the reason of absurdity and he spilled the sacred cup. Thus this is how he successively lost his shroud and sword, scepter and crown, tunics and degrees. This was the fatality. Geronimo was fulminated by the terrific ray of Cosmic Justice of the Sixteenth Arcanum.

Three Types of Resurrection

Thus, as three basic types of energy exist: Masculine, Feminine and Neutral, likewise, three types of Resurrection exist. The first is the Initiatic Spiritual Resurrection. The second is the Resurrection with the body of Liberation. The third is the Resurrection with the Physical Body. No one can pass through the second or through the third type of resurrection without having previously passed through the first, the Spiritual Resurrection.

SPIRITUAL RESURRECTION

Spiritual Resurrection is achieved only with Initiation. We must first resurrect spiritually in the fire and thereafter in the light.

RESURRECTION WITH THE BODY OF LIBERATION

The Resurrection with the body of liberation is achieved in the Superior Worlds. The Body of Liberation is organized with the best atoms of the physical body. This is a body of flesh that does not come from Adam; it is a body filled with indescribable beauty. The adepts can enter into the physical world and work in it with this Paradisiacal Body which they make visible and tangible by will.

RESURRECTION WITH THE PHYSICAL BODY

On the third day after his death, the adept comes (in his Astral Body) to the sepulcher, where his physical body lies. The Master invokes his physical body and it obeys (by taking advantage of hyperspace and escapes from the sepulcher). This is how the sepulcher remains empty and the shroud left lying there. The body resurrects within the superior worlds. In the supersensible

worlds, in Hyperspace, holy women treat the body of the initiate with perfumes and aromatic ointments. Then, by obeying superior orders, the physical body penetrates within the Master-Soul, through the top of his sidereal head. This is how the Master once again possesses his physical body. It is necessary to emphasize that in this type of resurrection, the physical body submerges itself within the supersensible worlds. When a Resurrected Master (whose body was within the holy sepulcher for three days) wants to enter into the physical world, he then exercises his willpower and can appear and disappear instantaneously, wherever he wants by will.

Jesus the Christ is a Resurrected Master that for three days had his physical body in the holy sepulcher. After the Resurrection, Jesus appeared before the disciples (who were on their way to the village of Emmaus) and dined with them. After this, he was before the eleven apostles and before the unbelieving Thomas, who only believed when he put his fingers in the wounds of the holy body of the great Master.

Hermes, Cagliostro, Paracelsus, Nicholas Flamel, Quetzalcoatl, St. Germain, Babaji, etc., preserved their physical body for thousands, and even millions of years, without death harming them. They are Resurrected Masters.

Elixir of Long Life

Only with the Arcanum A.Z.F. can the Elixir of Long Life be produced. Resurrection is impossible without the Elixir of Long Life.

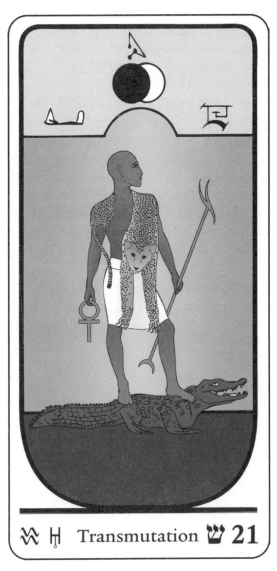

Transmutation 21

ARCANUM 21

Arcanum 21

Let us now study the Twenty-first Arcanum of the Tarot. The hieroglyphic of this Arcanum is the Fool.

THE FOOL

When examining this Arcanum, we perceive a wretched Fool with a shoulder bag on a stick (within which he carries all of his absurdities and vices) and who as a rootless wanderer goes wandering aimlessly with no course or objective. His clothes in disarray leave his sexual organs exposed and a tiger cat, which is following him, bites him incessantly and he does not try to defend himself. So, sensitivity is found represented in this Arcanum: the flesh, the material life.

We can also represent this Arcanum with the inverted flaming star. Every initiate that allows himself to fall is indeed the Fool of the Tarot. As a matter of fact, when the alchemist spills the Cup of Hermes, he is converted into the Fool of the Tarot.

It is necessary to annihilate desire if we want to avoid the danger of falling. Many Masters who swallowed soil (many Resurrected Masters) fell and converted themselves into the Fool of the Twenty-first Arcanum of the Tarot. It is enough to remember Zanoni during the French Revolution; he was a Resurrected Master and nonetheless he allowed himself to fall by falling in love with a female chorister from Naples. Zanoni died by the guillotine after having lived with the same physical body for thousands of years.

Whosoever wants to annihilate desire must discover its causes. The causes of desire are found in sensations. We live in a world of sensations and we need to comprehend them.

There are five types of sensations:

1. Visual sensations
2. Auditory sensations
3. Smell sensations
4. Taste sensations

5. Touch sensations

The five special types of sensations transform themselves into desire. Therefore, the causes of desire are found within the sensations.

We must not condemn the sensations, nor must we justify them. We need to profoundly comprehend them.

A pornographic image strikes the senses and then passes to the mind. The outcome of this perception is a sexual sensation that is soon transformed into animal desire. After passing through the sense of hearing and through the cerebral center of sensations, a vulgar morbid type of song is converted into sexual desire. We see a luxurious car, we sense it and thereafter we desire it.

We taste a delicious cup of liqueur, we perceive its odor with our sense of smell and feel its delicious sensations and thereafter we desire to drink more and more until we become inebriated. Thus, smell and taste turn us into gluttons and drunkards.

The sense of touch places itself under the service of all of our desires; thus this is how the "I" receives pleasure from amidst the vices and wanders like the Fool of the Tarot from life to life with his bag (within which he carries all of his vices and absurdities) on his shoulders.

Whosoever wants to annihilate desire, first of all, needs to intellectually analyze the sensations and thereafter profoundly comprehend them. It is impossible to profoundly comprehend the contextual concept enclosed within a sensation with the mere intellect, since the intellect is just a small fraction of the mind.

Therefore, if we want to comprehend the entire substantial context of a certain sensation (of any type) we then indispensably need the technique of internal meditation, because it is urgent to profoundly comprehend the "I" in all of the levels of the mind.

The mind has many layers, subconscious and unconscious levels which are normally unknown to humans. Many individuals, who have achieved absolute chastity here in the physical world, become terrible fornicators in other levels and profundities of the mind when they are submitted to difficult ordeals in the internal worlds. Great anchorites and hermit saints discovered with horror that the Fool of the Tarot continued alive in other more profound

levels of their understanding. Indeed, only by comprehending the sensations in all the creases of the mind can we annihilate desire and kill the Fool of the Tarot (who hides himself within all of those creases of our mind).

It is necessary for our students to learn how to see and hear without translating.

When a man perceives the beautiful figure of a woman and commits the error of translating that perception into the language of his sexual desires, then the outcome is sexual desire; this type of desire, even when it is forgotten, continues living internally in other unconscious levels of the mind. Thus, this is how the "I" incessantly fornicates in the internal worlds. Therefore, it is important to learn how to see without translating, to see without judging. It is indispensable to see, hear, taste, smell and touch with creative comprehension. Thus, just like this, we can annihilate the causes of desire. Indeed the tree of desire has roots that we must study and profoundly comprehend.

Upright perception and creative comprehension annihilate the causes of desire; this is how the mind escapes from the bottle of desire and is elevated unto the superior worlds, then the awakening of the consciousness arrives.

Normally, the mind is found bottled up within the bottle of desire; thus, it is indispensable to take the mind out of the bottle if indeed what we want is the awakening of the consciousness. To awaken the consciousness is impossible without taking the mind out of its bottled up condition.

We constantly hear complaints from many students who suffer because during the slumber of their physical bodies they live unconscious within the superior worlds. Many of them have performed many esoteric practices in order to achieve Astral projection, yet they do not succeed. When we study the life of these whiners, we discover within them the Fool of the Tarot; these people are full of desires.

We kill desire only by comprehending sensations. Only by annihilating desire can the mind that is normally bottled up within desire be liberated. The awakening of the consciousness is produced only by liberating the mind from desire.

The Fool of the Tarot is the psychological "I", "the myself," the reincorporating ego.

If we want to end the causes of desire, then we need to live in a state of constant vigilance. It is urgent to live in a state of alert perception, alert novelty. The "I" is a great book, a book of many volumes and only by means of the technique of internal meditation can we study this book.

When we discover and profoundly comprehend a defect in all of the levels of the mind, then it is completely disintegrated. Each time a defect is disintegrated, something new occupies its place: an esoteric password, a mantra, a cosmic initiation, an esoteric degree, a secret power, etc.

Thus, this is how, little by little, we fill ourselves with true Wisdom.

The Kabbalistic addition of this Arcanum gives us the following outcome: 2 + 1 = 3. One is the Father (Kether), Two is the Son (Chokmah), Three is the Holy Spirit (Binah): they are the resplendent Dragon of Wisdom within any human being that comes into the world. Anyone who achieves the dissolution of the psychological "I" (the Fool of the Tarot) incarnates his resplendent Dragon of Wisdom. Whosoever incarnates his resplendent Dragon of Wisdom becomes a Spirit of Wisdom.

Speak not in the ears of a fool: for he will despise the wisdom of thy words. - Proverbs 23: 9

Coexistence

It is not by isolating ourselves from our fellowmen that we will discover our defects. It is only by means of coexistence that we self-discover ourselves; thus by means of coexisting with others, we surprisingly discover our defects because they flourish and spring forth from within and emerge to the external world by means of our human personality. Thus, in social coexistence, Self-discovery and Self-revelation exist.

When we discover a defect, we must first intellectually analyze it and thereafter comprehend it in all of the inner layers of the mind, by means of the technique of meditation.

It is necessary to focus on the discovered defect and meditate on it with the intension of comprehending it profoundly.

Meditation must be combined with the slumber state; thus, this is how, by means of profound vision, we become cognizant of the defect that we are trying to comprehend. Thus once the defect is dissolved, "something new" arrives to us. It is necessary to be in a state of alert perception and alert novelty during Internal meditation.

In order to receive that "something new," a defect must be replaced by it; a defect must be substituted for it. Thus, this is how the human being becomes truly wise; this is the path of wisdom.

Intuition

While we are dissolving the Fool of the Twenty-first Arcanum of the Tarot, intuition is being developed within; intuition is the flower of intelligence. Intuition and comprehension replace reasoning and desire, since these are attributes of the "I." Intuition allows us to penetrate into the past, into the present and into the future. Intuition allows us to penetrate into the deep meaning of all things.

Intuition grants us entrance into the world of the ineffable Gods; any intuitive initiate converts himself into a true prophet.

Practice for the Development of Intuition

It is urgent for the devotee of the Path of the Razor's Edge to intensify the development of intuition. This faculty resides in the coronary chakra; this chakra shines upon the pineal gland, which is the seat of the soul, the third eye. Modern scientists believe that they know more than the ancient sages from the ancient school of mysteries; thus, they deny all of these esoteric matters related with the pineal gland and take it only to the purely physiological side (with this, pretending to strike the faces of the great hierophants with a white glove). Notwithstanding, the ancient sages from old times never ignore that the pineal gland is a small, reddish-gray cone-shaped tissue located in the posterior part of the brain. The

old sages knew very well that the hormone that is secreted by this gland is intimately related with the development of the sexual organs and that after maturity, this gland degenerates into fibered tissues that no longer secrete such a hormone, and then impotence arrives. An exception exists in this process and this is known only by the Gnostics.

Gnostics preserve the activity of their pineal gland and its sexual, functional secretion remains active by means of Sexual Magic throughout their entire life. The pineal gland is the center of the intuitive polyvoyance. Intuition manifests within the heart as presentments; yet, in the pineal gland such presentments are converted into intuitive images.

It is urgent for our devotees to practice the powerful mantra of intuition; this mantra is the following: TRIIIINNNNN... prolong the sound of the vowel "I" and of the consonant "N," it sounds like a bell. [EDITOR: PRONOUNCED AS THE "EE" IN "TREE."]

The student submerged within a perfect meditation with his/her mind in blank, must be inundated by the silence, and then must mentally vocalize the former sacred mantra. This mantra can be chanted as many times as one wishes to do so. After about ten minutes of vocalization, the student must cease vocalizing the mantra and continue with the mind in blank for an indefinite period of time. When the great Silence is inundating us, then the experience of the great Reality comes to us.

Arcanum 22

Let us now study the Twenty-second Arcanum of Kabbalah. This Arcanum is the Crown of Life.

Revelation 2:10 states:

> Be thou faithful unto death, and I will give thee a crown of life.

To find faithful people in these studies is difficult. All those who enter into Gnosis want to develop occult powers immediately; this is grave. People believe that the path of the realization of the Inner Self is like playing football or like playing tennis. People have still not learned how to be serious. Commonly, people enter into these studies with the longing of acquiring powers within a few months. However, when they realize that they need patience and hard work, they then desperately leave in search of another school. Thus, this is how they waste their life away, fleeing from one school to the next, from one lodge to another, from institution to institution until they get old and die without ever having achieved anything. Thus, this is how humanity is. One can count those who are truly serious and truly prepared for the practical Adepthood, on the fingers of the hands.

Beloved disciples, you need to develop each of the twenty-two major Arcana of the Tarot within yourselves. You are *imitatus*, or rather, one who others have put on the Path of the Razor's Edge. Exert yourself to become *Adeptus*, one who is the product of one's own deeds, the one that conquers science by his own, the child of one's own work.

Primeval Gnosis teaches three steps through which anyone who works in the flaming forge of Vulcan has to pass. These steps are as follows:

1. Purification
2. Illumination
3. Perfection

It so happens that curious people who enter into our Gnostic studies want immediate illumination, astral projection,

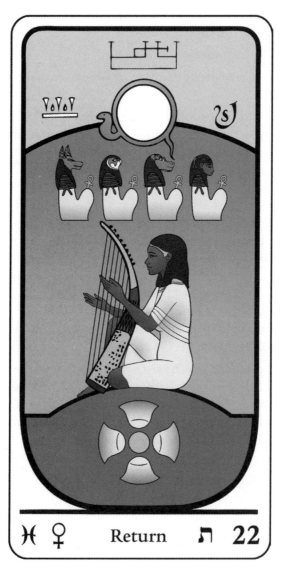

Arcanum 22

clairvoyance, practical magic, etc., and when they do not achieve this, they immediately leave.

No one can achieve illumination without having been previously purified. Only those that have achieved purification and sanctity can enter into the hall of illumination. There are also many students that enter into our studies purely out of curiosity. They want to be wise immediately. Paul of Tarsus stated:

> *We speak wisdom among them that are perfect.*
> - 1 Corinthians 2:6

Therefore, only those who achieve the third step are perfect. Only among them can divine wisdom be spoken of.

In the ancient Egypt of the Pharaohs, among the occult Masons, the three steps of the path were:

1. Apprentice
2. Companion
3. Master

Candidates remained in the degree of apprentice for seven years, and sometimes longer. Only when the hierophants were completely sure of the purification and sanctity of those candidates could they then pass them to the second step.

The first faculty that the candidate develops is the one related with the degree of listener, the faculty of clairaudience (occult hearing). Indeed, illumination begins only after seven years of apprenticeship. Nevertheless, students believe that spiritual faculties are going to be immediately developed, and when they realize that this subject matter is serious, they flee. This is the sad reality; this is why in life it is very rare to find someone who is prepared for Adepthood.

The Crown of Life

The Innermost is not the Crown of Life. The Crown of Life has three profundities and these are beyond the Innermost. The Crown of Life is our resplendent Dragon of Wisdom, our Inner Christ.

The Three Profundities

The first profundity is the origin of life, the second is the origin of the word, and the third is the origin of the sexual force. These three profundities of the resplendent Dragon of Wisdom are beyond the Innermost. The Innermost must be searched for within the unknowable profundities of oneself.

The Number 22

The three profundities of the resplendent Dragon of Wisdom emanated from a mathematical point, this is the Ain Soph, the interior Atomic Star that has always smiled upon us. The Holy Trinity emanated from this Inner Star; the three profundities will return, they will fuse together again with this Inner Star.

The number 22 is Kabbalistically added as follows: 2 + 2 = 4

The Holy Three emanates from the Inner Star, thus, the Holy Trinity plus its Inner Star is the Holy Four, the mysterious Tetragrammaton, which is Iod-Hei-Vav-Hei. Now we comprehend why the Twenty-second Arcanum is the Crown of Life.

TETRAGRAMMATON

Be thou faithful unto death, and I will give thee a crown of life. - Revelation 2:10

Blessed by the one who incarnates the Spirit of Wisdom (Chokmah); those Buddhas who do not renounce Nirvana can never incarnate the Cosmic Christ, who is beyond the Inner Buddha. Our Inner Buddha has to seek the Cosmic Christ within its own unknowable profundities. The Cosmic Christ is the Glorian, the incessant eternal breath profoundly unknowable to itself, the ray that joins us to the Abstract Absolute Space.

Hieroglyph

Hieroglyphics of this Arcanum: the Crown of Life is amidst the four mysterious animals of Sexual Alchemy. In the middle of the Crown, Truth is represented as a naked woman who has a little stick in each hand (the priest and the priestess); this is Sexual Alchemy. We can incarnate the Truth only by working in the flaming forge of Vulcan

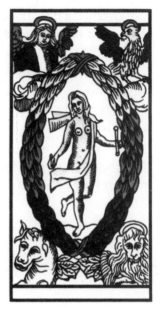

The Ark of Alliance

The Ark of Alliance had four Cherubim (two at each end); with the tip of their wings they touched each other and were found in the sexual position (a man and woman copulating). The (Iod) blossoming staff of Aaron, the (Hei) Cup or Omer containing the Manna, the Two Tablets of the Law, were within the Ark; these elements are four, as four is the outcome of the addition of 22 (2+2=4).

The Internal Lodge

The first duty of any Gnostic is to be sure that the lodge is protected. During the degree of Apprentice, the attention is focused on the Astral Plane. Thus, the inner lodge must be protected; the Astral Body must be clean from any type of animal passions and desire. In the second degree, the Mental Lodge must be protected. Thus, worldly thoughts must be cast out of the temple. It is necessary to protect the inner lodge very well so that doctrines, people, demons, etc. do not penetrate inside the inner sanctuary and thus sabotage the Great Work.

We have witnessed (apparently very serious) students who became careless, who did not know how to protect their inner lodge, and were thus invaded by people and strange doctrines. Most of the

time, these careless students continued their work in the flaming forge of Vulcan, but they combined it with very different methods and systems. Thus, the outcome of all of this was a true Tower of Babel, a barbaric confusion whose only purpose was to bring disorder into the inner lodge of their consciousness.

Therefore, it is necessary to have the inner lodge, the authentic school of inner education, in perfect order. We are absolutely sure that only one door and only one way exist: sex. Thus, anything that is not through this way is just a miserable waste of time.

We are not against any religion, school, sect, order, etc. Nonetheless, we firmly know that inside our individual inner lodge we must have order, so that we avoid confusion and error.

We have accomplished this charge and feel satisfaction, since we have served humanity and ourselves.

To present a work of such magnitude, encourages us and prepares us for new services.

Humanity has never liked the doctrine of the Gnostics.

Hence, the substantial content of this work is for a more advanced humanity, because the people of this barbaric epoch are not capable of understanding these things.

We hope that you, friend, as a good reader, know how to find the happiness, joy, and peace that we want for all beings within this treasure that you now hold in your hands. If however, you despise it, it is because you cannot find anything that entices you within it; but do not be selfish, think about the one who is next to you that might need it and give the book to them.

May your Father who is in secret and may your Divine Mother Kundalini bless you.

<div align="right">Samael Aun Weor</div>

Index

Aaannn Rrraaa 48
Aaron 145
Abdomen 55
Abel 67
Abiff 37
Abortion 63
Abraham 115
Abraxas 38
Absolute 4, 13, 48, 81, 103-104, 136, 144
Absorb 103
Absorbed 70
Abstinence 46
Abstract 13, 144
Abstract Absolute Space 13, 144
Abundance 28
Abuse 64
Abyss 33, 39, 52, 62-63, 67, 71, 107-109, 111, 115, 121, 128
Abysses 4
Accident 102
Accumulate 75
Accumulating 129
Acheron 10
Acquire 34, 46, 69, 81-82
Acquired 89, 119, 127, 131
Acquires 86
Acquiring 34, 141
Acrobatic 46
Acrostic 43, 45
Act 16, 53, 66
Action 61, 69
Actions 101-102
Active 40, 76, 140
Activities 13, 77, 102, 104
Activity 101, 140
Acts 103
Adam 5, 59, 61-63, 66-67, 69, 104, 132
Adam-Christ 59, 61, 65-66, 69, 81, 122
Adept 55, 86, 132
Adepthood 141, 143
Adepts 113, 120, 132
Adeptus 141
Adonia 14, 61
Adultery 63-64, 103

Adulthood 70
Aerial 29
Aeternae 43
Affections 102
Affinity 103
Ages 61
Agriculturalist 51
Ahamsara 90
Ahriman 113
Ain 13-15, 71, 96, 144
Ain Soph 13-15, 71, 96, 144
Air 19, 21, 25, 27-29, 31, 40, 56, 94-95
Akasha 56
Aklaiva, Bhagavan 10
Alchemical Retort 87-89
Alchemical Weddings 39, 96
Alchemical Womb 43
Alchemist 22, 27-28, 31, 38-40, 45, 52, 61, 66, 75, 78-79, 86, 95, 99, 135
Alchemists 14, 29, 31, 46, 83, 94
Alchemy 4, 13-15, 21, 25, 27, 31, 38-41, 45, 47-48, 51-52, 59, 75-76, 79, 81, 87, 105, 113, 145
Alcohol 21, 28, 53
Aleph 19, 22
Alert 64, 138-139
Alive 56, 123, 137
Alkaest 22
Allegory 51
Alliance 125-127, 145
Alloy 89
Almighty 37
Alphabet 21
Altar 23, 121
Altars 14, 101
Altruism 47
Amalgamation 79, 81
Amen 30, 49
America 76
Amphiteatrum Sapientiae Aeternae 43
Amphorae 4
Analogies 61
Analysis 107

Analyze 67, 83, 136, 138
Anchorites 64, 136
Ancient of Days 71
Androgynous 94
Angel 35, 42, 51, 93, 121, 129
Angelic 121
Angelical 108
Angels 5, 35, 38, 89, 107
Anger 47, 125
Animal 19, 28, 40, 55, 62, 75, 104, 108, 111, 136, 145
Animal Soul 19
Animals 27, 104, 145
Annihilate 81, 125-126, 135-137
Annihilated 105
Annihilating 137
Annihilation 79
Anra 48
Antares 70
Anteros 67
Antithesis 67, 70-71
Anubhava 17
Apocalypse 37, 42, 51-52, 55
Apollonius 4-5, 66
Apostles 64, 98, 133
Appear 39, 91, 94, 119, 133
Appearance 104
Appearances 41
Appeared 133
Appears 9, 11, 15, 22, 31, 35, 45, 55, 59, 63, 67, 89, 93, 113
Appetencies 69
Apple 47
Apprentice 143, 145
Apprenticeship 143
Apuleyus 96
Aqua 15, 19
Aquas 29-30
Arcades 5
Arcana 7, 141
Arcanum A. Z. F. 10, 14-15, 19, 21-22, 38, 43, 46-47, 57, 64, 76-77, 95, 99, 108-109, 116-117, 126, 129, 133
Archaeous 65
Archaic 27, 98
Archers 51
Archetype 63

Aries 3
Ark 145
Arm 9
Armor 47
Arms 15, 33, 49, 97, 107
Aroma 23
Aromatic 90, 133
Arrogance 73, 107
Art 23, 34, 49
Aryavarta Ashrama 77
Asana 49
Asanas 116-117
Ascend 5, 11, 14, 27, 29, 53
Ascending 52
Ascendit 30
Ascension 61, 73, 96, 119
Ashamed 109
Ashes 61, 83
Ashrams 117
Asia 76, 122
Asleep 9, 49, 83, 97, 109-110, 126
Ass 96
Assyrian 105
Astarte 76
Astral 4-5, 9-10, 15, 21, 27, 37, 40, 49, 66, 71, 78-79, 89-90, 95, 98, 103-104, 107-108, 122, 132, 137, 143, 145
Astral Body 10, 21, 37, 49, 66, 71, 78, 90, 95, 98, 104, 132, 145
Astral Body of Christ 98
Astral Plane 4, 9, 27, 145
Astral-Christ 86, 89, 95, 107, 108
Astrologer 21
Astrologers 77
Astrology 4, 40, 117
Astronomical 70
Astute Man 101
Asura Samphata 52
Atalanta 47, 127
Athanor 31
Atlantean 10
Atlantis 98
Atman 3
Atom 13, 63, 71, 113
Atomic 9, 19, 52, 63-64, 69, 72, 103, 113, 144
Atomic Star 144

Atomic Weight Table 72
Atoms 10-11, 14, 52-53, 67, 69, 98, 113, 132
Attention 145
Attire 79
Attracting 48
Attraction 103
Attributes 139
Auditory 135
Augias 15, 62
AUM 25
Aun 6-7, 147
Avarice 47
Avaricious 69
Avatars 65
Awake 77, 83, 109
Awaken 5, 9-10, 52-53, 78, 83, 109, 111, 113, 137
Awakened 83, 108, 111, 119
Awakening 5, 21, 52, 73, 81, 109-112, 137
Awakens 11, 14, 53, 111
Aware 4-5
Axis 76
Azoth 19, 25
Baal 76
Babaji 46, 90, 133
Babel 107-108, 146
Baby 126
Bachelor 17
Bachelorettes 17
Balances 57
Bald 63
Balm 14
Bandit 79
Baphomet 4, 99, 104-105
Baptist 5, 69
Barbarian 131
Barbaric 146-147
Bars 110
Basil Valentine 19, 50-51, 58, 82
Basilica Chymica 20
Basilisks 21
Battle 37, 67, 128
Battles 120
Beak 48
Bear 43, 69
Beast 37

Bed 16, 110
Beds 83
Being 3-4, 13, 15-16, 19, 27, 33-35, 37-38, 52, 57, 61, 65-66, 69, 71-73, 77, 79, 82-83, 85, 87, 90, 93-94, 96, 101-104, 107, 109, 113, 115, 117, 119, 121-122, 125-126, 128, 138-139
Beings 1, 5, 17, 41, 63, 86, 89-91, 107, 109, 113, 123, 147
Bel 76
Belief 116-117
Believe 52, 64, 83, 97, 107-108, 115-116, 119, 121, 139, 141, 143
Believed 125, 133
Believes 85
Bell 140
Bellow 30
Belly 78
Benedictine of Erfurt 19
Bestial 102-103
Bestially 55
Betrayal 113
Betrays 120
Bhagavan Aklaiva 10
Bible 37
Binah 3, 37, 71, 138
Binary 13
Bioelectromagnetic 40
Biorhythm 70
Bipolarized 53
Bird 31, 61, 77-78, 83
Birth 3, 46, 59, 95, 116-117
Bitter 34
Black 1, 4, 21, 37-38, 46, 52, 59, 67, 81, 101, 113, 119, 121
Black Dragon 37-38
Black Magic 21, 52, 67, 119
Black Magicians 1, 4
Black Path 121
Black Sexual Magic 52
Black Tantrism 52, 81
Blackened 51
Blackening 86
Blacksmiths 110
Blavatsky, H.P. 46, 69
Bless 147
Blessed 14, 23, 48, 126, 144

Blind 46, 103, 109, 111
Bliss 5
Blood 6, 52, 65, 98
Bloom 16
Blooms 21-22
Blossoming 145
Blue 13-14, 16
Blue Balm 14
Boast 73
Boasting 34
Boasts 34
Boaz 127
Bodhisattva 5, 34, 41
Bodhisattvas 6, 33-34, 41
Bodies 26-27, 35, 71, 79, 83, 86-87, 90,
 94, 98, 108-109, 111, 122, 137
Body of Gold 89
Body of Liberation 132
Body of Willpower 37
Boils 87
Bomb 69
Bone 11, 113
Book 15, 25, 41, 138, 147
Books 117, 121, 128
Born 19, 22, 59, 61, 65-66, 69-70, 73,
 77, 81, 86, 95-96, 108, 115-117,
 122, 126
Bosom 14
Bottle 131, 137
Bottled 129, 131, 137
Brahma 51
Brahmacharya 46
Brahmanism 10
Brahmans 10
Brain 11, 14, 28-29, 33, 62, 96, 113, 140
Branches 10, 79
Brass 38, 41, 53, 67
Bread 49, 98
Breaking 107
Breast 3
Breath 95-96, 144
Breathing 23
Bride 63
Buddha 6, 62, 65, 71, 122-123, 126,
 144
Buddha Gautama 6
Buddha of Perfections 123
Buddhas 6, 122-123, 144

Buddhic 3
Buddhist 76
Buddhist White Tantrism 76
Bull 27-28, 30, 51, 105
Burning 34
Burns 21-22, 81
Business 5
Butterflies 89
Butterfly 86
Cabala 28
Caduceus 10, 38, 43, 48, 53, 99
Cagliostro 91, 131, 133
Cain 67
Calf 105
Canal 14-15, 19, 25, 28, 38, 53, 119
Canals 14, 96, 113
Candle 29
Candles 101
Candlesticks 10-11, 52
Cane 14
Capes 131
Car 102, 136
Carcass 95
Cardiac 9
Care 129
Careful 113
Carefully 59, 72, 102, 110, 113, 115
Careless 145-146
Caresses 82
Carnal 55
Cat 135
Cauldron 21
Causal 4, 37, 71, 89, 95-96, 103, 107,
 122
Causal Body 4, 37, 95-96
Causal World 71, 107
Cause 109
Causes 103, 135-138
Cemetery 126
Center 9, 25, 31, 37-38, 45, 56, 63, 71,
 93-94, 102, 136, 140
Centers 40, 55, 79, 93, 101, 104, 107-
 108
Centuries 67, 69-70
Century 88
Cerebral 136
Ceremonies 121
Ceremony 27, 55, 98

Cervical 77
Ch 62
Chain 77-78
Chair 29, 78, 97
Chakra 16, 28, 38, 72, 77-78, 95-96, 113, 139
Chakras 48, 55-56, 77, 79, 104, 108-109
Chalice 11, 43, 96, 98
Cham-Gam 31, 63
Chamber 86
Chance 108
Chanellers 41
Change 69
Changed 13
Changes 69, 117
Chant 48
Chaos 79
Character 45, 104
Characteristic 87
Charcoal 21, 29
Charge 147
Chariot 4, 46
Charity 47, 102
Chaste 4
Chastity 35, 47, 63, 136
Chemist 13
Cherub 94
Cherubim 5, 145
Chesed 3, 71
Chi 76
Chief 115
Child 21-22, 69, 89, 129, 141
Children 3, 15, 23, 69, 103, 125
Chimica Basilica Philosophica 39
Chimney 28-29
Chinese 10, 76, 79, 81
Chinese Alchemy 76
Chinese Hoel-Tun 79
Chinese Taoism 76
Chiram 46
Chokmah 3, 37, 71, 138, 144
Chords 10-11, 96
Chorister 135
Christ 6, 15, 17, 22, 33, 37, 42, 47, 65, 69, 81, 95, 98, 104, 107, 113, 117, 122-123, 126-127, 133, 143-144

Christ-Mind 85, 89, 95, 104
Christ-Will 86, 89
Christic 65, 70, 87-89, 95, 98, 108-109, 126
Christic Astral Body 95
Christic Consciousness 70
Christic Energy 65
Christic Vehicles 87-89, 108, 126
Christification 1, 15
Christified 15, 22, 86
Christified Soul 22
Christs 3, 109
Chrysalides 86, 89
Church of Ephesus 38
Churches 55-56
Chymica 20
Chymicum 45, 50-51, 58
Cibeles 14, 61
Circe 14, 96
Circle 4, 42, 59, 61
Clairaudience 15, 48, 143
Clairteleidoscope 21
Clairvoyance 15, 21, 48, 78, 143
Clairvoyant 56, 111
Clairvoyantly 78, 85, 101
Clairvoyants 67
Clean 15, 35, 40, 62, 108, 145
Cleanse 35
Cleansing 35
Clothe 108
Clothed 5, 11
Clothes 135
Clue 1, 3, 10, 16, 25, 38, 72, 75, 78, 97
Clues 1
Coagula Solve 75
Coccygeal 11, 16, 38, 113
Coccyx 53
Coexistence 138
Cognizance 72, 111
Cognizant 78, 111, 139
Coitus 77, 81
Cold 53, 76
Colonel Olcott 46
Color 13
Colors 47, 111
Column 15, 43
Columns 15, 35, 127
Combination 52

Command 22, 77, 112
Commanded 31
Commanding 78
Companion 143
Compare 108
Compassion 5, 105
Compounds 72
Comprehend 1, 11, 38, 67, 70, 82,
 101-103, 119, 122-123, 131,
 135-139, 144
Comprehended 102
Comprehending 89, 104, 131, 137, 139
Comprehends 4, 131
Comprehension 13, 75, 101, 105, 119,
 137, 139
Conceal 63
Conceived 81
Concentrate 29, 49, 72, 129
Concentrating 31
Concentrically 63
Concept 136
Conception 103
Conceptions 22
Concepts 59
Condemn 136
Condemned 79
Condition 17, 64, 102, 137
Conditions 119
Coneshaped 140
Conflicts 64
Confused 101
Confusion 71, 87, 146
Conidia 121
Conjunction 35
Conjure 23
Connect 53
Connection 16, 42, 75, 82
Connubial 66
Conquer 15, 56, 62
Conquered 121
Conquers 141
Conquest 120
Conscience 67, 69
Conscious 67, 103
Consciously 10, 89, 95, 103, 111
Consciousness 3, 9-10, 14, 27, 59, 65,
 67, 69-70, 72, 79, 83, 85, 109-
 111, 137, 146

Consecrate 35
Consecrates 5
Consequences 46
Constellations 41
Contemplate 101
Continuous 66
Contrary 116-117, 121
Convents 64
Converse 17
Convert 3, 11, 38, 64, 121
Converted 17, 27-28, 38, 53, 69, 89, 98,
 115, 135-136, 140
Converting 64
Converts 16, 55, 95, 139
Cooperation 28
Copenetrate 71, 87
Copper 21, 48
Coptic 131
Copulating 145
Copulation 77
Cord 10, 53
Cords 43, 53
Corinthians 40, 143
Coronary 139
Corpse 51
Correspond 47, 107
Correspondences 40
Corresponds 27, 47, 63, 70, 75, 104
Corroborating 14
Corrupted 51
Cosmic 14, 17, 40-41, 45, 55-56, 61, 66,
 72, 95, 98, 108, 122, 127, 132,
 138, 144
Cosmic Christ 98, 122, 144
Cosmic Justice 55, 108, 132
Cosmic Laws 41
Cosmic Mother 14, 56, 61, 72
Cosmic Rhythms 66
Cosmogonic 67
Cosmos 23, 77
Count Cagliostro 131
Counted 131
Couple 17, 40, 82
Couples 40
Courage 5
Courageous 15
Coveting 128
Covetous 129, 131

Covetousness 129, 131
Cowardliness 102
Create 21, 89
Created 89
Creates 39
Creating 88-89, 93
Creation 76-77, 95
Creative 17, 19, 28, 95-96, 113, 137
Creator 16
Creature 73, 89, 126
Creatures 27, 30, 107
Credentials 64
Crime 38-39
Crimes 39, 63-64
Criminal 102
Criminally 52
Criticized 119
Croll 20
Cross 10, 17, 21-22, 25, 27, 31, 37, 57,
 79, 81, 97, 117, 125
Cross-Man 75, 81
Crossman 75, 81
Crow 61
Crown 3, 46, 55, 132, 141, 143-145
Crown of Life 141, 143-145
Crowned 15, 22, 46, 66, 75
Crows 51
Crucified 27, 69, 102, 117
Cruelties 64
Crystallize 41
Cteis 25
Cubic 46
Cuisine 121
Culminate 45
Cults 14
Cunning 29
Cup 11, 14, 30-31, 38, 66, 93, 98, 103,
 107, 113, 121, 129, 131-132,
 135-136, 145
Cup of Hermes 38, 66, 103, 107, 113,
 129, 131, 135
Cupid 90
Cups 14, 93, 116-117, 121
Curiosity 143
Curious 141
Custom 35
Customs 69
Cynocephalus 48

Daily 49, 95, 125
Damages 102
Dance 79
Dances 40, 77
Danger 78, 103, 135
Dangerous 81, 111, 121
Dangers 120-121
Dante 62
Darkness 67, 108, 113, 119, 131
Daughter 83
David 94
Day 34, 37, 49, 63, 81, 90, 97, 131-132
Days 11, 52, 63, 71, 133
Dead 5, 51, 129
Death 3, 27, 51-52, 59, 62, 73, 79, 85-
 86, 90, 104, 107-111, 120, 126,
 128, 132-133, 141, 144
Death of Satan 104
Decapitated 69
Decapitation 34
Deceased 51, 111
Deception 17
Decomposes 125
Decubitus 95
Deed 127
Deeds 141
Defect 138-139
Defects 47, 104, 138
Defunct 108
Degenerates 140
Degree 55, 104, 138, 143, 145
Degrees 131-132
Demon 33, 35, 37-38, 101, 105, 115
Demon of Desire 37
Demon of Evil Will 37
Demonic 102
Demons 35, 38, 52, 101, 107, 113, 115,
 145
Denying 79
Descend 38, 98, 113
Descends 15, 38, 52, 62, 67, 69, 113
Descent 61
Desire 37, 39-40, 42, 55, 86, 125-128,
 135-139, 145
Desires 59, 69, 83, 96, 123, 136-137
Desiring 125
Despise 138, 147
Destiny 1, 35

Destroy 28
Destroyed 21
Destroyer 29
Destroys 102
Develop 17, 66, 70, 82, 99, 102, 111,
 119, 141
Developed 85, 139, 143
Development 38, 109, 117, 139-140
Develops 72, 103, 109, 143
Devi Kundalini 17
Devil 69, 99, 101, 105
Devils 37
Devotee 23, 97, 120, 139
Devotees 17, 53, 55, 140
Dew 23, 87
Dharmakaya 5-6
Diamond Soul 69
Die 30, 59, 66, 69, 73, 77, 90, 126, 141
Died 123, 135
Dies 51, 107
Differentiating 62
Digestion 27
Dignified 131
Dignity 61
Diligence 47
Direct 72, 95-96
Direct Clue 72
Direct Knowledge 72
Disciple 4, 10, 22, 25, 46, 63, 72, 78, 83,
 126, 131
Disciples 1, 16, 27, 67, 72, 77, 93, 101,
 119, 121-122, 133, 141
Discipline 108
Disincarnate 59
Disintegrate 21, 47, 90, 122, 127
Disintegrated 21, 95, 138
Dissolution 101, 138
Dissolve 47, 69, 77, 90, 99, 101-102,
 105
Dissolved 37, 82, 139
Dissolves 81, 87
Dissolving 104, 139
Divine Atom 13, 63
Divine Being 3, 79
Divine Body 89
Divine Child 89
Divine Cosmic Mother 56, 61, 72
Divine Hierarchies 90

Divine Mother 14-17, 23, 72, 147
Divine Mother Kundalini 14, 16, 23,
 147
Doctrine 1, 76, 113, 147
Doctrines 145
Dog 119
Dogs 4
Don Giovanni 64
Dona Ines 64
Door 27, 61, 105, 115-116, 146
Door of Eden 105
Doors 5, 9, 17, 46, 61
Dormant 83, 85
Dorsal 53, 95, 120
Double 9, 38, 57, 59, 61, 63
Dragon 23, 37-38, 48, 76, 113, 122,
 138, 143-144
Dragon of Wisdom 23, 37, 113, 122,
 138, 143-144
Dragons 4, 21
Drama 123
Dramas 83
Dream 9, 73, 83, 109-111
Dreaming 83, 97, 110
Dreams 23, 83, 110, 126
Drink 28, 53, 81, 136
Drinking 23
Drukpas 52
Drunk 115
Drunkard 79
Drunkards 110, 136
Dryness 21
Duality 13
Dust 95, 127
Duties 83
Duty 145
Dying 66
E. O. U. A. N. 23
Eagle 27-28, 31, 48, 61
Eagles 35
Ear 56
Ears 138
Earth 5, 10-11, 14, 19, 21, 25, 27-28,
 30-31, 37, 40, 43, 49, 52, 56,
 62-63, 67, 71-72, 76, 94, 97,
 105, 113
East 10, 31, 43, 81
Ecstasy 16, 40, 55-56, 65-66, 82

Eden 27, 38, 41, 46, 61, 65, 67, 69, 94, 105
Edge 1, 116, 120-121, 139, 141
Education 146
Ee 140
Eeennn Rrreee 48
Effort 95
Efforts 120
Egg 51-52, 65
Ego 37, 67, 73, 77, 79, 101, 110-111, 123, 138
Egos 103, 123
Egypt 27, 29, 143
Egyptian 105, 125
Egyptian Tarot 125
Eight 9-10, 53, 62-63, 113
Eighth 4-5, 50-51, 55, 57, 71
Eighth Arcanum 55, 57
Eighth Key of Basil Valentine 50-51
Eighty-four 70
Ejaculate 52, 81, 113, 131
Ejaculated 53
Ejaculates 52
Ejaculating 131
Ejaculation 14, 17, 52, 81-82, 113
Ejus 30
El-Shaddai 37
Elder 45, 48, 69, 79
Electric 4
Electromagnetic 95
Electronic 69
Element 76, 103
Elemental 21, 27-28, 31, 43
Elemental Paradises of Nature 21, 28, 31
Elementals 27-29, 31, 42
Elementals of Nature 29, 31, 42
Elements 5, 9, 13, 19, 21, 25, 27-28, 38, 40, 59, 72, 94, 145
Elements of Nature 21, 28, 72
Eleusis 40
Eleven 75, 133
Eleventh 5, 71, 75
Eliminated 102
Elixir of Long Life 89-90, 93, 127, 133
Elixirs 94
Emanate 71
Emanated 13, 144

Emanates 144
Emanations 27
Embryo 85, 107, 123, 126
Embryonic 126
Emerald 13, 78
Emerge 51, 59, 138
Emerged 79
Emerges 23, 51, 76, 89
Emmaus 133
Emotion 101, 107-108
Emotional 101
Emotions 40, 78, 83, 102
Emperor 3, 31
Empress 3, 22
Empty 9, 95, 132
Emptying 97
Enemies 52, 119
Enemy 67, 105, 113, 116
Energies 17, 53, 65-66, 104
Energy 9, 13, 16, 65, 69, 72, 95-96, 103, 125, 128, 132
Engender 85-86, 95, 108, 122, 126
Engendered 86-87, 94-95, 108, 122
Engenders 86, 95, 109
Enjoy 53, 55, 70
Enjoying 55
Enjoyment 65
Enjoys 40
Enre 48
Ens Seminis 14, 17, 22, 25, 28, 34, 38, 45, 52-53, 55, 57, 59, 77, 79, 81-82, 87, 113, 131
Entrance 27, 120, 139
Envy 47
Ephesus 38
Epoch 147
Epochs 98
Equal 10, 123
Equals 75, 119
Equilibrate 14, 57
Equilibrated 3, 57
Equilibrates 57
Equilibrium 13, 42, 57, 64, 71
Era 35
Erfurt 19
Eros 67
Erotic 121
Eroticism 52

Error 59, 137, 146
Errors 104
Escape 79, 90, 126
Escapes 107, 132, 137
Escaping 129
Esoteric 4, 15, 27, 40, 51, 55, 99, 108-109, 113, 119, 137-139
Esoteric Astrology 4, 40
Esoteric Ordeals 55
Esoterically 10
Esotericism 35, 77, 93
Essences 103
Est 30, 96
EST SIT 96
ESTO 96
Estolsio 45
Eternal 13, 15, 23, 25, 33, 37, 90, 107, 113, 125, 144
Eternal Beloved 15
Eternal One 25
Eternal Seity 23
Eternal Youth 113
Eternally 107
Eternity 4, 108
Ethereal 5, 65, 71, 89, 95-96
Ethereal Body 5, 96
Ethereal Plane 65, 71
Ethereal World 95
Eve-Venus 55
Evil 17, 34, 37, 49, 81, 113, 121
Evolution 13, 59, 116, 121
Evolve 59
Evolves 103
Evolving 59
Exercise 9, 49, 73, 96-97, 112
Exercises 15, 109, 116-117, 133
Exert 73, 120, 141
Exerts 101
Exhale 96
Existence 55, 79, 81, 95, 126
Existing 3
Exorcism 30
Experience 4, 9, 126, 140
Experiences 49, 69
Experiments 40
Exterior 9
External 138
Eye 51, 139

Eyebrows 25, 53, 56
Eyes 23, 110, 117
Ezekiel 27, 57, 67
Face 29, 45, 78, 103-104
Faces 139
Fact 39, 98, 101, 129, 131, 135
Faculties 15, 22, 79, 143
Faculty 139, 143
Fail 85, 129
Fails 5
Failure 41
Failures 57
Faith 47
Faithful 141, 144
Fall 27, 29, 34, 38, 49, 59, 97, 107, 109, 111, 128, 135
Fallacy 79
Fallen 33-34, 107
Falling 9, 59, 97, 107, 135
Falls 33-34, 107
False 37, 41, 79, 82, 115-116
Fame 129
Familiar 27, 29, 78
Family 69
Famous 21, 77
Fantasies 78
Fascination 109-110
Fast 9, 102
Fastest 93
Fatal 46-47, 63-64, 67, 69, 108, 123
Fatality 107, 131-132
Father 14-16, 25, 28, 34, 37, 41, 43, 49, 56-57, 66, 76, 83, 113, 117, 138, 147
Father Star 117
Fatuous 108
Fear 5, 102
Fearful 69
Fears 69
Feather 31
Feathers 78
Fecundated 25
Fecundity 22
Feel 35, 70, 126, 128, 136, 147
Feeling 64-65
Feelings 101
Feels 97
Feet 17, 22, 33

Fell 115, 135
Fellow 33
Fellowmen 138
Female 53, 55, 135
Feminine 40, 42-43, 45-46, 51-52, 70,
 75-76, 96, 103, 132
Fermentation 82-83
Fermented 83
Fertile 16, 22, 29
Fetus 61
Fiat 30, 96
Field 109
Fiery 77-78, 113
Fifth 4, 33, 35, 56, 71, 95-96, 103-104
Fifth Era 35
Fifty-six 16
Filthy 39-40, 46, 107
Final Judgment 51
Finger 9
Fingers 121, 131, 133, 141
Fire 4-5, 10, 14-17, 19, 21-22, 25, 27-29,
 31, 34, 40, 43, 45-46, 48, 52-53,
 55-56, 66, 75-77, 81-83, 87, 94,
 99, 105, 132
Fire Projection 77
Fires 108
Firmly 64, 146
First 3-4, 7, 14, 37, 56, 65-66, 71-72,
 91, 96, 102, 104, 119, 122,
 126, 129, 131-132, 136, 138,
 143-145
Five 33-35, 49, 79, 99, 101, 104, 135-
 136
Fixed 76
Flame 23, 65, 126
Flamel 133
Flaming 15, 21, 33, 43, 55, 61-62, 67,
 69, 120, 135, 141, 145-146
Fledgling 45, 51, 66, 75
Flesh 14, 33, 82, 98, 132, 135
Float 111
Floating 13, 78, 111
Floor 49, 97
Flourish 138
Flow 67
Flower 23, 28, 55, 139
Fluid 52-53
Fly 5, 86

Focus 139
Focused 63, 145
Fool 135-139
Foot 27, 81, 97
Football 102, 109, 141
Force 13, 23, 38, 47, 64, 86, 103, 112,
 120, 125, 144
Forces 4, 14, 17, 42-43, 47-48, 53, 57,
 102
Forehead 93, 99
Forever 6, 39, 52, 121
Forge of Vulcan 15, 61, 65, 69, 141,
 145-146
Forget 13, 66, 110
Forgets 85, 110
Forgetting 6
Forgive 49
Forgiven 40
Forgives 126
Forgotten 14, 137
Form 4, 10, 31, 45, 49, 81
Formal 25
Formation 9
Formations 122, 126
Forms 21, 25, 45, 81
Formula 17
Formulated 121
Fornicates 137
Fornication 40, 63
Fornicators 52, 136
Forty 70
Forty-two 70
Foundation 4, 71, 76, 95, 104, 113
Fountain 67
Four 19, 21, 25, 27-28, 30-31, 38, 42,
 59, 67, 71-72, 79, 94, 115, 144-
 145
Fourth 3-4, 31, 56, 71, 81, 95-96, 101,
 103-104, 108
Fourth Initiation of Major Mysteries
 108
French Revolution 135
Friend 29, 131, 147
Frightful 62
Frogs 37
Fu 81
Fugiens 127
Fulminated 107-109, 132

Fulminated Tower 107, 109
Furnace 28, 66
Fuse 144
Fusion 103
Future 21, 139
Fíat 30
Gabriel 47
Ganglionic 10-11, 53
Garden 43, 94
Garden of Eden 94
Garment 95
Gas 90
Gate 115
Gautama 6
Geburah 3, 71
Gemini 4
Generate 77
Generation 22, 45, 59
Genesis 41
Genie 14, 30-31, 62-63
Genii 30, 97
Genii Michael 30
Genii of Jinn Science 97
Genitalia Murielis 75, 82
Gentle 75
Gentlemen 14, 110
Germain 91, 133
Germinate 59
Geronimo 131-132
Gestation 61
Gift of Cupid 90
Giovanni 64
Gland 21, 55-56, 77, 139-140
Glands 77
Glass 86
Glorian 144
Glory 4, 6, 14, 63, 103
Gluttons 136
Gluttony 47
Gnomes 28-29, 31
Gnosis 33, 141
Gnostic 1, 15-16, 27, 34, 42, 67, 72, 78, 93, 98, 110, 113, 119, 121-122, 143, 145
Gnostic Kabbalah 1
Gnostic Lumisials 27, 34
Gnostic-Rosicrucian Brethren 53
Gnostics 29, 38, 51, 119, 140, 147

Goat 33, 38, 99
Gob 31
God 10-11, 14, 16-17, 19, 37, 40, 42, 49, 52, 66, 75, 81, 97, 115, 127, 131
Goddess 14, 23, 59, 61
Gods 1, 3, 13, 22, 29, 43, 57, 90, 99, 107, 139
Gods of Medicine 22
Goethia 4
Gold 15, 21, 28-29, 31, 38, 48, 59, 67, 75, 79, 81-83, 89, 105, 113, 117
Golden 21, 51-52, 77-78, 105
Golden Alchemy 52
Golden Chain 77
Golden Child of Alchemy 21
Golden Egg 51
Gong 66
Good 59, 83, 111, 115, 121, 126, 147
Gospels 28, 115
Governor 41
Governors 47
Governs 41, 70, 77
Grace 14
Graciously 53
Grail 98
Grain 59
Graveyard 126, 129
Great Arcanum 45
Great Chain 78
Great Initiations 5, 89
Great Light 35
Great Man 81
Great Master 46, 69, 115, 133
Great Masters 41, 62, 79, 111, 115
Great Reality 108, 140
Great Service 91
Great Tempter 128
Great Vulcan of Nature 65
Great Work 19, 28-29, 38, 40, 45, 51, 53, 61, 66, 70, 81, 83, 87, 125, 127-128, 131, 145
Greeks 22
Green 13, 78
Grey Tantra 81
Grimoires 121
Guard 48
Guarded 63

Guardian 5, 90, 105
Guardian Wall 90
Guardians 63
Guidance 82
Guide 117
Guides 71
Guiding 109
Guillotine 135
Guru 82
Guruji 10
H 30, 69
Habit 111
Habits 69, 102
Hadit 16
Hair 63
Half 38, 70
Hall 143
Hallowed 49
Hand 3, 15, 22, 34, 41, 55, 57, 93-94,
 145
Hands 35, 75, 81, 116, 120, 125, 131,
 141, 147
Happily 89
Happiness 13, 28, 47, 55, 126, 147
Hatha Yoga 46
Hatred 17, 64, 76, 125, 128
Head 9, 11, 15, 33-34, 48, 55, 61-62, 78,
 90, 97, 107, 119, 133
Healing 5, 22, 41, 67, 78
Health 117
Hear 17, 137
Heard 73, 112
Hearing 49, 136, 143
Heart 10, 14-17, 23, 25, 31, 48, 56, 62-
 63, 71-72, 96, 119, 125, 140
Heart Temple 17, 25, 31, 72
Hearth 94
Hearts 59
Heat 21, 70, 76
Heated 27
Heaven 4-5, 14, 22-23, 28, 34, 49, 52,
 72, 76, 120
Heavenly 40, 87
Heavens 16
Hebraic 21, 119, 129
Hebrew 10
Hei 25, 145
Height 16, 56, 95

Heights 17, 65, 95
Heliogabalus Stone 127
Help 6, 10, 29, 90
Hercules 15, 62
Hermanubis 67
Hermaphrodite 86-87
Hermes 38, 62, 65-66, 103, 107, 113,
 129, 131, 133, 135
Hermetically 30
Hermeticum 94
Hermit 4, 66, 136
Hetaeras 64
Hidden 19, 27, 41, 72
Hierarchies 31, 90
Hieroglyph 3, 145
Hieroglyphic 31, 75, 113, 125, 135
Hieroglyphics 129, 145
Hierophant 3, 27-28, 35, 43, 48, 61
Hierophants 43, 139, 143
Himalayas 10
Hindustan 46, 117
Hippomenes 47
Hiram Abiff 37
History 77
Hoa Se 81
Hod 4, 71
Hoeltun 79
Holy Alchemy 39, 76
Holy Eight 9-10, 62-63
Holy Four 144
Holy Gnostic Unction 98
Holy Grail 98
Holy Seven 43
Holy Spirit 4, 37, 40-41, 75, 113, 138
Holy Three 144
Holy Trinity 144
Hominis 29
Homosexuality 63-64
Honor 10
Hope 5, 7, 47, 62, 64, 113, 147
Horaccio 121
Hormone 140
Horus 75
Hot 53
Hour 4-5, 22
Hours 83, 110
House 109, 115
Hue 113

Huiracocha 16
Human Beings 41, 89, 107, 109, 113, 123
Human Soul 34, 104
Human Specter 107, 122
Human-Christ 109
Human-Gods 105
Humanities 70
Humanity 5-6, 62, 69, 71, 83, 90, 109, 141, 147
Humanization 104
Humanoid 67, 110
Humble 1, 27, 34, 51, 66
Humidity 21
Humility 47
Hunting 128
Hurricane 4
Hurt 52
Husband 76
Hydrogen 69
Hyle 38
Hyperspace 90, 97, 132-133
I. A. O. 15, 19, 21-22, 31, 47-48, 66, 72
I. N. R. I. 29, 48
Ida 10-11, 14, 43, 53, 96
Idea 111
Identify 83, 97
Identity 86
Igneous 11, 14, 82
Ignis 15, 19
Ignited 21
Ignoramuses 41, 116, 119
Ignorance 59
Ignore 34, 111, 139
Ignores 121, 128
Ill 78
Illuminate 116
Illuminated 38, 46, 119
Illuminates 66
Illumination 23, 46, 65, 131, 141, 143
Illusion 13, 17
Image 31, 78, 136
Images 140
Imagination 78, 96
Imagine 9, 78, 97
Imagined 9
Imitated 40
Imitating 30

Imitators 61
Imitatus 141
Immaculate 22, 61, 90
Immaculate Conceptions 22
Immortal 1, 46, 79, 85-86, 90-91, 107-109
Immortal Beings 1, 90-91
Immortality 85, 89, 108
Imperative 112
Imperfect 82
Imperishable 107
Impersonal 122
Impostor 117
Impotence 140
Impulse 113
Impure 55
Inanimate 5
Incapable 131
Incarnate 22, 37, 85, 87-89, 95, 104, 113, 117, 122-123, 126-127, 144-145
Incarnated 79, 85, 122-123, 125
Incarnates 59, 86, 90, 122-123, 138, 144
Incarnating 113
Incarnation 89, 117, 126
Incarnations 123
Incubi 21
India 52, 76, 82, 90, 116-117
Individual 104, 146
Individuality 122
Individuals 136
Ines 64
Inferior 3, 33, 37, 39, 101, 104
Infernos 52, 113
Infinite 9-11, 14, 16, 37, 53, 62-63, 71, 105, 122, 126
Infinity 75
Influence 40, 87
Influences 40, 45, 77, 103
Infrasexual 63-64, 76, 116
Infrasexuality 64
Inhale 95-96
Inheritance 69
Iniquity 115
Initiate 5, 22, 28, 34, 55, 73, 90, 95, 107, 117, 133, 135, 139
Initiated 35, 55, 117

Initiates 10, 53, 55, 69, 101, 107, 111
Initiatic 27, 55, 132
Initiatic Spiritual Resurrection 132
Initiating 97
Initiation 4-5, 17, 25, 27, 31, 46, 55, 61-63, 65, 69, 73, 95, 108, 113, 119, 123, 132, 138
Initiation of Minor Mysteries 63
Initiations 5, 33, 63, 73, 89, 131
Initiations of Major Mysteries 5, 89, 108
Inner Buddha 126, 144
Inner Christ 15, 17, 37, 113, 122, 126-127, 143
Inner God 17, 49, 52, 66
Inner Magnes of Paracelsus 125
Inner Self 46, 116-117, 141
Inner Star 13, 144
Innermost 13, 31, 41, 43, 71, 73, 143-144
Innocent 69
Inquisitive 110
INRI 29, 48, 66
INRI ENRE ONRO UNRU ANRA 48
Inseparable 45
Insertion 25
Inside 21, 37, 43, 145-146
Insobertha 14, 61
Instability 87
Instinct 102
Instinctively 63
Instincts 75, 102
Instinctual 55, 101-102
Institution 141
Instruct 23
Instructed 131
Instruments 107, 125
Intellect 102, 121, 136
Intellectual 1, 79, 101, 104
Intellectually 136, 138
Intelligence 3, 71, 89, 139
Intelligent 72, 93
Intelligently 31
Interchange 40, 82
Intercourse 103-104
Interior 3, 43, 71, 125, 144
Interior Magnes of Paracelsus 125
Interlaced 37-38

Internal 17, 27, 33, 42, 46, 49, 65-66, 72, 78, 83, 86-87, 95, 97, 110-111, 120, 122, 126, 136-139, 145
Internal Christ 33, 42, 122
Internal Lodge 145
Intuition 48, 139-140
Intuitive 1, 56, 139-140
Intuitive Kabbalists 1
Inverted 33, 81, 107, 135
Invisible 21, 78
Invocation 16-17, 23, 97
Invocations 42
Invoke 10, 29-30, 97
Invoked 10
Invokes 90, 132
Invoking 21
Iod 25, 145
Iod-Hei-Vav-Hei 144
Iron 31, 48
Isaac 115
Isaiah 34
Ishtar 76
Isis 14-15, 23, 61, 76
Israelites 41, 67
Jachin 127
Jacob 72, 94, 115
Jao Ri 78
Jesus 22, 48, 62, 98, 115, 133
Jinn 17, 42, 96-97
Jinn Science 17, 42, 97
Jinn State 96-97
Job 55
John 5, 22-23, 28, 34, 37, 69, 79
Johns 79
Joy 3, 70, 83, 97, 113, 147
Joyful 48
Judas 120
Judge 34, 121
Judged 34
Judges 101
Judging 137
Judgment 34, 51, 110, 129
Jump 97, 111
Jungle 27, 67
Jupiter 3, 47-48, 57
Justice 4, 43, 55, 71, 108, 132
Justify 39, 136

Kabbalah 1-2, 7, 13, 22, 27, 40, 42, 61,
 71-72, 83, 119, 141
Kabbalist 61
Kabbalist-Alchemist 21
Kabbalistic 22, 48, 63, 72, 138
Kabbalistic Aleph 22
Kabbalistic Traditions 63
Kabbalistically 11, 16, 75, 144
Kabbalists 1
Kabbel 41
Kakof 16
Kali 61
Karma 13, 67
Karmic 90
Kawlakaw 66
Kephren 48
Kether 3, 37, 71, 138
Key 1, 9, 15, 46, 50-51, 58-59, 61, 82
Keys 19
Kill 28, 39, 126-127, 137
Killed 52
King 27-28, 45, 86
Kingdom 4, 13, 31, 49, 64, 67, 71-72,
 89, 91, 95, 115, 120
Kings 27, 37, 75
Kiss 16
Kissing 23
Knife 31
Knock 15, 17, 115
Knot 53
Knots 14
Knotted 53
Know 1, 14, 17, 23, 28, 34, 46, 51, 62,
 72, 79, 86, 102-103, 115, 119,
 125-126, 128, 139, 145-147
Knower 69
Knowing 126
Knowledge 10, 40, 67, 69, 72, 89, 128
Known 43, 46, 53, 69, 72, 119, 140
Knows 117, 125-126
Kore 66
Kout Humi 46
Krumm-Heller 13-14, 16, 95
Kuan-Chi-Yin 6
Kundabuffer 52, 113, 115
Kundalini 4, 11, 14, 16-17, 22-23, 25,
 52-53, 75, 77, 81, 99, 108, 119-
 120, 147

Kunrath, Heinrich 75
Labor 22, 29
Laboratorium Oratorium 43, 48, 55,
 86, 113
Laboratory 3, 16, 21, 27-28, 38-40, 48,
 52, 66, 89
Ladder 72
Lamp 29, 34, 66
Language 10, 137
Lapidum 43
Lapis Philosophorum 79
Larva 67
Larvae 21, 35
Larynx 56, 95
Lasciate Ogni Speranza Voi Ch 62
Last Supper 98
Latin 96
Latter 122, 125, 131
Launched 110
Law 5, 39, 52, 57, 61, 63, 71, 109, 145
Laws 41, 93, 103
Laziness 47
Left-hand 113
Legion 85-86, 107
Legs 31, 33, 38, 49, 81, 107
Lemon 127
Length 70, 97
Leo 4
Lethargy 5
Letter 29-30, 95-96
Letters 21, 25, 40, 45
Levels 70, 103, 136-138
Liar 116-117
Liberate 3, 13, 69, 103
Liberated 67, 137
Liberates 13, 69, 71
Liberating 138
Liberation 25, 73, 99, 132
Licanto 72
Lie 49, 95
Lies 101, 132
Lifaros 72
Light 5-6, 11, 15-17, 27, 29, 33, 35, 38,
 41, 46, 67, 70, 81, 116, 119,
 131-132
Lighting 87
Lightning 27, 59
Ligoria 72

Lilith 63-64
Limitless 5
Lingam-yoni 25, 39, 42
Lion 27-28, 48, 67, 75, 77, 82
Lion of Fire 77
Lions 75
Lips 16, 22-23, 30, 41
Liquid 81
Liquor 4, 52, 65, 82, 136
Living Buddhas 123
Living Christs 109
Living God 42
Living Reincarnations 123
Lodge 14, 77, 113, 131, 141, 145-146
Lodges 76
Logos 28
Longing 131, 141
Loom 37
Lord 49, 98, 115
Lord of Atlantis 98
Lot 5
Lotus 55
Love 1, 4-6, 17, 23, 28, 34, 37, 40, 42, 47, 57, 75, 102, 125-126, 128, 135
Loved 22, 121
Lover 4, 42
Lovers 1, 125
Loves 125-126
Loving 23, 125-126
Lucifer 34
Luke 28, 115
Luminous 4, 115, 128
Lumisial 34
Lumisials 27, 35
Luna 30
Lunar 10-11, 46-47, 52-53, 67, 69, 104
Lunar Avarice 47
Lunar Conscience 67, 69
Lust 47, 53, 102
Lustful 75
Lustral Water 21
Lying 10, 78, 132
Lyre 47
M 30, 95-96, 127
Machine 83, 101
Machines 85
Macrocosmic 39

Macrocosmos 13, 38, 57, 65
Made 16, 22, 33, 38, 75, 113, 121
Magi 5, 33
Magic 3-4, 7, 11, 16, 21, 42-43, 46, 48, 52, 66-67, 76, 78, 85-87, 95, 113, 117, 119, 128, 140, 143
Magical 11, 13-14, 19, 43, 49, 113, 121
Magician 3, 9, 11, 17, 55
Magicians 1, 4, 11
Magisterium 66
Magnes 125
Magnetic 9, 25, 55-56, 104
Magnetism 4, 42
Magnetize 40
Magnitude 147
Magnum 21, 79
Magnum Work 21
Magnus Opus 28-29, 40
Magnus Work 28
Mahasaya, Lahiri 46
Maiden 34
Maier 127
Maithuna 43, 76
Major 5, 7, 10, 89, 108, 141
Major Arcana 7, 141
Male 33, 38, 53, 99
Malicious 69
Malignant 21, 63-64
Malkuth 4, 71
Man 3-6, 14-17, 22, 25, 27, 34, 38-40, 42, 52, 57, 59, 61, 65-66, 71, 73, 77, 81-82, 93-94, 101-102, 109, 117, 122, 125-127, 129, 131, 137, 145
Manicheans 77
Manifestations 13
Manifested 19, 21
Manifests 140
Manna 145
Mantra 15, 19, 29-31, 48, 66, 78, 138, 140
Mantras 16-17, 48, 66, 72, 75, 96
Mark 28, 97
Marriage 63
Married 46
Mars 3, 15, 47-48, 57, 62
Martyrs 6
Mary 4, 14, 61

Masculine 40, 43, 45-46, 51, 70, 75-76, 96, 103, 132
Masons 143
Mass 13
Master 5-6, 13, 16, 34, 46, 51, 65, 69, 90, 97, 113, 115, 120, 132-133, 135, 143
Master of Perfection 6
Master of Samadhi 65
Master Oguara 97
Master-Soul 133
Masters 14, 33, 41, 55, 62, 77, 79, 91, 111, 115, 129, 131, 133, 135
Masters of Samadhi 55
Mataji 90
Mater 30
Material 5, 51, 135
Maternal 61
Mathematical 85, 144
Matrimony 39, 46, 103, 116
Matter 13, 25, 28-29, 46, 59, 61, 65, 69, 76-77, 79, 87, 89, 104, 116, 135, 143
Matthew 15, 17, 28, 34, 120
Mature 70, 79
Maturity 140
May 147
Maya 13
Mayans 14
Me 29, 97, 112, 115
Measurements 40
Meat 53
Mechanical 78, 116, 121
Mechanically 102
Mechanicity 103
Mechanism 85, 102
Medallions 42
Mediator 41
Medicine 22
Medieval 39, 46
Medieval Alchemists 46
Meditate 15-16, 23, 29, 31, 72, 126, 139
Meditates 10
Meditating 10, 16, 30, 49
Meditation 17, 23, 31, 136, 138-140
Mediums 41
Medulla 10-11, 14, 28, 53, 55, 116
Medullar 14-15, 19, 25, 28, 38, 53, 119

Medusa 15, 34, 62, 69
Melchizedeck 27
Mem 19, 22
Membrum Virile 75, 82
Memories 123, 128
Memory 48, 67, 77, 86, 111
Men 6, 39-40, 64, 70, 96, 103
Mendes 33
Mendez 38, 99
Menstrum Universale 79
Mental 37, 71, 79, 89, 95-96, 103-104, 107-108, 122, 126, 128, 145
Mental Body 37, 95-96, 104
Mental Christ 107
Mental Lodge 145
Mentally 72, 78, 96, 131, 140
Merchant 79
Mercurial Matter 59, 61
Mercury 4, 10, 19, 21, 25, 27, 34, 38, 43, 45-48, 53, 57, 59, 61, 76, 83, 99, 125
Mercury of Secret Philosophy 25, 27, 53
Metal 48
Metallic 35, 51, 61
Metals 14, 29, 42, 48, 82
Mexico 10
Michael 29-30, 47
Michelspacher 28
Micro-cosmos 13, 38-39, 65
Microcosmic 39, 57, 71
Microcosmos 13, 38-39, 65
Midnight 81
Million 70, 90
Millions 4, 59, 133
Mind 9, 13, 37, 41, 43, 49, 55, 78, 82, 85, 95, 97, 101-102, 104, 107-108, 128, 131, 136-140
Mind-Christ 108
Minds 85, 117
Mineral 13, 104
Minerva 77
Minor Mysteries 5, 63
Mirror 21
Miserable 108, 126, 146
Misery 35
Misterium Magnum 79
Mithras 75

Mix 52
Mixed 17, 52, 98
Mixes 5, 93
Mixture 21, 93, 122
Mmmmmmmm 30
Molecular Weight Table 72
Moment 16-17, 61, 77, 81, 95, 103, 131
Moments 10, 17, 27, 35, 95, 97, 111-112
Money 129
Monks 64
Monotony 119, 129
Months 61, 141
Moon 3, 15, 22, 38-39, 43, 45, 47-48, 57, 59, 61, 76, 81, 86-87, 94, 113, 119
Moon-Mercury-Sophic 59
Moons 48
Morbid 136
Morning 34
Mortal 23
Mortally 64, 76
Moses 38, 105
Mother 14-17, 21-23, 25, 43, 56, 61, 63, 72, 76, 83, 147
Mother Goddess 14
Motto 10, 15, 27, 47, 51
Mountain 28
Mountains 14
Mouth 3, 37, 52
Movement 25, 59, 75, 101-102
Movements 102
Moves 48
Mud 105
Muladhara 28, 38
Multiple 79
Multiplied 53
Multitudes 110, 116, 125
Murielis 75, 82
Muse 72
Music 40, 47
Musical 93, 95
Mylius 87
Myself 117, 138
Mysteries 5, 19, 23, 27, 34, 39-40, 42, 46, 55, 61, 63, 72, 89, 108, 139
Mystery 16, 37, 67, 98, 105, 117, 121
Mystery of Baphomet 105

Mystic 46, 65, 116
Mystical 55, 65
Mystical Ecstasy 65
Mysticism 113
Mystics 64
Mythological 61
Na 16
Nachash 38, 41, 53
Nahemah 63-64
Naked 16, 113, 116, 145
Name 10, 25, 30-31, 43, 48-49, 63, 69
Named 46, 65
Names 79
Naples 135
Narrow 27, 115-116
Narrow Door 115-116
Nasal 53
Natural 103
Naturalizing 23
Nature 4, 17, 21-22, 27-29, 31, 39-43, 59, 63-65, 72, 85, 116, 119, 121
Navel 56
Negation 42, 81
Negative 13, 41-42, 52-53, 70, 76, 81, 119, 121, 123
Neophyte 4, 41, 121
Neophytes 27
Nephesh 19
Neptune 77
Nereids 28
Nervous 53, 95
Neshamah 19
Netzach 4, 47, 71
Neutral 40, 132
Nicholaitans 38, 113
Nicholas Flamel 133
Nicksa 30
Night 4, 10, 23
Nights 21, 56
Nine 5, 14, 61, 63, 119, 121, 123
Nine Initiations of Minor Mysteries 63
Nine Spheres of Universal Vibration 63
Ninth 4-5, 9-11, 25, 58-59, 61-63, 66, 71, 94, 119, 123
Ninth Key 58-59, 61
Ninth Key of Basil Valentine 58
Ninth Sphere 9-11, 25, 61-63, 94, 119, 123

Ninth Stratum 63
Nirvana 3, 5-6, 144
Nirvikalpa-Samadhi 17
Nocturnal 23, 46
Nomine 30
Non-identification 83
North 31
Nostradamus 21
Nothing 10, 61, 73, 91, 122, 126
Nourished 77
Nourishes 43, 63
Novel 16
Novelty 138-139
Number 5, 16, 22, 35, 43, 55, 75, 119,
 121, 144
Numbers 40, 85
Nuptial 86
Nut 16, 23
Nutu 30
O 15-16, 19, 21-23, 31, 34, 48, 66, 72
O. A. O. KAKOF NA. KHONSA 16
O. OU AOAI OUO OUOAE KORE 66
Obey 29, 77
Obeying 90, 133
Obeys 132
Objective 53, 81, 135
Oblige 112
Observe 72, 83, 93, 110
Occult 3-4, 10, 15, 34, 40, 43, 113, 141,
 143
Occultism 4, 46, 59, 79, 109, 115
Occultist 61, 131
Occultists 107-108
Ocean 29
Oceans 27
Octave 70, 95
Octaves 93
Offspring 113
Ogni 62
Oguara 97
Oil 5, 29
Ointments 90, 133
Olcott 46
Olive 10-11, 52
Olympic 75
Omer 145
Omnipenetrating 69
Omnipotence 33

Omnipotent 16
Omnipresent 69
Onro 48
Opposite 53
Opposites 40, 76
Opus 28-29, 40
Oratorium 43, 48, 55, 86, 113
Ordeal 5, 41
Ordeals 10, 27, 55, 136
Order 3, 5, 9-10, 14-17, 21, 23, 27, 29,
 34-35, 37-38, 40, 46, 48-49,
 52-53, 59, 62, 66, 69, 72-73,
 77-79, 81, 83, 89, 96, 103, 105,
 108-109, 111-112, 115, 117,
 119-123, 126-127, 129, 137,
 139, 146
Order of Melchizedeck 27
Orders 90, 112, 133
Ordinary Sleep 110-112
Organism 43, 52, 65, 90
Organizations 64
Organized 13, 63, 132
Organs 28, 43, 53, 56, 99, 113, 135, 140
Orgasm 131
Oriental 10, 66
Orifice 53
Orifiel 47
Origin 77, 85, 144
Originated 9
Originates 21, 69
Origo 15, 19
Oro 75
Orpheus 47
Osiris 76
Oswald Croll 20
Ovaries 53
Ovum 103
Pact 98
Pain 13
Painful 13-14, 62, 128
Pains 22
Paint 113
Painting 39
Pair 40, 53, 76
Pair of Opposites 40, 76
Palpitate 3
Pantacles 11, 57
Papus 10

Paracelsus 125, 133
Paradise 67
Paradises 21, 28, 31
Paradisiacal 17, 132
Paradisiacal Body 132
Paragraph 110
Parents 103
Partner 103
Partners 103-104
Parts 93, 125
Parvati 76
Passion 55, 73, 75
Passionate 63
Passions 108, 145
Passive 40, 76, 103, 125
Password 138
Pater Noster 49
Path 1, 4, 28, 33, 35, 59, 65, 73, 101,
 113, 115-116, 120-121, 128,
 139, 141, 143
Paths 19, 63, 115
Patience 7, 97, 141
Patient 127
Patriarchs 66
Paul of Tarsus 143
Peace 7, 28, 147
Penetrate 71-72, 83, 87, 95, 97, 108,
 139, 145
Penetrates 90, 133
Penetrating 97
Pentagram 33-35, 48, 99, 107
Pentagrammaton 30
Perceive 135-136
Perceives 101, 137
Perception 17, 136-139
Perdition 109, 128
Perfect 10, 17, 19, 28, 35, 39-40, 46, 48-
 49, 51, 64, 103-104, 113, 116,
 126-127, 140, 143, 146
Perfect Matrimony 39, 46, 103, 116
Perfection 6, 59, 69, 126, 141
Perfections 123
Perfectly 104
Perfume 105
Perfumes 35, 90, 133
Period 27, 140
Periods 70, 77
Perseus 15, 62, 69

Persian 77
Personalities 123
Personality 15, 21, 28, 41, 59, 75, 83,
 105, 138
Perverse 69, 115
Perversions 102
Phallic 25, 37, 125
Phallus 25, 38-39, 43
Phantasmal 104
Phantom 85, 89, 95
Phantoms 21, 79, 85-86, 89, 91
Pharaohs 143
Phenomena 70, 85
Philanthropy 47
Philosophia 87
Philosophica 39
Philosophical 14, 19, 34-35, 38, 40, 43,
 45, 51-52, 61, 65, 67, 79, 82,
 127
Philosophical Earth 19, 43, 52, 67
Philosophical Egg 51-52, 65
Philosophical Stone 14, 34, 38, 40, 43,
 45, 51, 79, 82, 127
Philosophorum 79
Philosophy 25, 27, 38, 53, 57
Phlegethon 10
Phoenix Bird 61, 83
Physical 13, 27, 40, 46, 55-56, 61, 71-
 72, 79, 86, 90-91, 96-97, 103-
 104, 107, 110-112, 126, 129,
 132-133, 135-137
Physical Body 13, 40, 56, 61, 72, 86, 90,
 96-97, 104, 110-112, 126, 132-
 133, 135
Physically 112, 123
Physiological 139
Pigs 96
Pineal 55-56, 77, 139-140
Pingala 10-11, 14, 43, 53, 96
Pituitary 21
Pity 128
Plagiary 29
Plagues 52
Plane 4, 9, 27, 65, 71, 103-104, 145
Planet 3, 63, 77
Planetary 14, 47-48, 70
Planets 3, 45, 47-48, 70
Plant 28

Pleasant 101
Pleasurably 53
Pleasure 136
Pleasures 43, 83
Plenitude 22
Plexus 9, 48
Pluralized 85-86, 90
Poetries 125
Poison 104, 125
Poisoned 128
Polarities 103
Polarity 103
Polarize 53, 55
Polarized 13
Pole 61, 70
Poles 53, 70, 103
Policemen 110
Polluted 35
Pollutions 46
Polyvoyance 56, 140
Pope 3
Popess 3, 15, 17
Pornographic 136
Positive 38, 41-42, 52-53, 70, 76, 81-82,
 119, 121, 123, 125
Positive Principle 125
Positively 13, 111
Possess 122
Possesses 83, 90, 108, 133
Possession 41
Posterior 140
Postmortem 107
Potable Gold 31, 75, 79, 81
Powder 21, 82
Power 3, 10-11, 16-17, 19, 21, 40-41,
 43, 46, 48, 51-52, 78, 82-83,
 103, 110, 113, 138
Powerful 10, 19, 47, 66, 78, 107, 140
Powers 11, 14-15, 41, 46, 56, 66, 73,
 78, 89, 96, 113, 117, 121, 129,
 131, 141
Practical 1, 38, 141, 143
Practice 1, 7, 9-10, 15-16, 29-31, 46,
 49, 52, 57, 61, 72, 76, 78, 96-97,
 109, 111-112, 117, 139-140
Practiced 27, 77, 81-82, 98, 117
Practices 17, 21, 38, 42, 48, 97, 113,
 137

Practicing 21
Pranayamas 116-117
Pratyeka Buddhas 6
Pray 15-16, 23, 42, 72
Prayer 16-17, 23, 49
Praying 15, 49
Presence 110-111, 115
Present 27, 79, 81, 83, 85-86, 91, 95,
 107, 109, 121-123, 125-126,
 139, 147
Pride 47
Priest 5, 55, 145
Priestess 3, 23, 55, 145
Priestesses 27
Priestly 15, 17
Priests 27
Prima Matter 28-29, 61, 76, 87
Primeval 3, 10, 141
Primeval Gnosis 141
Primordial 23, 79
Principle 15, 19, 21, 43, 62, 125
Principle Spirit 15, 19
Principle-Elements 21
Principles 40, 43, 51, 61, 93
Prism 47
Problem 59, 77, 89, 103-104, 129
Problems 110, 128
Process 5, 13, 27, 61, 93, 101, 104, 140
Processes 51, 65
Procreate 103
Projection 10, 15, 77, 82, 137, 143
Pronounce 30
Pronounced 140
Propagate 116
Prophecy 11, 52
Prophesies 21
Prophesy 11
Prophet 34, 37, 139
Prophets 115
Proselytes 64
Prostate 56, 95
Prostatic 95-96
Protect 103, 145
Protected 145
Protective 5, 66
Protects 90
Protoplastus 62
Proverbs 138

Proweoa 78
Prudence 66
Prudent 47, 66, 126
Psuchikon 89
Psychic 129
Psychological 34, 37, 47, 59, 62, 105, 125, 128-129, 138
Public 77, 110
Pulmonary 48
Pump 96
Purification 141, 143
Purifications 27
Purified 5, 143
Purify 17, 55
Purity 23, 103
Putrefaction 51, 61, 86
Putrid 86
Pygmies 29
Pyramid of Kephren 48
Pyramids 119
Pythagoras 57
Quantum Table 72
Queen 22-23, 27, 45, 86
Queen of Heaven 22
Queen of Space 23
Queens 27
Quetzal 77-78
Quetzalcoatl 65, 91, 133
Quetzals 77
Quicksilver 48
Quiet 5, 78, 82
Quietude 75
Race 69
Radiant 72, 113, 125
Radiant Star 113
Radium 13
Rain 52
Raja 52
Ramakrishna 17
Raphael 47
Rattlesnake 29
Ravens 86
Ray 25, 33, 107-108, 132, 144
Ray of Death 107
Rays 33, 40-41, 46, 113, 116
Razor 1, 116, 120-121, 139, 141
Rea 61
Reality 71, 108-109, 125, 140, 143

Realization 28, 40, 46, 116-117, 141
Realizations 7, 45
Realize 141, 143
Reason 10, 46, 128, 132
Reasoning 128, 139
Reasons 128
Reborn 14
Recapitulates 33
Receptive 103
Recipes 121
Rectangle 59
Rectificatur 43
Rectifying 43
Red 13-14, 29, 78, 82, 93-94
Red Balm 14
Red Sea 29
Redemption 64
Reed 25, 73
Reflect 119, 126
Reflected 105
Reflection 111
Reflective 111
Reformata 87
Refuge 128
Regenerate 77
Regenerated 25
Regeneration 59, 76-77
Regent 10
Region 38, 71
Regions 64, 71-72
Regnum 7, 43, 55
Reheating 89
Reigns 5, 13
Reincarnate 6, 85
Reincarnated 42
Reincarnates 69, 123
Reincarnating 37, 67
Reincarnation 117
Reincarnations 66-67, 86, 117, 123
Reincorporate 103, 123
Reincorporates 123
Reincorporating 138
Reins 35
Relationship 3
Relative 111
Relax 49, 97
Relaxed 16, 29
Religion 146

Religiosity 40
Religious 14, 79
Renounce 144
Renounced 6
Renounces 5
Representation 101, 110-111
Represented 3, 9, 28, 35, 39, 42, 46, 51,
 63, 73, 94, 104, 127, 135, 145
Representing 10
Represents 10, 14, 33, 37, 39, 43, 51,
 59, 81, 94, 99, 104, 119
Reproduction 65
Reptiles 35
Reservatus 77
Rest 9, 81, 110, 121, 123
Resting 43, 97
Resurrect 51-52, 132
Resurrected 129, 131, 133, 135
Resurrected Master 133, 135
Resurrected Masters 129, 131, 133, 135
Resurrection 1, 51, 73, 90-91, 129,
 132-133
Resurrects 132
Resuscitating 129
Retain 17, 86, 95
Retemper 15, 62
Retort 87-89
Retrospective 49, 73, 112
Return 13-15, 27, 34-35, 46, 59, 61, 85-
 86, 96, 144
Returns 13, 33, 107
Revelation 11, 34, 37, 51-52, 141, 144
Revolution 59, 135
Rhythms 66
Right 10, 14, 33-34, 52-53, 67, 81, 89,
 94-95, 104
Rigor 71, 105
Ring 13, 41, 42
Rise 10, 21, 33-34, 51, 53, 59, 86, 96,
 113
Risen 115
Rises 15, 38, 51, 67, 83, 89, 119
Rising 59
Risks 9
Rites 35, 121
Ritualistic 16
River 81
Rivers 27, 67

Robe 5-6, 66
Rock 48, 109
Roll 39, 107-109
Romances 125
Rome 121
Room 21
Rooster 38
Root 11, 23
Rootless 135
Roots 10, 137
Rose 21, 105
Rosicrucian 16, 77
Rosicrucian Novel 16
Royal 10, 86, 98
Rrraaa 48
Rrreee 48
Rrriii 48
Rrrooo 48
Rrrrrrrrrrrriiiiiiiiiiiiiiiiii 29
Rrruuu 48
Ruach 19
Rubies 13
Sabtabiel 30
Sackcloth 11
Sacred Order of Tibet 10
Sacrifice 81
Sacrifices 40
Sad 143
Sadhana 82
Sages 139-140
Saintly 131
Saints 55, 64, 136
Salamanders 27, 29, 31
Salt 19, 21, 25, 46, 59, 61, 83, 125
Salvation 64
Samadhi 55, 65
Samael 6-7, 29, 35, 47, 147
Samphata 52
Samyak Sambuddha 6
Sanctify 57
Sanctity 119, 121, 143
Sanctuaries 10, 27
Sanctuary 1, 25, 27, 41, 56, 113, 115,
 145
Sanctuary of Vulcan 113, 115
Sanctum 7, 43, 55
Sanctum of Sanctums 55
Sanctum Regnum 7, 43, 55

Sands 109
Sane 110
Sanskrit 10, 46
Sap 113, 116-117
Satan 33-34, 37, 42, 52, 104, 108, 115,
 123, 125-126, 128
Satanic 52, 113
Satisfaction 128, 147
Satisfy 59, 123, 125
Saturn 4, 47-48, 57, 59
Save 69, 116
Saved 116
Savior 5, 73, 98
Sawlasaw 66
Scale 55, 57, 95
Scales 89
Scandals 117
Scenes 83
Scepter 22, 132
Scholastic 14
School 69, 77, 129, 131, 139, 141, 146
Schools 64, 76-78
Science 10, 13-14, 17, 19, 33-34, 42, 45,
 47, 61, 77, 97, 141
Scientifically 14
Scientists 139
Scoria 81
Scorpion 119
Se 9, 81
Sea 15, 29
Seal of Solomon 37-38, 40-42
Sealed 30
Second 3-4, 13, 15, 37, 46, 52, 56, 65-
 66, 71-72, 89, 96, 104, 119, 129,
 132, 143-145
Second Birth 46
Secret 1, 10, 14, 16, 19, 22, 25, 27, 34,
 37-38, 46, 53, 57, 63, 66-67, 75,
 77-78, 119, 131, 138, 147
Secret Philosophy 25, 27, 38, 53, 57
Secret Sister Master 46
Secrete 140
Secreted 140
Secretion 140
Secretly 117
Secrets 1
Sect 77, 131, 146
Secure 128

Security 128
Seduced 29, 128
Seduces 64
Seed 23, 29, 51, 59, 61
Seeds 5
Seer 21
Seers 16, 101
Seity 23
Self 40, 46, 116-117, 141
Self-discovery 102, 104, 138
Self-independence 85
Self-observe 102
Self-realize 57
Self-realized 46, 55, 86, 103, 109
Self-remembering 110-111
Self-revelation 138
Selfish 147
Semen 29, 43, 65
Seminal 4, 10-11, 43, 52-53, 65, 69,
 81-82, 95
Seminis 14, 17, 22, 25, 28, 34, 38, 45,
 52-53, 55, 57, 59, 77, 79, 81-82,
 87, 113, 131
Sensation 136
Sensations 40, 65, 135-137
Sense 49, 136
Senses 79, 136
Sensitivity 135
Sentiment 102, 126
Sentiments 70, 101-102, 125-126
Separate 29, 37
Separately 93
Separates 9
Separating 39, 52
Sepher Yetzirah 19
Sephirah 56, 71-72
Sephiroth 3-4, 19, 56, 71-72
Sephirothic 3, 61, 72
Sephirothic Crown 3
Sephirothic Tree 61
Septenary 45, 93
Sepulcher 90, 132-133
Sepulchers 4
Seraphim 5
Serenity 75
Serious 141, 143, 145
Serpent 11, 14-16, 23, 25, 38, 40-41, 48,
 52-53, 61, 67, 82, 113

Serpents 4, 38, 45, 59, 83, 89
Served 43, 147
Serves 21, 27, 46
Service 91, 136
Services 147
Set 17
Seven 3, 10, 14, 27, 42-43, 45, 47-49,
 55, 77, 79, 93-94, 103-104, 115,
 143
Seven Centers 93
Seven Churches 55
Seven Ordeals 10
Seven Serpents of Alchemy 45
Seventh 4-5, 43, 46, 56, 71, 105
Seventy-two 10
Severity 3
Sex 10-11, 14-15, 25, 27, 33-34, 46, 55,
 61-62, 64, 70-71, 77, 103, 105,
 109, 115-116, 119, 127, 146
Sexes 70
Sexual 3-4, 14, 16-17, 19, 22, 27-29, 37-
 38, 40-41, 43, 46, 48, 51-53, 56,
 59, 61, 64-66, 70, 75-78, 81-82,
 85-87, 93-94, 99, 101-105, 113,
 116-117, 121-122, 125, 128,
 135-137, 140, 144-145
Sexual Alchemy 4, 48, 81, 105, 145
Sexual Cycles 70
Sexual Enjoyment 65
Sexual Magic 3-4, 16, 43, 46, 48, 52,
 66, 76, 78, 85-87, 113, 117, 128,
 140
Sexual Sublimation 65
Sexuality 64
Sexually 38, 70, 93
Shadow 13, 39, 73, 108-109, 111, 120,
 127
Shadows 13, 38
Shakespeare 14
Shame 110
Shape 77
Shapeshift 96
Shell 95
Shells 90
Shikan 79
Shin 19, 22
Shiva 76
Shroud 132

Shrouds 131
Shuhsa 52
Sick 22
Sicknesses 5
Sidereal 1, 90, 133
Silence 140
Silent 66
Silver 38, 48, 59, 113, 117
Sin 40, 71, 79, 86
Sincere 121
Sinful 55
Sinned 73
Sinning 66-67, 69, 73, 104
Sins 40
Sister 46, 90
Sisters 23, 35, 42, 104
Six 40, 42
Sixteen 111
Sixteenth 107, 132
Sixth 4, 37, 42, 56, 71, 105
Sixth Seal 42
Sky 16, 23, 27, 33, 110
Sleep 73, 110-112, 126
Sleepily 109
Sleeping 83, 126, 128
Sleeps 67, 110
Sleepy 49, 72
Slumber 16, 23, 30-31, 97, 112, 126,
 137, 139
Slumbering 97
Slumbers 38
Smoke 21, 81
Smudge 35
Social 129, 138
Soil 135
Sol 30
Solar 3-4, 10-11, 46-48, 52-53, 69-71,
 98, 113, 122
Solar Astral Atoms 98
Solar Conscience 69
Solar Consciousness 69-70
Solar Faith 47
Solar Internal Bodies 122
Solar Internal Vehicles 122
Solis 30, 88
Solitude 27
Solomon 37-38, 40-42
Solve 75

Soma Psuchikon 89
Somnambulist 97
Son 15, 22, 34, 37, 41, 43, 65, 73, 83, 113, 122, 138
Son of Man 65, 73, 122
Song 136
Sophic Mercury 34, 45
Sophic Sulfur 34
Sophism 115
Soul 10, 15, 19, 22-23, 26, 33-34, 37, 42, 69, 79, 81-82, 85-90, 95, 103-104, 107-108, 122-123, 125-126, 128, 139
Soul-Consciousness 65, 71
Soulless 89, 107, 126
Souls 19, 33, 35, 38, 62, 86, 115, 121, 126, 128
Sound 5, 29-30, 95, 140
Sounding 79
Sounds 140
South 31
Sowing 51
Space 13, 15, 23, 53, 59, 144
Spanish 75
Spark 126
Spasm 14, 17
Specialist 42
Species 28, 61, 65
Specter 107, 109, 122-123, 126
Specters 108, 123, 128
Speranza 62
Spermatozoon 103
Sphere 9-11, 16, 25, 35, 61-65, 94, 119, 123
Sphere of Lilith 64
Sphere of Nahemah 64
Spheres 63-65, 71-72
Sphincters 95
Sphinx 27, 41, 67, 105
Sphinxes 46
Spill 38, 103, 131
Spilled 132
Spilling 113, 129
Spills 66, 107, 135
Spinal 10-11, 14, 28, 43, 53, 55, 116
Spinal Medulla 10-11, 14, 28, 53, 55, 116
Spine 53, 120

Spirit 4, 13-15, 19, 21, 25, 28-29, 37, 40-41, 47, 59, 65, 75, 83, 102, 105, 113, 123, 138, 144
Spirit of Life 14, 123
Spirit of Wisdom 138, 144
Spiritism 41
Spirits 37
Spiritual 19, 132, 143
Spiritual Resurrection 132
Spiritual Soul 19
Spiritualists 64
Spiritually 132
Splendid 78
Splendor 71, 88
Splendors 19, 70
Sports 102
Spot 27, 97
Spouse 23, 46, 86
Spread 33, 49, 113, 116
Spring 138
Square 93-94
St. Germain 91, 133
Stable 131
Stables 15, 62
Staff 47, 66, 145
Star 5, 13, 33-35, 40-41, 45, 49, 71, 94, 99, 113, 117, 135, 144
Star of David 94
Star of Five Points 33, 35, 99
Star of Seven Points 45
Star of Solomon 40
Stars 22-23, 117
Stigmatized 27
Still 5, 27, 30, 64, 87, 89, 104, 120, 122, 141
Stone 13-14, 34, 38, 40, 43, 45-46, 51, 79, 82, 127
Stone of Grace 14
Stonemason 131
Stones 13, 48
Stoning 110
Straight 27, 116
Strait 115-116
Stratum 63
Stratums 63
Strength 4, 43
Strengthen 69, 126
Strengthened 85

Strong 65, 131
Strongly 119
Structure 72
Struggle 14, 33, 42
Struggles 42
Student 1, 5, 27, 41, 46, 49, 97, 110, 113, 120-121, 140
Students 1, 27, 34, 38, 46, 59, 78-79, 81, 96, 109-110, 115, 119, 121-123, 128, 137, 143, 145-146
Studied 82, 102, 108, 115
Studies 34, 41, 64, 141, 143
Study 1, 4-5, 7, 13, 15, 25, 33, 37, 41, 51, 61, 67, 72, 75, 79, 81, 85, 93, 99, 101-102, 107-108, 113, 119, 125, 129, 135, 137-138, 141
Studying 7, 59, 129
Subconscious 136
Subconsciousness 111-112
Subhuman 102-103
Sublimate 17, 125
Sublimated 66
Sublimation 65
Sublunar 113, 115
Submerge 9
Submerged 115, 140
Submerges 133
Submerging 97
Substance 14, 82, 125
Substances 93-94, 103
Substratum 19
Subtle 17, 115, 121
Succubi 21
Suffer 102, 137
Suffering 5-6, 131
Sufferings 55
Suffers 120
Sufis 77
Sulfur 19, 21-22, 25, 34, 46, 59, 61, 76, 83, 125
Sum 79, 93
Sum Matter 79
Summarized 33, 41
Sun 3-5, 15, 22, 27, 38-41, 43, 45, 47-48, 57, 67, 70, 72, 76, 86-87, 93-94, 109, 113, 125
Sun of Leo 4
Super-Human 89, 91

Super-Humans 105
Super-Man 59, 89
Superior 4, 17, 22, 33-34, 37-39, 41, 46, 55, 64, 78, 90, 97, 101, 107-108, 111, 117, 132-133, 137
Superior Emotion 101, 107-108
Superior Mind 101, 107-108
Superior Worlds 17, 22, 41, 46, 55, 78, 97, 111, 117, 132, 137
Supersensible 90, 110-111, 132-133
Suprasexuality 65
Swan 61
Swear 125
Sweet 23, 64
Sweetness 125
Swindler 125-126
Sword 11, 14-15, 31, 43, 47-48, 55, 57, 62, 67, 69, 105, 120, 131-132
Syllabifying 48, 72
Syllables 29
Sylphs 28-31
Symbol 9, 11, 21-22, 28, 33, 39-40, 43, 63, 86, 119
Symbolic 125
Symbolism 27, 61
Symbolize 15, 25, 28, 51, 83
Symbolized 28, 51
Symbolizes 10-11, 27, 37, 45-46, 59, 66
Symbols 38
Sympathetic 43, 53, 96, 113
Sympathies 40
Synthesis 13, 19, 40, 83, 99
System 3-4, 10-11, 38, 43, 53, 70
Systems 146
Table 72, 97
Tables 72
Tablets 145
Taboos 64
Tail 38, 52, 115
Tail of Satan 52, 115
Talismans 48
Tantra 81-82
Tantric 82
Tantrism 52, 76, 81
Taoism 76
Tashisni 6
Taste 136-137
Tau 37-38, 125

Taurus 4
Tavern 79
Teach 27, 77
Teaches 23, 141
Technique 110, 136, 138-139
Techniques 101
Teeth 115
Telepathy 15, 48
Temperance 47, 96
Templars 77
Temple 1, 10, 14-15, 17, 25, 31, 35,
 40-41, 45, 55, 72, 109, 120, 127,
 145
Temples 14, 27, 97, 121
Temples of Jinn Science 97
Temptation 49, 115
Temptations 29
Tempter 128
Tempting 14, 29, 38, 41, 67
Ten 3-4, 71-72, 79, 140
Ten Sephiroth 3-4, 71-72
Tenacity 7, 97
Tenderness 125
Tennis 102, 141
Tenor 79
Tenth 5, 71, 81
Ternary 22, 129
Terrestrial 59, 61-63, 66, 109
Test 13, 61-62
Testicles 53
Tetragrammaton 25, 30-31, 144
Thelema 15, 27, 47, 51, 59
Theories 129
Theorize 1
Theory 61
Theosophy 108
Thessaly 121
Think 46, 49, 117, 128, 147
Thinking 9, 19
Thinking Soul 19
Thinks 128
Third 3-4, 22, 28, 37, 56, 65, 71-72, 90,
 95-96, 98, 104, 108, 125, 132,
 139, 143-144
Third Initiation of Major Mysteries
 108
Third Logos 28
Thirty 19

Thomas 133
Thought 64-65, 95, 127
Thoughts 9, 21, 40, 55, 75, 97, 121,
 125, 145
Thousand 11, 55
Thousands 97, 133, 135
Threatened 5
Three 3, 14, 19, 21-22, 37-38, 41, 46,
 59, 65, 69, 72, 83, 93, 113,
 115-116, 132-133, 138, 141,
 143-144
Three Mother Letters 21
Three Profundities 143-144
Three Rays 46, 113, 116
Three Types of Resurrection 132
Three Worlds 22
Threescore 11
Threshold 5, 62, 67, 105
Thrice-spiritual Sun 3
Thrones 75
Thumb 9
Thunder 27
Thundering 57
Tiara 15
Tibet 10, 76-77
Tibetan Yogas 76
Tiger 76, 135
Time 4, 13, 42, 46, 55, 59, 66, 73, 96-
 97, 108, 116, 121, 138, 140, 146
Tin 48
Tincture 83
Tiphereth 4, 71
To-Soma-Psuchikon 95
Tomb 86
Tomorrow 129
Touch 136-137
Touched 145
Touches 41, 101
Tower of Babel 107-108, 146
Towers 5, 107
Tradition 79
Traditions 10, 63
Traitor 37
Traitors 37, 41
Trancestate 78
Transcend 103
Transcendental 4
Transcends 122

Transform 43, 78, 82-83, 99, 105, 113, 136
Transformation 93, 96
Transformed 15, 27, 47, 75, 104, 107, 122, 127, 136
Transforming 61
Transforms 82-83
Transmutation 51, 59, 61, 65, 93, 99, 105
Transmutations 14, 22, 47
Transmutator 40
Transmute 15, 17, 28-29, 47, 59, 75, 82, 95, 104, 125
Transmuted 21, 43, 47, 53, 59, 65-66, 105, 117
Transmutes 65, 82
Transmuting 16-17
Transplant 65
Transubstantiation 93, 98
Treasure 147
Treasury 10, 34, 61
Treatise of Occult Science 10
Tree 2, 26, 39, 61, 67, 137, 140
Tree of Knowledge 67
Tree of Life 2, 26
Trees 11, 52
Triangle 19, 31, 37-39, 46, 79, 81, 93
Triangle-Spirit 75, 81
Triangles 37, 94
Trident 31
TRIIIINNNNN 140
Trinity 40, 144
Trismosin 88
Triumph 97, 129
Triveni 53
True Identity 86
Trumpet 51, 129
Trunk 23
Trunks 79
Truth 1, 19, 34, 43, 59, 145
Tube 13
Tunics 79, 131-132
Twelfth 5, 71, 79, 81-83
Twelfth Key of Basil Valentine 82
Twelve 19, 22, 40-41, 71-72, 79, 81, 83, 115
Twelve Secret Keys of Basil Valentine 19

Twilight 119
Two 1, 4, 10-11, 13, 15-17, 19, 22, 28-29, 33, 35, 37-39, 42-43, 45-46, 48, 51-53, 56, 59, 63, 70, 75, 77-78, 81, 85, 93-94, 96, 101, 107-108, 113, 116, 119, 125-127, 129, 138, 145
Two Tablets 145
Two Witnesses 10-11, 51-53
Typhon 4, 67, 99
Typhon Baphomet 4, 99
Ulysses 14, 29
Unbelieving 133
Unclean 37
Unconscious 136-137
Unction 98
Understand 11, 41, 64, 70, 73
Understanding 137, 147
Understands 73
Understood 123
Undertail 78
Undines 28-31
Unfaithful 67
Union 22, 28, 34, 42, 52, 76, 94, 103
Unite 96
United 39, 83, 93, 98
Unities 75
Unity 13, 15, 40, 95
Unity of Life 13, 15
Universal 14, 17, 42, 56, 59, 63, 71-72, 105, 113, 123
Universale 79
Universe 3-4, 13, 51, 72, 76, 79
Universe of Brahma 51
Unknowable 16, 144
Unru 48
Urania-Venus 22, 55
Uranus 70, 77
Urdhavareta 46, 52
Urdhavareta Yoga 52
Urdhavareta Yogis 46
Urethra 95
Uriel 47
Uterine 95-96
Uterus 25, 38-39, 43, 56, 95
Vagina 52
Vajroli 52
Valentine 19, 50-51, 58, 82

Valentinus 19
Value 4
Values 82, 85, 123
Vampire 39
Vanity 73
Vapors 21, 29, 53
Vau 25
Vedas 17
Vegetables 28
Vegetal 104
Vehicle 41, 65, 89, 95, 104, 108
Vehicles 72, 86-89, 108, 122, 126
Veil 1, 13, 15, 23, 63
Veil of Isis 15
Venom 40
Venus 3-4, 15, 47-48, 57, 62, 70, 113
Venus of Taurus 4
Venus-Eve 55
Venus-Urania 55
Venusian 47
Venusian Lust 47
Venustic 62, 65, 113, 123
Venustic Initiation 62, 65, 113, 123
Vertebra 119-121
Vertebrae 77, 121
Vertical 25
Vesture 93
Vibrates 70
Vibration 17, 63, 71-72
Vice 42
Vices 47, 135-136
Victory 4, 47, 62, 71
View 79
Vigil 9
Vigilance 83, 138
Vigilant 64
Violence 110, 120, 125
Violent 120
Violently 101, 113, 120
Vipers 34
Virdarium Chymicum 45
Virgin 14-15, 81
Virgo 4
Viridarium Chymicum 45, 50-51, 58
Virile 75
Virille 82
Virtue 42, 83
Virtues 4-5, 119

Visible 91, 132
Vision 139
Visions 4, 23
Visual 135
Vitae 29-30
Vital 63, 65, 79, 90, 95
Vital Body 65
Vitriol 43, 45
Vocalization 140
Vocalize 29-31, 72, 75, 78, 140
Vocalized 29
Vocalizing 72, 140
Voi 62
Volatile 76, 87
Volatility 61
Volcano 27
Volitions 125
Volumes 138
Voluptuous 29
Vowel 140
Vowels 72
Vulcan 15, 61, 65, 69, 113, 115, 141,
 145-146
Vulgar 136
Wand 11, 31
Warrior 3, 29, 46-47
Watan 10
Watch 42
Watchers 90
Water 10, 14-15, 19, 21-22, 25, 27-28,
 30-31, 40, 43, 45, 56, 76-77, 94
Watering 67
Waters 4, 21, 30, 34, 52
Way 19, 30, 52, 81, 99, 102, 111, 133,
 146
Wealth 5, 46
Wedding 63, 95-96
Weddings 39
West 31
Western World 116-117
Westerners 117
Wet Path 28
Wheat 51
Wheel 3, 57, 67, 69-70, 123
Wheels 104
White 1, 14, 21, 37, 46, 51-52, 61, 67,
 76-78, 81-82, 93-94, 119, 139
White Balm 14

White Dragon 37
White Lodge 14, 77
White Magic 21, 67, 119
White Magicians 1
White Sexual Magic 52
White Tantra 82
White Tantrism 76
Whiten 61
Whiteness 90
Widow 15
Widowed 46
Wife 76
Wilderness 41, 67
Willpower 15, 27, 37, 47, 59, 71, 75, 86, 96-97, 103, 133
Wind 43
Wine 11, 28, 98
Winged 16
Wings 5, 145
Wisdom 3, 5, 19, 23, 28, 34, 37, 47, 57, 66, 71, 73, 93, 95, 103, 113, 122, 131, 138-139, 143-144
Wise 61, 66, 117, 139, 143
Wisely 52, 59, 117
Wishes 140
Witchcraft 121
Witnesses 10-11, 51-53
Wives 63
Wolf 119
Woman 14-17, 22-23, 25, 34, 38-40, 42, 55, 57, 63, 75, 77, 82, 93-95, 103, 113, 116, 125-127, 129, 137, 145
Womb 43, 61, 81, 85
Women 39-40, 70, 90, 133
Word 14-16, 22-23, 33-34, 43, 49, 110, 127, 144
Words 38, 40, 45, 52, 65, 75, 77, 81, 95, 123, 138
World 6, 14, 19, 22-23, 33, 37, 46, 55, 65, 69, 71, 91, 95, 98, 103, 107, 110-111, 116-117, 121-123, 132-133, 135-136, 138-139
Worldly 145
Worlds 17, 22, 41, 46, 55, 72, 78, 90, 95, 97, 110-111, 117, 120, 132-133, 136-137
Wormwood 34

Worship 14-15
Worshiping 49
Wounds 133
Woven 37
Yang 76
Year 77
Years 40, 66, 70, 77, 81, 90, 133, 135, 143
Yellow Lodges 76
Yesod 4, 46, 71
Yetzirah 19
Ying-Yang 76
Yoga 46, 52, 57, 76, 82, 116-117
Yogas 76
Yogi 46, 57, 116-117
Yogi-Avatar 46
Yogi-Christ 90
Yogic 46, 116-117
Yogini 46, 57
Yoginis 76
Yogis 46, 52, 82, 116-117
Yoni 38-39
Youth 28, 79, 113
Zachariel 47
Zanoni 135
Zeesar 66
Zephyrs 13
Zodiac 41
Zodiacal 40-41
Zohar 19, 22, 62
Zoroaster 62

Books by the Same Author

Aquarian Message
Aztec Christic Magic
Book of the Dead
Book of the Virgin of Carmen
Buddha's Necklace
Christ Will
Christmas Messages (various)
Cosmic Ships
Cosmic Teachings of a Lama
Didactic Self-Knowledge
Dream Yoga (collected writings)
Elimination of Satan's Tail
Esoteric Course of Runic Magic
Esoteric Treatise of Hermetic Astrology
Esoteric Treatise of Theurgy
Fundamental Education
Fundamental Notions of Endocrinology
Gnostic Anthropology
Gnostic Catechism
The Great Rebellion
Greater Mysteries
Igneous Rose
The Initiatic Path in the Arcana of Tarot
 and Kabbalah

Introduction to Gnosis
Kabbalah of the Mayan Mysteries
Lamasery Exercises
Logos Mantra Theurgy
Manual of Practical Magic
Mysteries of Fire: Kundalini Yoga
Mystery of the Golden Blossom
Occult Medicine & Practical Magic
Parsifal Unveiled
The Perfect Matrimony
Pistis Sophia Unveiled
Revolution of Beelzebub
Revolution of the Dialectic
Revolutionary Psychology
Secret Doctrine of Anahuac
Three Mountains
Transmutation of Sexual Energy
Treatise of Sexual Alchemy
Yellow Book
Yes, There is Hell, a Devil, and Karma
Zodiacal Course
150 Answers from Master Samael Aun Weor

To learn more about Gnosis, visit gnosticteachings.org.

Thelema Press is a non-profit publisher dedicated to spreading the sacred universal doctrine to suffering humanity. All of our works are made possible by the kindness and generosity of sponsors. If you would like to make a tax-deductible donation, you may send it to the address below, or visit our website for other alternatives. If you would like to sponsor the publication of a book, please contact us at 212-501-6106 or help@gnosticteachings.org.

Thelema Press
PMB 192, 18645 SW Farmington Rd., Aloha OR 97007 USA
Phone: 212-501-6106 · Fax: 212-501-1676

Visit us online at:
gnosticteachings.org
gnosticradio.org
gnosticschool.org
gnosticstore.org
gnosticvideos.org